Art of Embroidery

ENDPAPERS
Detail of a ricestitch candle design from a sofa in
the Panelled Room of Westwood Manor, Wiltshire

OVERLEAF
The meeting of Jael and Sisera, a detail from one of
the biblical panels at Parham Park, West Sussex

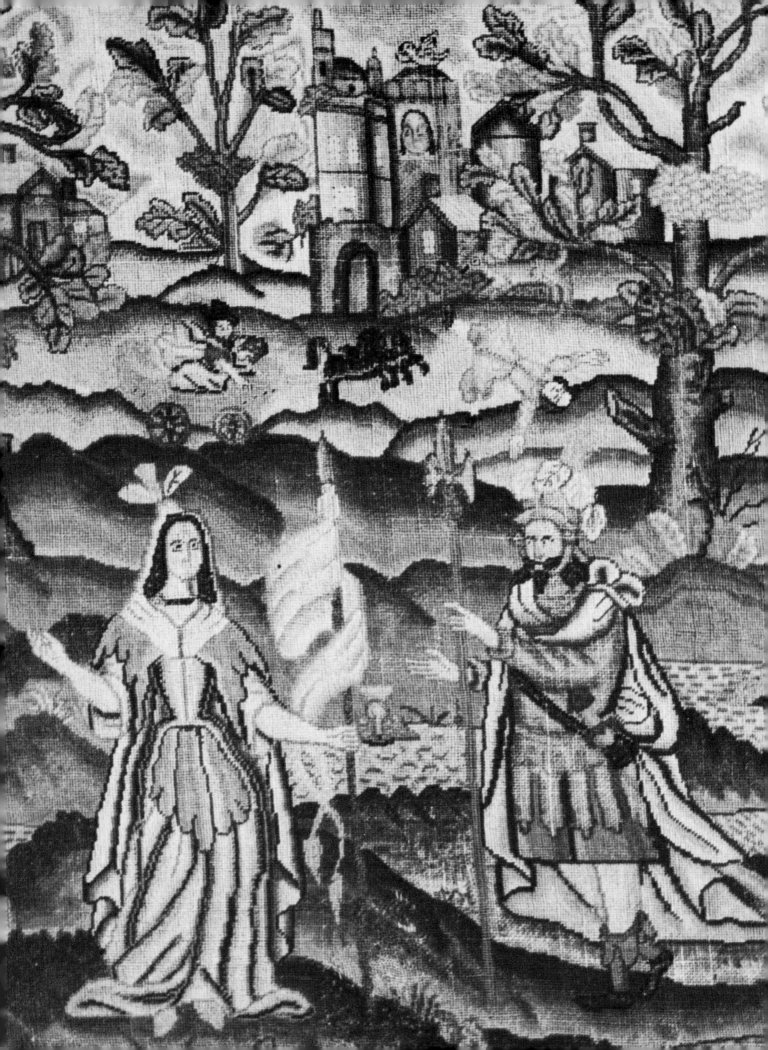

Mary Gostelow

Art of Embroidery

Great Needlework Collections of Britain and
the United States

E. P. DUTTON
New York

Contents

Contents

First American edition published 1979 by E. P. Dutton,
a Division of Elsevier–Dutton Publishing Company, Inc., New York

Designed by Gail Engert

Library of Congress Catalog Card Number: 78–68557
ISBN 0–525–93064–7

Printed in Great Britain by
Butler and Tanner Ltd, Frome and London
Color Separations by Newsele Litho Ltd.

10 9 8 7 6 5 4 3 2 1

List of Colour Plates

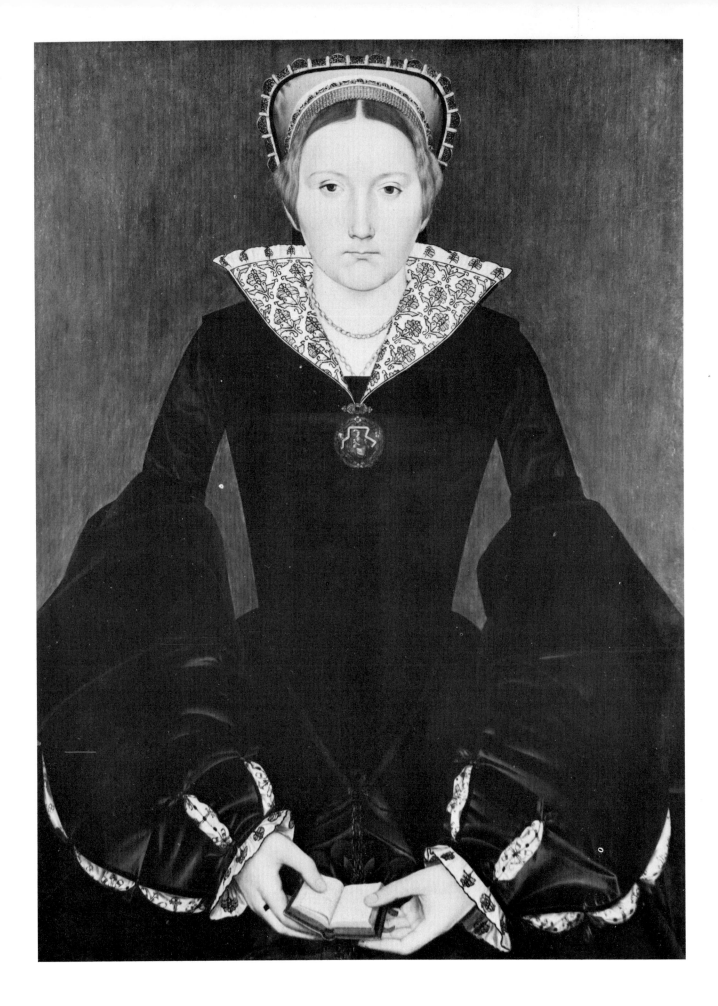

Introduction

 MBROIDERY – or decorative stitchery – is an art form which is an essential ingredient of our culture and this book is a study of that art through the history, the houses and the lives of the people connected with outstanding embroidery collections in Britain and North America.

Most of the chapters are set on stages provided by beautiful homes all regularly open to the public. In Britain, Claverton Manor (the American Museum in Britain), Blair and Glamis Castles, Hardwick Hall, Mellerstain, Milton Manor House, Parham Park, Traquair House and Westwood Manor are each accorded a whole chapter. American homes are visited within the complex of Colonial Williamsburg, Historic Deerfield, Old Sturbridge Village, the Wickham-Valentine House of the Valentine Museum and at Winterthur. Other sections are devoted to the Daughters of the American Revolution Museum, the Helen Allen Collection in Madison, the Henry Ford Museum and the Ohio Historical Society. Wells Cathedral and the National Cathedral represent ecclesiastical embroideries. One exception to the plan that each chapter covers a single site is provided by Mount Vernon, Woodlawn and Kenmore which together offer needleworks associated with George Washington's family.

Any such anthology is personal and this one is my own selection. Other famous houses and buildings have embroideries that may warrant coverage and better known museums have been excluded because their collections are already published. Material from such places as Oxburgh Hall, Shelburne, the Victoria and Albert Museum and the Metropolitan Museum of Art, to name but a few organizations, is however sometimes referred to in comparisons with other works.

Historical uses of embroidery can often best be studied through painting. Here blackwork details embellish a portrait, *c.* 1545, thought at one time to be of Mary I but now thought to be a likeness of Anne Bodenham, a Dorset nun given a pension after the 1540 Dissolution.
oil on two boards joined vertically, 30 × 22 in, 76·2 × 55·9 cm

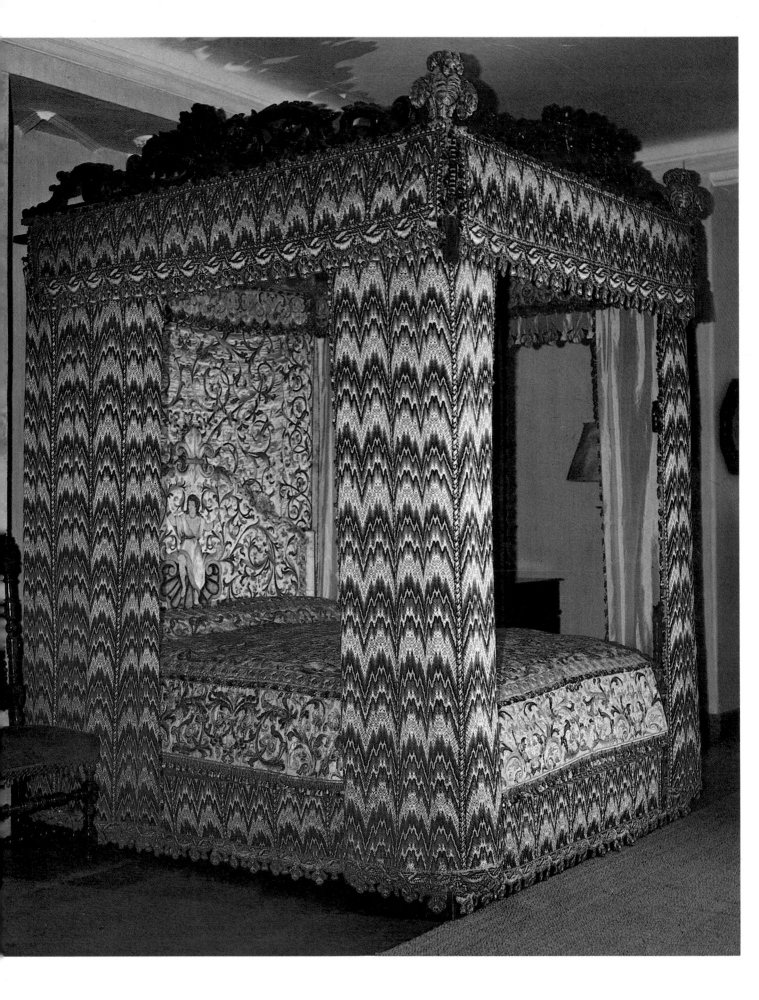

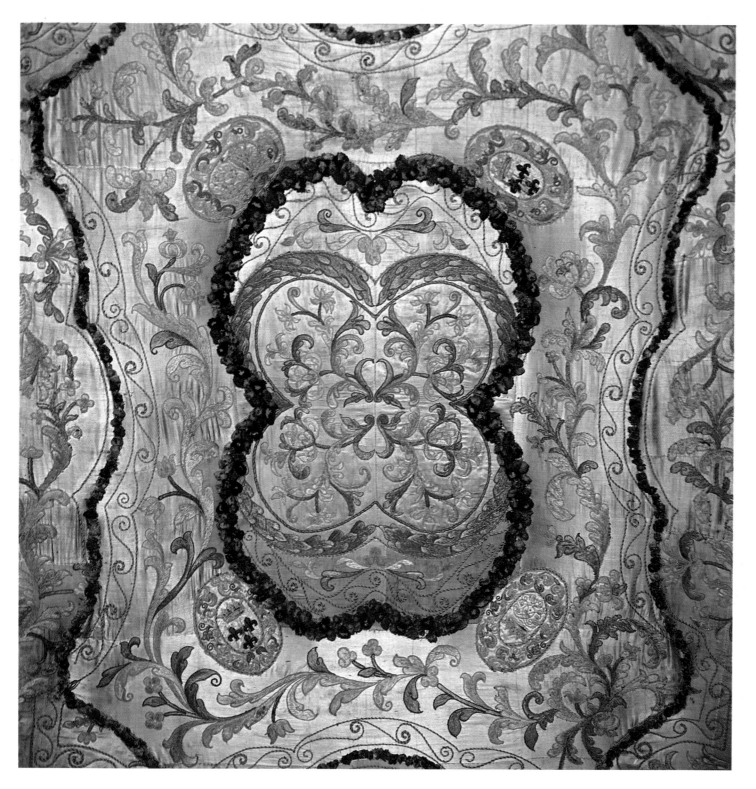

Plate 1 Parham Park's famous bed, the headboard of which is on the cover of this book. Silk coverlet, headboard, headcloth and canopy were embroidered in silks with pearl and metal thread embellishment in designs of flowers and other motifs, *c.* 1585; linen canvas side curtains and tester and base valances were added later.

Plate 2 (above) A detail of the four-tiered inner canopy reveals a fleur-de-lys motif that once led the silk coverings to be associated with Mary Queen of Scots, whose first husband was Francis II of France.

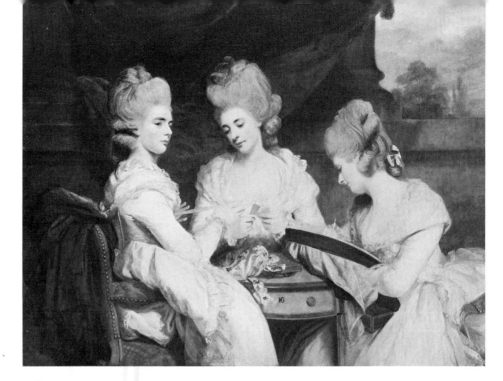

TOP Lady Horatia Waldegrave works on her tambour frame, producing a continuous chain stitch by means of looping thread around a crochet-type hook; her sisters Lady Maria and Lady Laura are holding silks. The painting was commissioned in 1781 by their great-uncle, Horace Walpole, who wrote, 'Sir Joshua has begun a charming picture of my three fair nieces, the Waldegraves, and very like. They are embroidering and winding silk.'
The Ladies Waldegrave *by Sir Joshua Reynolds* (1723–92); *oil on canvas,* 56½ × 66 *in,* 143.5 × 167.6 *cm*

BOTTOM An example of a pattern completely formed from tamboured chain stitch, worked with a hook.
satin worked with silks, 12½ × 15¾ *in,* 31.8 × 40 *cm*

...er has a similar format. The history of the house or site is ... a tour around the area open to the public. This provides ... on to needleworks which are then studied in detail through, ... rchitecture, interiors, paintings, furniture and costume. The ... esign is paramount but interesting personalities, some royal ... nous, continually appear in a text that is to a great extent ... th people. Did men, women or children work the embroi- ... they professionals or amateurs? How did they learn their ... Were those traits and the emphasis of embroidery the results

of religious fervour, the importance of trade or local peace? How have needleworks survived the years? And how are they displayed and studied today in their ambience of social heritage?

Although the book is planned to be read in order, each chapter is self-sufficient. Needlework techniques are fully explained only once, generally at their first appearance. Popular stitches are diagrammed at the back of the book, together with notes to the text, bibliography and index.

Colour and black-and-white photographs integrated within the text have mostly been specially taken by Martin Gostelow to show the sheer beauty of embroidery, which the magnification of some items can in fact often emphasize. I find that after a stimulating visit to yet another exciting stately home during which I have become momentarily satiated by its architecture, paintings and other treasures as well as embroideries, the memory is savoured and my knowledge considerably increased by the photographs taken. Line drawings are also included to highlight details.

Art of Embroidery is intended to whet the appetite for appreciating embroidery. Perhaps a return visit to a house will beckon so that, this time, other treasures can be studied. Going back to Parham Park, to take but one example, may reveal 'embroidered' details on the upturned collar, cuffs and undershirt of a Tudor portrait, indicating the use that many sixteenth-century painters made of blackwork, generally black-on-white embroidery. Other houses may be visited for the first time. The book may encourage a trip to the hilly pasturelands of Berwickshire to visit Mellerstain, a fine Adam house in Scotland, which includes among its cornucopia of treasures the unique 1706 canvaswork panel here studied in detail. My hope too is that *Art of Embroidery*, through its examples of collections on both sides of the Atlantic, may inspire a search for embroidery in other places. A visit to the National Gallery of Scotland, for example, brings forth that marvellous Reynolds of Horace Walpole's three great-nieces, the Ladies Waldegrave, one of whom holds an oval frame and upright hook with which she is tambouring, producing the same continuous chain stitch which is used for a floral panel now in the Ohio Historical Society.

Some of the many practical uses to which decorative needlework can be put are indicated. Traditionally embroidery in Britain and America has been employed particularly for household furnishings, clothing and ecclesiastical and other ceremonial purposes. Although it is not anticipated that every reader will want (let alone be able) to work a facsimile of the famous bed at Parham Park (*see front jacket and Plates 1 and 2*), it is hoped that many will want to try for themselves some of the easier designs of their forebears. Only in this way, indeed, can needlework heritage be continued, a point which I substantiate in the chapter devoted to the continuing traditions mentioned throughout the anthology.

Mary Gostelow

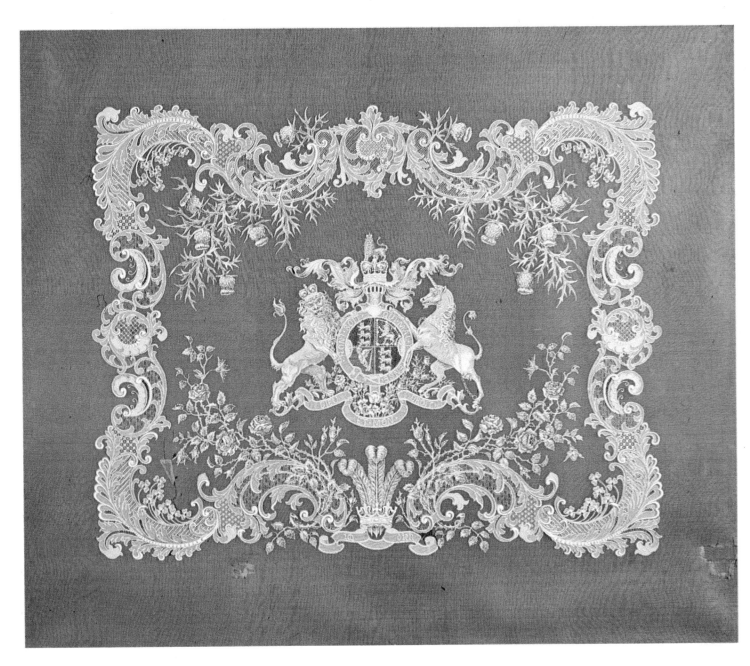

Plates 3 and 4 'Lady Evelyn's whitework', designed and worked by Lady Evelyn Stewart-Murray (1868–1940) and now displayed at her family home, Blair Castle. Shortly after she finished it, in Belgium in 1912, it was stolen; before it was recovered, damp had caused the brown stain on one of the thistles.

Claverton Manor, designed in
1820 by Sir Jeffry Wyatville.

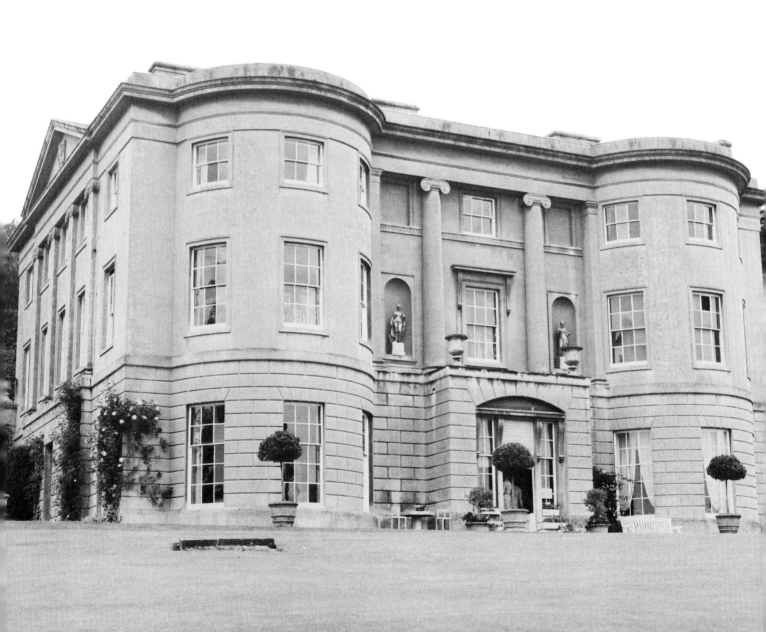

1

The American Museum in Britain

American Coverlets

SUITABLE appetizer to a study of artistic needlework on both sides of the Atlantic is offered by the superb bed coverlets, many of them quilted, in the American Museum in Britain at Claverton Manor, high above the Avon Valley near Bath.

In 1820 a Cornishman, John Vivian, barrister, solicitor to the Excise and bencher of the Middle Temple, commissioned a design from King George IV's architect, Sir Jeffry Wyatt (1766–1840), who took the name Wyatville. Responsible also for the modernization of Windsor Castle, Wyatville designed Claverton with an imposing pedimented west entrance and an east wall relieved by two semi-circular monumental projecting bays in neo-classical style. It is an impressive house, with spacious gardens and spectacular views of the countryside around.

Claverton Manor has many Anglo-American associations. Sir Winston Churchill (1874–1965), later the only Briton to be honoured on one of America's National Cathedral canvasworks, made his first political speech here, on 26 July 1897, at a garden fête organized by the Primrose League. Sixty years later, Churchill's compatriot John Judkyn and Dr Dallas Pratt of New York, both deeply concerned that Americana was little understood in Europe, purchased Claverton with a view to redressing this. They appointed a director, Ian McCallum, and enlisted the help of curators and private individuals throughout the States. Ceilings, walls with doors and windows, floors and furnishings were carefully transported across the Atlantic and accurately reset within Claverton's large rooms. By the time the Museum opened in 1961, eleven typically American rooms were furnished and seventeen thousand visitors arrived during the first year (a

figure now swollen to over a hundred thousand annually).

There is much to see and learn at Claverton and its rooms are so accurately recreated that it is easy to imagine that the original occupants are about to appear at any moment. The Lee Room, an all-purpose family room from New Hampshire, has a white-clothed round table set with treen and facsimile food as if ready for a meal. A crewel canopy extending high up one wall shields a convenient folding bed similar to those discussed later at Colonial Williamsburg and Historic Deerfield. Illustrating another aspect of American life, the New Orleans Bedroom is full of southern elegance: ornate wallpaper and heavy furniture from the workshop of Prudent Mallard (1809–79) are offset by delicate white window curtains decorated with tamboured chain stitch. There are also a country store and a tavern to visit and, outside, an 1896 Pullman car, a tepee, a herb shop and garden, including a copy of the Mount Vernon garden presented by the Colonial Dames of America.

Some visitors, however, prefer to spend most of their time in the Textile Room, where coverlets and other items can be seen fully displayed on vertical panels hinged to a ceiling-high pole. The many different types of bed coverlets, used for warmth and decoration, include bed rugs (discussed later at Colonial Williamsburg) and others sometimes known as 'quilts' which should, technically, have three layers consisting of 'top' (upper fabric), 'filling' and 'bottom layer'. 'Quilting' is the method of holding these layers together, usually with stab stitch, which looks like running stitch but which is formed by a series of movements making alternate entries and exits through the fabrics.

Traditionally English and Welsh quilts rely for decoration on outline quilting motifs and especially until the 1776 Revolution American quilt-makers emulated their designs, sometimes working with tops of calamanco (glazed worsted) brought across the Atlantic. Thereafter, until about 1850 when there was sufficient roller-printed cotton fabric within America to make new material more readily available, American women had to rely on their ingenuity. They used left-over clothing and bits from their scrap bags to form tops of patchwork, with small pieces of cloth 'pieced' or 'patched' together to form the required shape or area.

British contemporaries formed patchwork with bits of imported Indian 'chints' or 'painted callicoes' by folding small bits of fabric over paper templates which were only removed after all edges were joined to neighbouring shapes. American patchwork, by contrast, is still often worked by marking the wrong sides of bits of fabric around the edge of templates which are removed before stitching is worked along the marked lines joining two patches at one edge. Alternatively, a larger area of plain fabric forming a coverlet top is decorated with appliqué, a technique which usually implies smaller motifs or areas of another fabric applied (laid above and stitched on) to the ground (the main fabric).

In the past many young American girls had to have thirteen coverlet tops all ready to be quilted as soon as they were betrothed: particularly important were special bridal coverlets with traditional love-hearts. The time consumed in working many tops and subsequently quilting them was one reason why, as will be seen from the Westover-Berkeley coverlet at the Valentine Museum, the making of coverlets was often a communal affair, with a group of people meeting together to work on one item.

Some coverlet patterns indicate a particular region. For instance, many Pennsylvanian tops have neat stitching worked on brightly coloured areas which sometimes include tulip motifs. Amish coverlets, from Indiana,

American bridal coverlets traditionally include heart motifs: this 'Christmas bride' coverlet also depicts sprigs of holly with bright red berries. *cotton applied with cotton motifs and subsequently quilted, 74 in, 188 cm square*

Nineteen hexagonal-patch
block, worked in three colours;
blocks can be fitted close to
neighbours or separated by
borders as required to form
variants of the 'grandmother's
garden' pattern.

'Robbing Peter to pay Paul',
which has many alternative
names, consists of blocks of
two patches fitted together
as shown.

Iowa, Ohio and Pennsylvania, have large solid blocks of dull-coloured wool patched together in simple geometric formation with no pictorial representation. All-white cotton coverlets often indicate southern provenance and Hawaiian items are identified by graceful curvilinear shapes, often formed of one piece of fabric, applied to another coloured top and subsequently quilted in half-inch (1·2 cm) concentric lines around the application, thus forming 'contour quilting'. Other motifs recur in many areas. Some of the most popular patterns have, not surprisingly, been taken from everyday observation: little basket designs are employed, as are garden shapes, sometimes in the form known as 'grandmother's garden' in which differently coloured hexagonal patches are set in an alignment reminiscent of flower beds. 'Windmill' and 'turkey track' designs are similarly descriptive. In other instances common patterns have such local names as 'robbing Peter to pay Paul', also known as 'rocky road to Kansas' and 'rocky road to California'. Similarly, 'meadow' or 'Carolina lily' becomes 'prairie lily' beyond the Mississippi and 'mariposa lily' even further west, showing that many coverlet designs were carried westwards as more of America was opened up.

One design particularly suitable to the New World is 'log cabin', which consists of overlapping rectangular patches pieced in turn to one side after another of a small square centre in ever-increasing peripheral dimensions. Finished areas, known as 'blocks', are then themselves pieced with colours aligned to form 'pineapple', 'barn raising' or other required patterns. Other designs which enjoyed continual popularity include 'tumbling blocks', formed of diamond-shaped motifs fitted together to give a three-dimensional appearance, and 'nine patch', with blocks of three rows of three square motifs subsequently pieced into 'nine patch chain' or another pattern. Other designs such as the haphazard shaping of 'crazy' or 'kaleidoscope patchwork', associated with the middle of the nineteenth century, were restricted to a temporary following.

After a top area is decorated, sometimes with an outer border to the main design, quilting is worked. Except in some areas of east Kentucky and east Tennessee, where a full-size frame is employed which can be raised to the ceiling when not in use, quilting is traditionally worked on a horizontal roller frame, perhaps supported on chairs. The backing fabric is sewn on to the rollers and covered with filling, formerly cotton wool (sometimes with seeds still to be seen), but nowadays usually polyester. The top fabric is placed above and the three layers are temporarily tacked or basted with long running stitches before quilting is worked, either outlining motifs or forming a trellis pattern or an independent outline shape such as the pineapple of hospitality. After the quilting has been worked, the tacking stitches are removed, the item is taken off the frame and the edges are secured. Either the top and backing edges are neatly turned over to the reverse of the coverlet and held with two rows of ordinary running

RIGHT 'Nine patch' coverlet worked by Margaretta Boone Wintersteen of Port Carbon, Pennsylvania, in the first half of the nineteenth century. Printed cotton blocks alternate with white.
coverlet backed with homespun and filled with cotton wool with seeds, 84 × 80 in, 213·4 × 203·2 cm

ABOVE A log cabin overlapping patchwork block is formed around a central bit tacked to backing and, in turn, rectangular bits are stitched and turned back (1) to produce increasingly-sized blocks. Colouring can be arranged (2) so that blocks can be aligned in various ways (3 and 4).

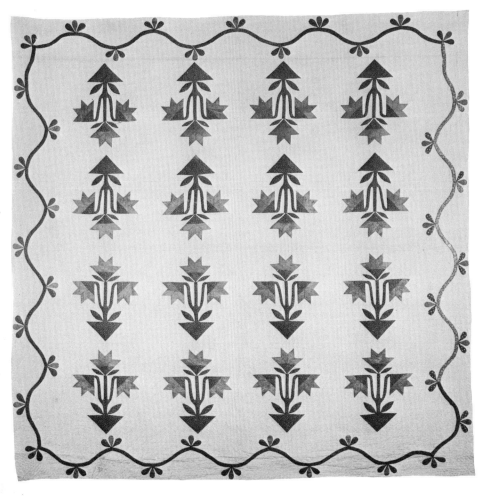

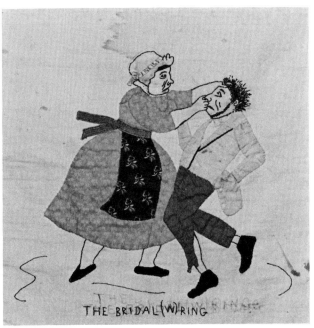

THE BRIDAL (W)RING

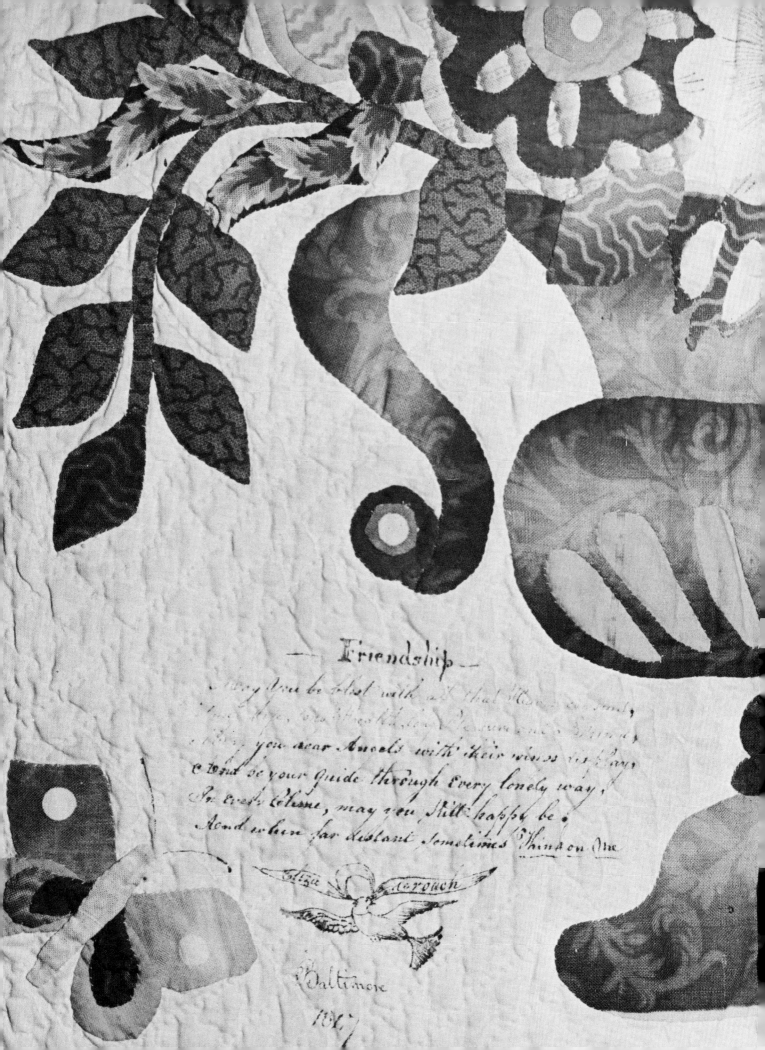

— Friendship —

May you be blest with all that Heaven can send,
Long life, long health, long pleasure, and a friend;
May you dear Angels with their wings display,
And be your guide through every lonely way;
In every Chance, may you still happy be;
And when far distant sometimes think on Me.

Eliza Crouch

Baltimore
1847

stitch or all edges are brought to the front and hemmed down to make a binding; alternatively, a separate binding is sewn on.

A sense of humour that, throughout this anthology, will be seen to be a characteristic of many needleworkers is certainly evident among coverlet makers. A charming item worked in Saratoga, New York, in the middle of the nineteenth century has a top embellished with red cotton squares themselves decorated with bits of applied fabric and surface stitchery illustrating such poignant scenes as 'Ho! for California', which has two men meeting perhaps to discuss a journey west, and 'the bridal (w)ring' (*sic*), which needs no explanation!

Coverlets have sometimes been worked to express sentiments such as friendship, as when stitched by groups to form presents, perhaps for young people's maturity. One interesting 'friendship coverlet' in the Museum's collection may have been formed from commercially bought patchwork squares, for there is uncanny uniformity among some of the motifs. Others have been worked by congregations for their ministers' wives. 'Mrs Water-bury's coverlet', to take but one example (finished in 1853), is made of ninety square blocks of white calico, some suitably embellished with religious motifs. Appropriate design, an important element in assessing a coverlet's attraction, can be seen also in the stark black-and-white palm pattern on a widow's coverlet also in the collection.

Suitable design is still, indeed, admirably important to coverlet construction for, although the art of making bed coverings has never completely died out, during the last few years a high point has once more been reached. In 1976 staff and friends of the American Museum worked together in typical communal spirit to form two bicentennial friendship coverlets. One has a main design of fifty-six squares of unbleached calico decorated with such motifs as the rocking horse on show in the Stencilled Bedroom and the other has sixty-three square blocks mostly applied with motifs of State flowers. As if to symbolize British–American symbiosis in embroidered as in other art forms, the rose of England, Scottish thistle, Irish shamrock and Welsh daffodil and leek are also included in this latter design. It will be seen again and again in this study of the heritage of needlework that a cross-fertilization of British and American designs, ideas and techniques has often contributed greatly to the high standard of embroidered art in both countries while at the same time national characteristics have developed partly as a result of work done by outstanding individual embroiderers.

ABOVE Detail of a bicentennial coverlet worked by staff and friends of the American Museum, in which symbols of England, Scotland, Ireland and Wales have been included. *coverlet formed of sixty-three cotton blocks with green borders, backed with cotton and filled with polyester, quilted in feather patterns, 100 × 80 in, 254 × 203.2 cm*

LEFT Another bicentennial coverlet, worked through the Museum in 1976. *unbleached calico blocks in olive green surrounds, backed with cotton and filled with polyester, quilting outlines following applied designs, 106 × 93 in, 269.2 × 236.2 cm*

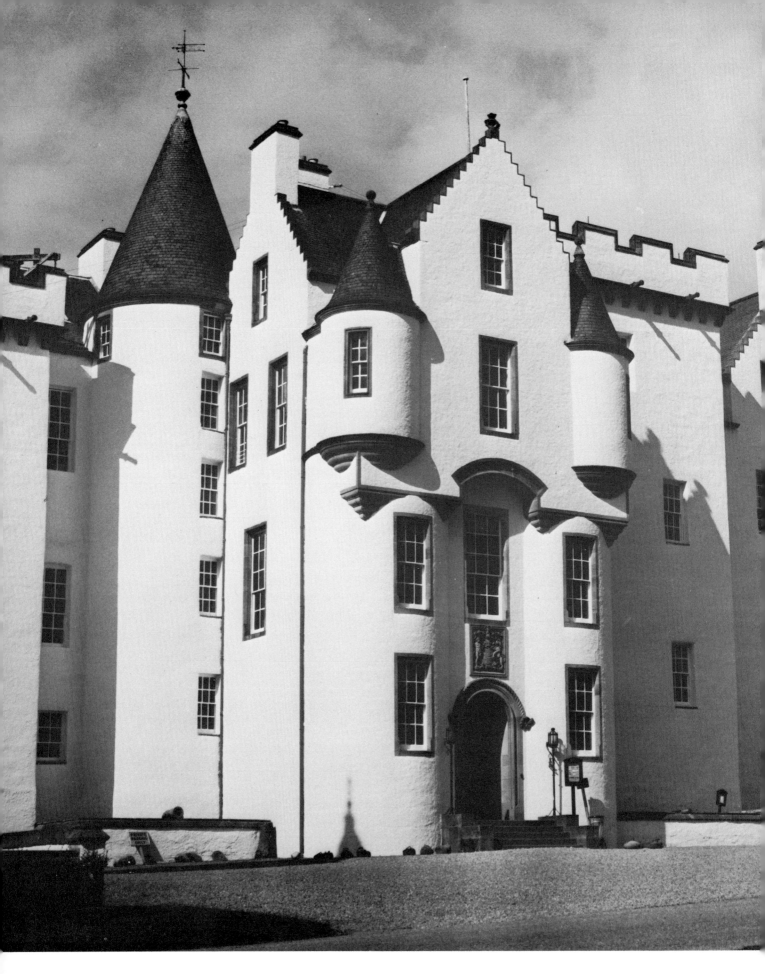

Blair Castle, Perthshire.

2

Blair Castle

Lady Evelyn's Whitework

LAIR CASTLE, in Perthshire, magnificently illustrates how an outstanding collection can rely on a single needlework technique worked by one embroiderer, as seen in the whitework (white-on-white embroidery) executed by Lady Evelyn Stewart-Murray (1868–1940).

Arriving at Blair Castle gives a foretaste of the embroidered treat in store, for this is a white-harled fairy-tale fortress with the distinction of being the last castle in Britain to be besieged. A flag may be flying from the square tower; other walls rise through three storeys with Georgian windows to castellations and bartizans which add to its romantic image. There has been a castle here since 1269 when David, the Earl known as the Crusader, found that during his absence in England John Comyn, or Cumming, of Badenoch had invaded Atholl territory and built a tower at Blair, an act remembered by the naming of the tower after him. The Crusader Earl's descendants temporarily forfeited their title when a holder opposed Robert the Bruce (1274–1329), but it was restored in 1457 and in 1703 elevated to a dukedom by Queen Anne (1665–1714). It has since passed directly to the present, 10th Duke (born 1931).

As with Glamis and many Scottish castles Blair has numerous royal associations. Queen Victoria (1819–1901) recuperated here in 1844; over half a millenium earlier Edward III (1312–77) had stayed at Blair and Mary Queen of Scots (1542–87) was once entertained here at a superb hunt at which 5 wolves and 360 red deer were bagged. In 1745 Charles Edward Stuart, Bonnie Prince Charlie (1720–88), marched to the castle after landing at Glenfinnan and subsequently Hanoverian troops under Colonel Sir Andrew Agnew successfully defended the castle's siege by Jacobite troops

Lady Evelyn (far right) with her family: (from the left) Lady Dorothea Stewart-Murray (1866–1937), the 7th Duke of Atholl, Lord George Stewart-Murray (1873–1914), the Duchess of Atholl, Lord James Stewart-Murray later 9th Duke (1879–1957), Lady Helen Stewart-Murray (1867–1934) and the Marquess of Tullibardine later 8th Duke (1871–1942).

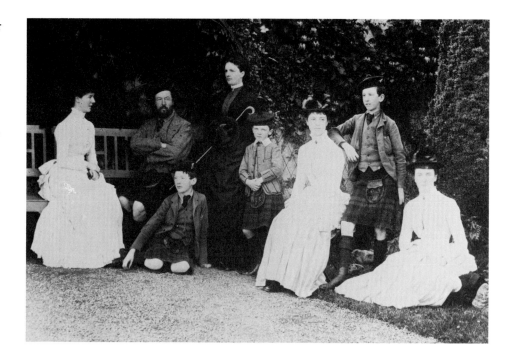

led by Lord George Murray, brother of the 2nd Duke. The house had to be substantially rebuilt and castellations and bartizans were replaced by low-pitched roofs and chimney stacks. It was not until 1869 that two Scottish architects, David and John Bryce, were called in by the 7th Duke, John James Henry Stewart-Murray (1840–1917), to restore the castle to its former glory.

A portrait of the 7th Duke now hangs in the lofty entrance hall of panelled walls splendidly decorated with assorted firearms. Nearby is Tilt, one of his stags and now a taxidermist's delight. Other family mementoes include a silver stag centrepiece, now in the dining room, given by tenants to celebrate the silver wedding of the 7th Duke and his Duchess, Louisa Moncreiffe of Moncreiffe (1844–1902).

It was one of their seven children, Lady Evelyn Stewart-Murray, who created the exquisite whiteworks to be seen in the China Room. Lady Evelyn was educated at home but because of family friction, caused to some extent because she refused to 'come out', she left when she was eighteen, in 1886, never to return. Her only contact with her family after this was an occasional correspondence with her two brothers, the Marquess of Tullibardine (1871–1942) and Lord James Stewart-Murray (1879–1957), 8th and 9th Dukes respectively. Little is known of Lady Evelyn's adult life. She remained single ('Marriage', she wrote three years before her death in 1940, 'is said to be a lottery but so is life') and within ten years of leaving Blair she arrived in Belgium, where she settled in Malines.

In about 1896 Lady Evelyn purchased a fine whitework panel, now dis-coloured with age, embellished with the coats of arms of Belgium and its

nine provinces. This inspired her to commission a smaller companion piece emblazoned with the Atholl arms but, dissatisfied with the result, she resolved to work a more exquisite piece herself. Whether or not she already knew how to embroider must be a matter for conjecture, but perhaps she learnt her needlework skills in one of the Belgian convents which have a tradition of especially fine needlework; she certainly maintained contact with at least one institution to which she used 'occasionally to send my work ... for advice to ask what they thought of it – a sort of examination'. Lady Evelyn's own 'heraldic whitework' turned out to be the 'British coat of arms' panel that is now the best-known piece of the Blair embroidery collection, comprising items collected or worked by her between 1896 and 1914. (Two years before this latter date, twelve of her pieces, including two pairs of cuffs, were stolen, but fortunately the British arms panel was recovered, although the damp to which it had been subjected resulted in the brown stain visible on one thistle.)

From occasional references in letters to friends it is probable that Lady Evelyn suffered during the First World War, and in the 1930s, with the looming threat of further catastrophe, she determined to send her collection to safety. She made contact with her elder brother and on 29 October 1936 four cases containing two wooden seventeen-drawer chests and six cardboard boxes, weighing 788 kilos in all and valued at £250, were sent from 'Miss Murray, 20 rue Louise, Malines' and shipped on the s s *Crichtoum* to 'Miss Osborn, Eastwood, Dunkeld, Perthshire'. The sender instructed under separate cover that a cable, 'Arrived safely', be sent on receipt of the goods. She stated that she had 'placed all the celophane [*sic*] in the drawers so as not to have things touched elsewhere and to be sure that it is right'. Her instructions read: 'IMPORTANT ... open first large top drawer of cupboard, marked with red ribbon on handles. Take out the long green portfolio, which is the one underneath ... take from inside it, brown cardboard (envelope) cover marked VIIe and there will be found all instructions and full lists.' To aid successful unwrapping and setting up of the fruits of this treasure hunt she enclosed, in cardboard box number 6 (her numbering), 'pin lifter, Phénix pins, 4 (extra) knobs of drawers, extra round labels if required and labels for drawers, all numbered'.

The methodical organization of this exercise indicates that Lady Evelyn realized she herself would not be further responsible for her needleworks. Whatever her final plan, she probably crossed the Channel sometime shortly afterwards and she died in Wimbledon in 1940 without re-establishing general contact with either her collection or her family who were now to look after it.

She had obviously intended the collection to aid and inspire needle-workers. The main part, which includes lace, macramé and polychrome embroideries as well as whitework, is still divided among the thirty-four drawers of the two 47½-in (120·6-cm) high sturdy wooden chests, which

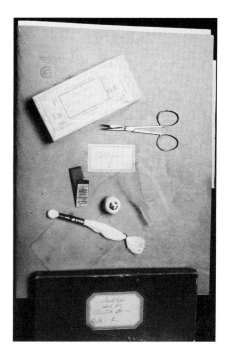

Photographed on one of the two loose-covered green exercise books in which Lady Evelyn described and explained her needleworks sent back to Blair Castle in 1936 are some of her embroidery tools and samples of the glass cambric she used on her famous 'British coat of arms' panel.

also house her gold and silk shade cards (some from M. Maurer of VII/I Kandlgasse, Vienna) as well as small bits of white 'glass' cambric, so fine as to be almost transparent, skeins of white DMC cotton thread, needles, special curved manicure scissors and a pencil, sharpened to a fine point and marked 'speciality – E!', all required for the execution of her superb whitework embroideries. Each embroidered panel is carefully numbered with one of the adhesive round white labels to which she referred in her instructions in 1936. She further marked all items which she had herself worked with a capital E.

The collection is minutely annotated in green 'portfolios', in fact two green loose-covered exercise books $11\frac{5}{8} \times 8\frac{7}{8}$ in (29.5×22.5 cm). Whereas Catalogue II simply itemizes the collection, Catalogue I 'contains all details and explanations' and explains such processes as the

method of transferring a design to fabric: by pricking with a needle on special solid oiled tracing paper when the tracing is finished it is fixed on to the stuff which is stretched in the embroidery frame, and then pounced [pushed] through with a black powder. It is then drawn out carefully with a pencil.

Lady Evelyn obviously always worked with her fabric held taut:

For working embroidery in a frame (and good embroidery can only be worked in a frame), one must learn to work with the left hand, which is used under the frame. It takes some time to get accustomed to this. A finger-end of a kid glove is used for the left finger instead of a thimble as the needle must be felt as it cannot be seen ... when transparent white stuff is used for embroidery a black apron must be worn so as to see the threads of the stuff.

Pulled thread, as seen so exquisitely in the ten different patterns worked

Lady Evelyn included even her sample pieces: the E on the label shows that she worked this little tester.
glass cambric worked with white cotton, only $1\frac{1}{2} \times 6$ in, 3.8×15.2 cm in all

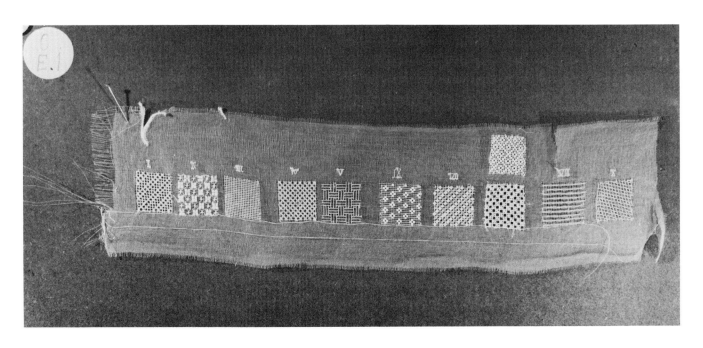

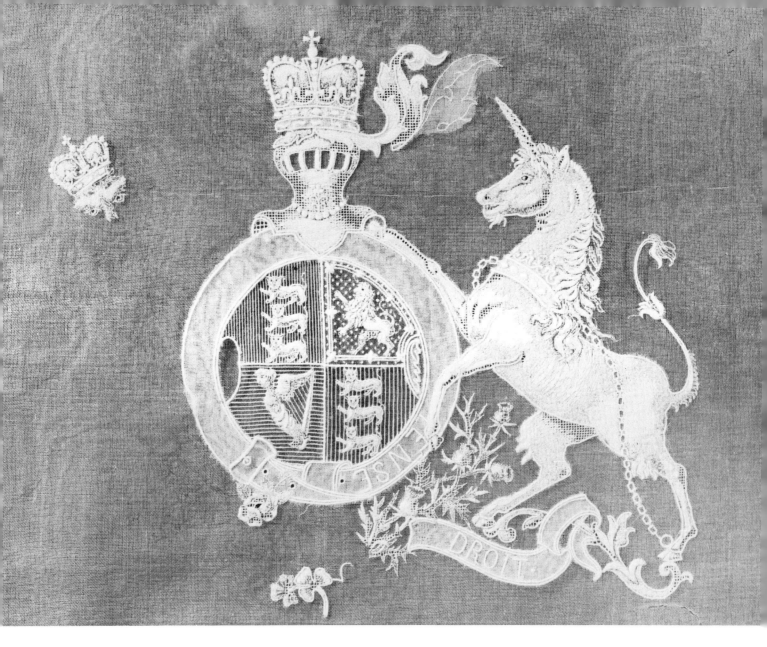

on an area of glass cambric $1\frac{1}{2} \times 6$ in $(3 \cdot 8 \times 15 \cdot 2$ cm), which was one of five sample pieces (labelled OE 1–5) for the British arms, is worked 'by pulling together the threads of the cambric with tiny little stitches all along. This should be looked at with a magnifying glass.' Another of the sample pieces is worked in 'shaded white embroidery' formed of minute seeding, satin and stem stitches. Other areas of fabric are given density by shading with small pieces of cambric laid above the ground fabric and embroidery worked through both layers, after which the surplus of the upper, applied, fabric is carefully removed, presumably with her curved scissors. A carefully executed pencil outline drawing set next to these sample pieces indicates the complexity of her design. A copy of this drawing would be made on oiled paper, pricked and then used to transfer the design on to the master area of cambric.

The finished panel (*see Plates 3 and 4*) is a masterpiece of embroidery art. Within a frame $22 \times 24\frac{1}{2}$ in $(55 \cdot 9 \times 62 \cdot 2$ cm), the *raison d'être* of the piece, the British arms, $4\frac{5}{8} \times 5\frac{1}{4}$ in $(11 \cdot 7 \times 13 \cdot 3$ cm) in dimension, is set within a scrolled border $14\frac{7}{8} \times 17\frac{3}{4}$ in $(37 \cdot 8 \times 45 \cdot 1$ cm) that displays a repetition of

She perfected part of the royal arms.

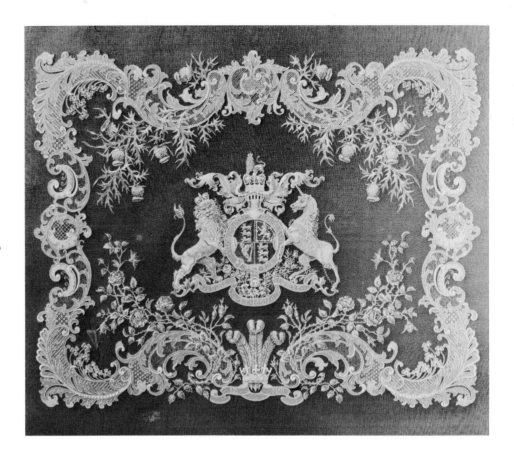

RIGHT Lady Evelyn's masterpiece: white glass cambric worked with white cotton thread in satin and padded satin stitches, stem stitch and many pulled thread techniques. The denser areas have been worked through two layers of fabric; the surplus of the upper was subsequently removed.
embroidered area $14\frac{7}{8} \times 17\frac{3}{4}$ in, 37.8×45.1 cm overall

BELOW Around the edge of the panel is a scrolled border indicative of Low Countries influence: Lady Evelyn worked the panel in about 1912 when she was living in Belgium.

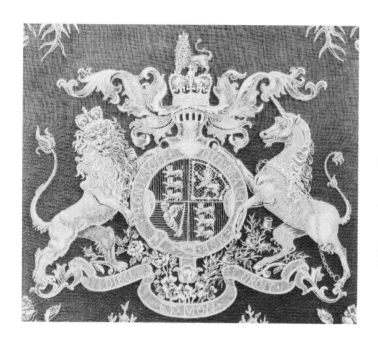

sophisticated curves indicating Flemish influence. At the base of the border are the three feathers of the Prince of Wales with his motto, *Ich dien* (I serve), and within and around the curves are sprigs of roses, thistles and shamrock balanced so symmetrically that those in the right half are mirror-images of those in the left. The minutiae of this panel demand prolonged and awed study. The motif of the coat of arms alone is of immense fascination. These are the arms as used from the time of Queen Victoria to the present day: Lady Evelyn's embroidered version is illustrated next to Her Majesty Queen Elizabeth II's arms, as officially authorized by the College of Arms.

Erudition and skilled design and execution combine to make Lady Evelyn's panel one of the greatest needleworks of all time. There are many whitework embroideries displayed nearby (a little picture of waterlilies and reeds rewards particular study) and coloured needleworks and other textile arts are also on show, but it is for this panel alone that Lady Evelyn remains such an inspiration today. As she herself wrote: '*Die feine Weissstickerei, welche Sie betreiben, ist wohl das Kunstvollste, dass es auf Erden gibt und das muss Ihnen bewusst Sein und Sie befriedigen.*' (Fine whitework is perhaps the most artistic pursuit in the world, and you must realize this and be glad that it is so.)

LEFT In the middle of it all, the glorious coat of arms, as used by British rulers from the time of Queen Victoria.
motif $4\frac{5}{8} \times 5\frac{1}{4}$ *in*, $11 \cdot 7 \times 13 \cdot 3$ *cm*

RIGHT As comparison, Her Majesty Queen Elizabeth II's arms.

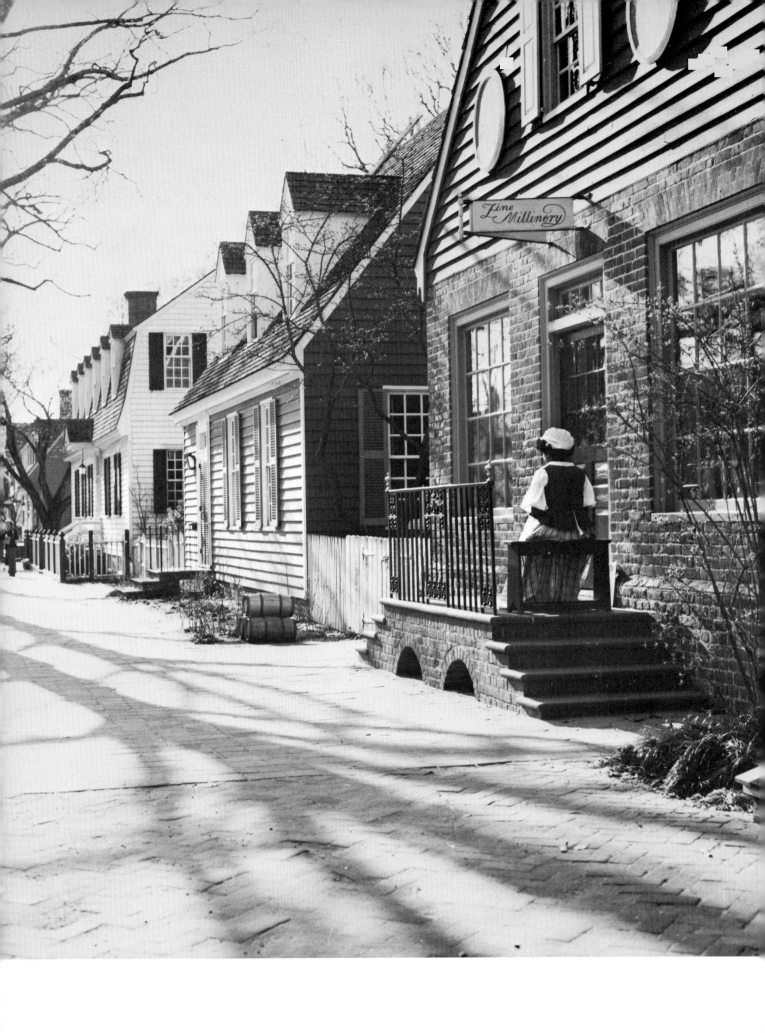

3

Colonial Williamsburg

Embroideries for the Home

I N contrast to a study of needlework primarily aesthetic in appeal, it is valuable to reflect on embroideries used in the home. An exciting insight into decoration of bed hangings, coverlets, chairs, settees and stools, tables, screens and floors of the middle of the eighteenth century is provided by Colonial Williamsburg, Virginia.

Although settlers first reached the area from neighbouring Jamestown in 1633, Williamsburg's town plan was laid out by the Lieutenant Governor, Francis Nicholson, from 1698. He planned a ninety-nine foot (thirty-metre) wide central avenue, Duke of Gloucester Street, crossed at right angles by the Palace Green leading to the Governor's Palace, with two parallel streets, Francis and Nicholson.

Today it has spread over such a vast area that it can absorb thousands of tourists as well as its permanent inhabitants while preserving its past for those interested in former days. Students of William and Mary College, founded nearly three hundred years ago, jog down Duke of Gloucester, passing interpreters and guides dressed in eighteenth-century costume going for their lunch break. A service is taking place in Bruton Parish Church. Outside Margaret Hunter's millinery shop a young girl in a mob cap enjoys the sun and watches passers-by in blue jeans and sweat-shirts. By day modern traffic is banned from the historic area; shuttle buses transport visitors who want to rest their feet. Dusk heralds Williamsburg's continued activities as cars appear and residents and visitors gather, perhaps to sample the food of Christiana Campbell's tavern, called after 'a little old Woman, about four feet high and equally thick with a little turn up Pug nose' who arrived in 1770 to take control of an establishment that

View looking west along Duke of Gloucester Street, in the heart of Colonial Williamsburg, Virginia. On the right is the millinery shop called after Margaret Hunter who in the 1770s advertised such diverse wares as jet necklaces and earrings, 'black love ribands' and 'stuff shoes for ladies'.

was to number among its regular clientele George Washington (1732–99), who once ate here ten times within two months.

Plenty of time is needed properly to explore the historic area but no visitor to Williamsburg today on business or pleasure should miss the chance to see over the three-storey Palace, thus derisively labelled by colonists who resented levies authorized at the beginning of the eighteenth century to pay for its construction. The house served as official residence and headquarters first of the king's deputy and, after 1776, of the first two elected governors of Virginia, Patrick Henry and Thomas Jefferson. The governor was provided with basic furniture for his house which, rebuilt, is today garnished with textiles changed twice-yearly by the textile department of Colonial Williamsburg. The department is also especially concerned with furnishings for the Brush–Everard house on the east and the Wythe house on the west of the Green and with the Peyton Randolph house on the junction of North England and Nicholson Streets. But, as the proverbial iceberg shows but a small tip above the surface, only a minute percentage of the vast textile holdings is on general display. The major part is carefully and admirably stored in moisture- and light-controlled storerooms: coverlets and curtains hang from ceiling-high racks and shelf after shelf of differently coloured canvasworks indicate the wealth of a superb collection of eighteenth-century needleworks; this was mainly assembled after 1926 when the preservation of the historic area began with the support of John D. Rockefeller Jr, as a result of which Colonial Williamsburg was able to make its public début in 1934.

A visit to some of the houses today indicates the typical furnishings of professional as well as other classes of eighteenth-century life. Essential to every home was at least one bed, perhaps in folding style similar to those in the Lee Room at the American Museum and in the Ashley house at Historic Deerfield so that, by day, it could be stored vertically against the wall to save space. Around the edges of a half-tester forming a shelf above the closed bed there might be a small valance and long curtains which could be pulled when the bed was stored so that it was completely hidden. More permanent beds include the large family of the four-poster, with valance and curtains which could be drawn completely to enclose the occupants, thus providing warmth and privacy. Sometimes there were matching base valances hanging from the mattress to the ground on three sides of the bed and behind the pillows there could be a co-ordinating head cloth. (American beds did not generally have matching embroidered headboards or canopies, as at Glamis and Parham Park.)

Because of the scarcity of rare damasks and silks American beds in the eighteenth century were sometimes hung with embroidered curtains. Crewel embroidery on linen and fustian (linen warp and cotton weft) was often employed, and, as will be seen clearly in Historic Deerfield's Ashley House, locally worked crewel can be identified by the fact that the ground

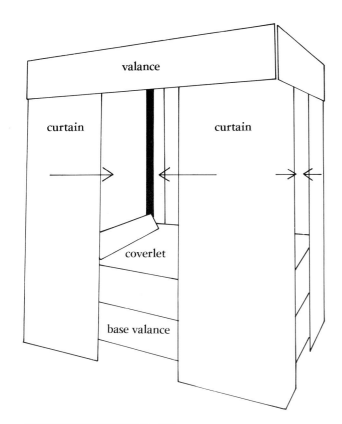

valance

curtain curtain

coverlet

base valance

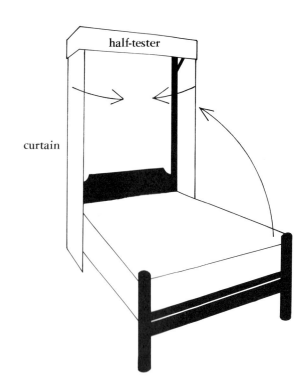

half-tester

curtain

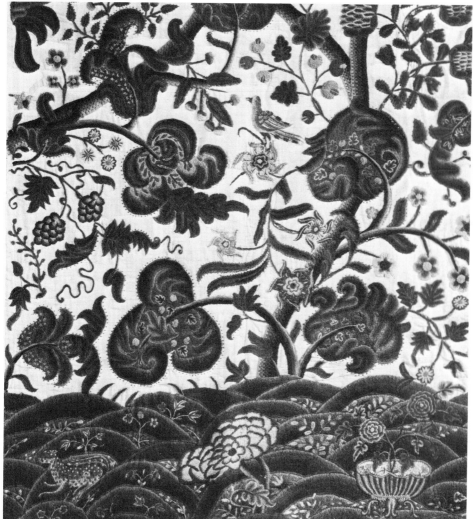

ABOVE Diagrams of bed styles:
the handy folding bed (right)
could be stored vertically in a
framework perhaps attached to
a wall and curtains drawn to
hide it. By contrast, the four-
poster remained *in situ* even
when not in use.

LEFT Dense patterns on crewel
generally denote English
workmanship: this detail is
from one of four curtains
probably worked in England
1690–1730.
*detail of panel 81 × 40 in,
205·7 × 101·6 cm*

Diagram of a bed rug in
Williamsburg's collection:
probably worked by a member
of the Browne family of
Flushing, New York, in the
third quarter of the eighteenth
century, the natural wool rug is
embroidered in darning, long
and short and stem stitches.
*79 × 97 in, 200·7 × 246·4 cm
overall*

fabric is less densely embroidered. Sometimes bits of women's petticoats
were re-made to form bed curtains. On a made-up bed there might be
a quilted coverlet, or perhaps a bed rug signed and dated by its embroi-
derer. A style which developed mainly in New England, the bed rug con-
sisted of two or three joined widths of thick, multi-plied home-dyed
woollen cloth. Two corners might be rounded to accommodate posts at
the bottom of the bed and the rug was sometimes embroidered in running
stitch and pattern darning (long running stitches worked to a design),
perhaps with cut loops to form pile, to produce exotic floral patterns
similar to Indian or English printed textiles and wallpaper.

Although there is no evidence that windows were ever covered by hang-
ings specially worked in crewel, bed curtains were sometimes later made
into window coverings. They could, alternatively, be cut to form settee,
chair or stool furnishings, as evidenced by a late eighteenth-century New
England cherry, maple and pine armchair, now in the south-west bedroom
of the Wythe house, with back and seat panels formed of linen twill
embroidered in a flowing crewel design. However, the technique most
employed for stitched seat coverings was canvaswork, that popular form
of needlework studied in this anthology specifically at the Henry Francis
du Pont Winterthur Museum. As new settlers arrived in Williamsburg they
may have brought with them from their former homes such treasured items
as the canvaswork panel illustrated here, removed from the back and
seat of a chair, probably worked in England in the second quarter of the
eighteenth century.

Perhaps, in a hypothetical eighteenth-century room, there was an
embroidered screen standing near to the chairs. A floor-standing model
may have been decorated with a type of 'fishing lady' or 'Boston Common'
canvaswork picture, several of which can be seen at Winterthur. It may,

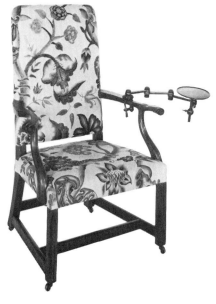

Crewel curtains were
sometimes cut and used to
cover such items as this cherry,
maple and pine high-backed
chair in Chippendale style,
1770–90.

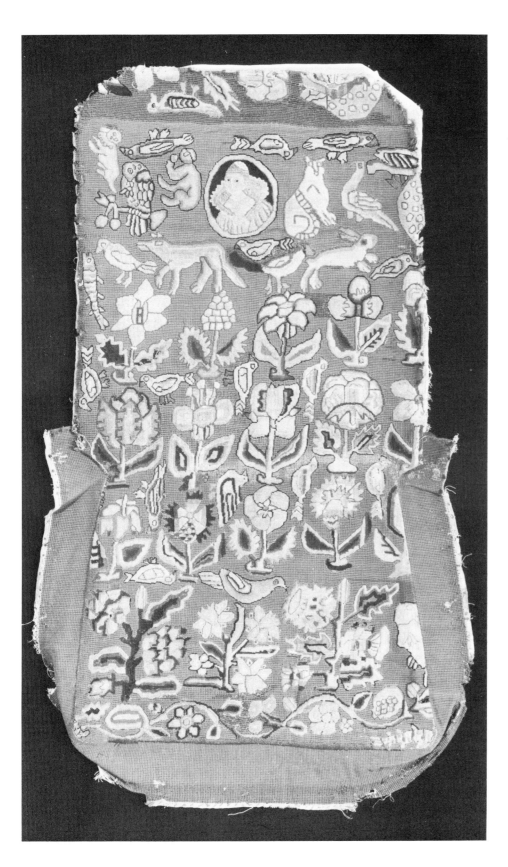

Canvaswork panel probably
specifically worked for a
chair back and seat; English,
1725–50.
*linen canvas embroidered in
tent stitch, 42 × 26 in,
106·7 × 66 cm*

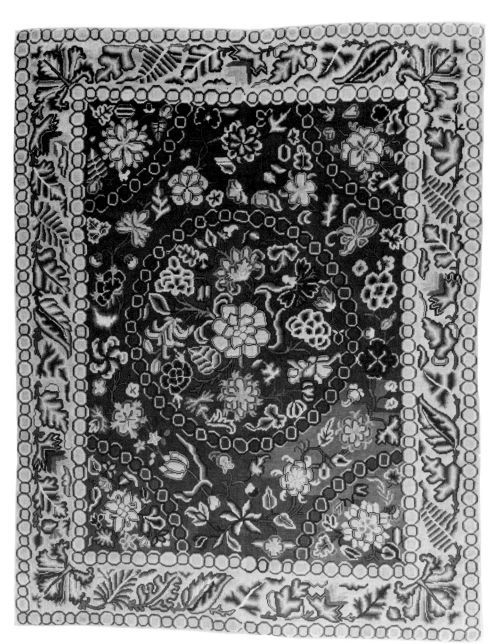

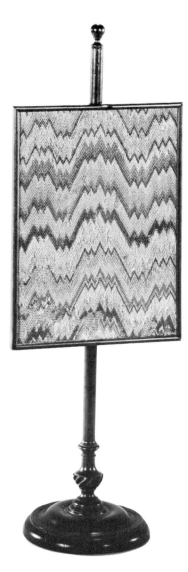

LEFT Small candle pole screen with moveable screen embellished with wool and silk flamestitch; American, eighteenth century.
pole 21½ in, 54·6 cm, high

RIGHT Canvaswork carpets were especially valued; this one was worked in England in the late eighteenth century.
linen canvas worked with seven wool and silk cross stitches to the inch, 66 × 84 in, 167·6 × 213·4 cm

on the other hand, have been decorated with a repeating flamestitch canvaswork design, a smaller panel of which can be seen at Williamsburg embellishing a tiny candle pole screen. Tables in many of the rooms at Colonial Williamsburg have been covered with decorated cloths as if to continue a tradition of table carpets or cloths popular in England and Europe from the late fifteenth century. Floor coverings were also sometimes embroidered: rectangular homespun items, intended to cover tables as well as areas of floor, could be worked in clipped running stitch or, perhaps, in the chain stitch employed by Zeruah Higley Guernsey Caswell, who partly worked the early nineteenth-century carpet now seen in the Metropolitan Museum of Art.

Canvaswork carpets were especially prized by the wealthy. One fine eighteenth-century English example now at Williamsburg might well have been brought by a settler of former times although it did not, in fact, cross the Atlantic until it was purchased in 1959. As with many contemporary items to be seen in the Gubbay Collection at Clandon Park, back in

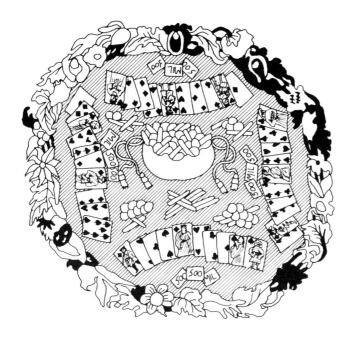

Drawing of an octagonal gaming table top that could have been worked in the middle of the eighteenth century, perhaps in Scotland, and now in a private collection. The centre part of the 36 × 36 in, 91·4 × 91·4 cm, tentstitch and crossstitch panel is worked with a pattern of cards, counters and chips on a dark field. The game laid out is the then-popular quadrille, a four-handed version of ombre in which the eight, nine and ten of each suit are discarded.

England, the Williamsburg carpet has a multitude of differently coloured flowers set on a dark blue field and it is worked with forty-nine wool and silk cross stitches to each square inch of canvas.

As well as the main needlework furnishings that could have embellished an eighteenth-century home, such accessories as hanging wall-pockets and ruffled calico or linen valances on mantel shelves could also be embroidered. Some houses, too, had needlework pictures and such glorious looking-glass surrounds as that mentioned at the Henry Ford Museum. There were also gaming tables which, unlike the specimen at Kenmore, were possibly embellished with canvaswork tops worked with suitable designs of cards and counters. Essential and desirable furniture can thus become attractive or even more lovely through embroidered embellishments and identification of the embroiderers concerned is, as has already been established at Blair, an especial fascination.

It is time now, in this tour of embroidery heritage, to travel north from Williamsburg to study embroidered pictures and samplers, exquisite decorative furnishings sometimes worked by quite young girls.

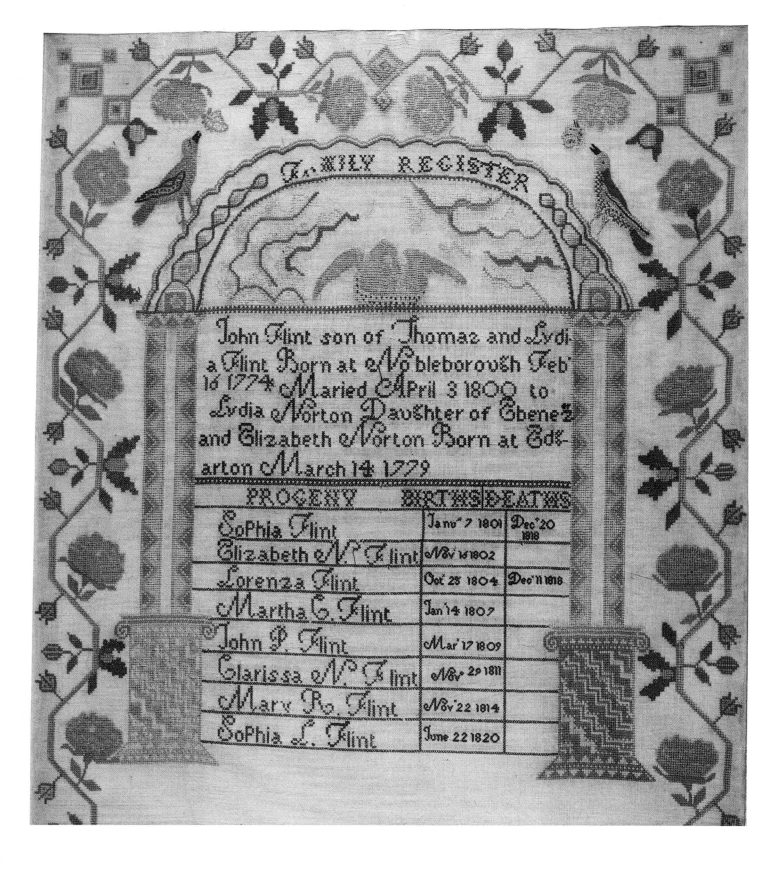

FAMILY REGISTER

John Flint son of Thomas and Lydia Flint Born at Nobleborough Feb 16 1774 Maried April 3 1800 to Lydia Norton Daughter of Ebenez and Elizabeth Norton Born at Edgarton March 14 1779

PROGENY	BIRTHS	DEATHS
Sophia Flint	Janu 7 1801	Dec 20 1818
Elizabeth N. Flint	Nov 16 1802	
Lorenza Flint	Oct 28 1804	Dec 11 1818
Martha C. Flint	Jan 14 1807	
John P. Flint	Mar 17 1809	
Clarissa N. Flint	Nov 29 1811	
Mary R. Flint	Nov 22 1814	
Sophia L. Flint	June 22 1820	

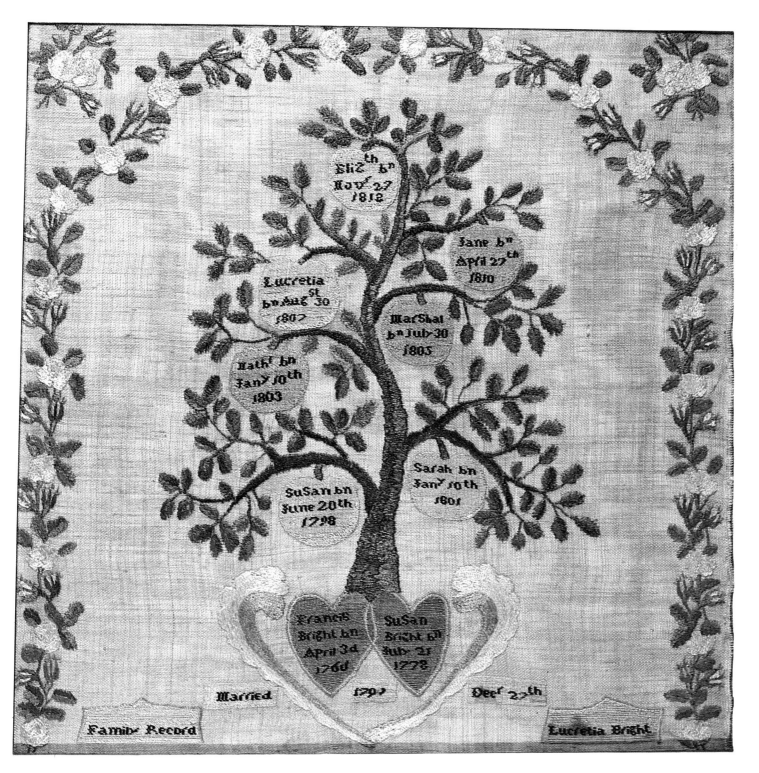

Eliz^th b^n
Nov^r 27
1812

Jane b^n
April 27^th
1810

Lucretia
1st
b^n Aug 30
1807

MarShal
b^n July 30
1805

Nath^l b^n
Jan^y 10th
1803

SuSan b^n
June 20th
1798

Sarah b^n
Jan^y 10th
1801

Francis
Bright b^n
April 3d
1766

SuSan
Bright b^n
Aub 21
1778

Married 1797 Dec^r 27th

Family Record Lucretia Bright

Plates 5 and 6 Samplers with genealogical details such as
these from the Daughters of the American Revolution
Museum are especially interesting. The family record on
the left was probably worked by one of the young
daughters of John Flint, a trader from Bath, Maine.
Lucretia Bright, of Watertown, Massachusetts, preferred
to set out her family details (right) in the form of a fruit-
laden tree.

The portico of Memorial Continental Hall, Daughters of
the American Revolution headquarters in Washington DC:
thirteen pillars represent the first United States.

4

Daughters of the American Revolution Museum

Family Records, Pictures and Samplers

HROUGHOUT America people of all ages are fascinated by the challenge of genealogical research: the thrill of going through records to find ancestors of long ago strengthens patriotism today. The records stored at the Daughters of the American Revolution headquarters at 1776 D Street, Washington DC, form one of the most comprehensive registers of long-established American families. Many of the two hundred thousand members of this national organization as well as those interested in genealogy spend a great deal of time working in the library researching their lineage.

Church registers of births, marriages and burials are often studied but needlework samplers and pictures inscribed with family records offer another, less usual, source of information and one which is of particular interest to the needlework devotee. The Daughters of the American Revolution Museum at the national headquarters has a wealth of such material as well and its embroidery collection tells many stories.

With few exceptions the pieces, in a collection which also includes coverlets, crewel and flamestitch and other canvasworks, have been donated by local societies or by individual members of the Daughters of the American Revolution. As many as possible of the needleworks have patriotic interest: at least six samplers, for instance, are known to have been worked by daughters of Revolutionary soldiers. Some of the embroideries are displayed in rooms named after and suitably furnished for one of the States. The Maine drawing room, decorated in subdued pinks and browns and furnished with American antiques, some in Chippendale style, gives pride of wall space, near to a reverse painting on glass of Washington,

Plate 7 A family record from the Daughters of the American Revolution Museum stitched by Caroline Litchfield Newcomb in 1817, designed *en grisaille* to emphasize its mournful character.

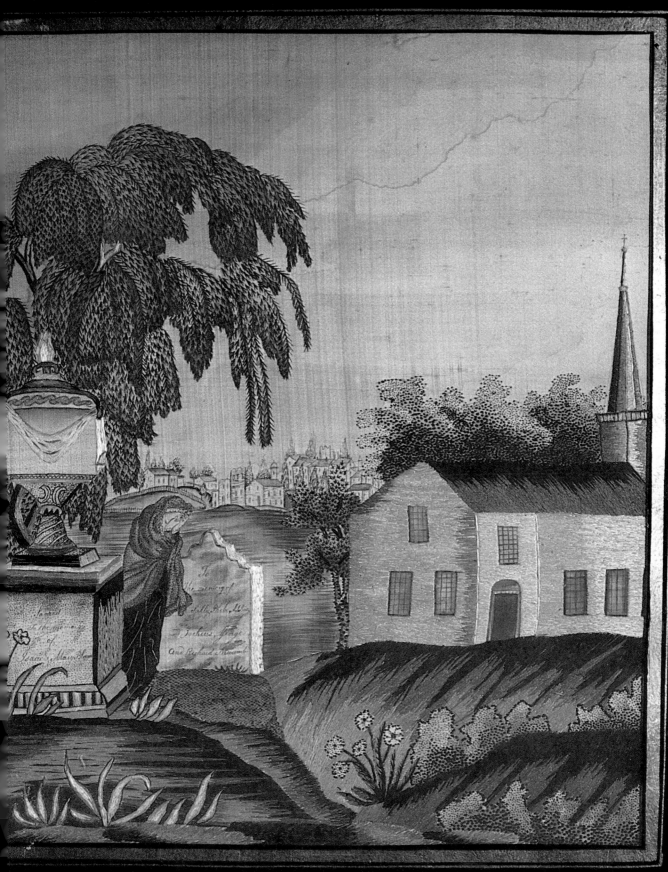

INE L. NEWCOMB. 1817.

to a family tree sampler recording the progeny of John Flint (born 1774), a Bath trader (*see Plate 5*).

Typical of many New England samplers at the beginning of the nineteenth century, the Flint piece has a design dominated by an arch supported by two columns on stout Ionic pedestals with zigzag geometric infilling. Within the apse the American eagle feeds her young, and underneath begins the legend: 'John Flint son of Thomas and Lydi-/a Flint Born at Nobleborough Feb/16 1774 Maried [*sic*] April 3 1800 to/Lydia Norton Daughter of Ebenezer/and Elizabeth Norton Born at Edg/arton March 14 1779.' Then follow the names of their eight children, the first, Sophia, born almost nine months to the day after her parents' marriage. Both she and a sister, Lorenza, were to die before the birth of the last child, another Sophia, in 1820.

Perhaps the embroiderer was interrupted in her work for, although the reserves outside the arch are filled with birds and a repeating design of roses on meandering stalks, the area underneath the names has been left unworked. The exact identity of the embroiderer remains a mystery. (The piece subsequently passed via the only son, John P. Flint, born 1809, to his daughter, another Sophia, born 1837.) It is, however, safe to assume that one of the Flint daughters was responsible for the embroidery, for most family records, like samplers or testpieces, were executed by women, usually girls, some of whom were as young as five. It is indeed rare to come across a sampler worked by a man or boy, although the Museum does possess one example, dated 1826, from the hand of one George Eisenbrey.

Especially after the Revolution many samplers were produced as testpieces by pupils in schools which taught academic subjects, character development and such accomplishments as fine needlework, which might later provide one of the few acceptable means for a woman to support herself should she fall on hard times. The skilled curvilinear design of another family record sampler worked by Lucretia Bright of Watertown, Massachusetts, is typical of boarding school work from that area. Lucretia's record (*see Plate 6*) is in the shape of a tree with two hearts at its base in which are recorded her parents' birthdates, 'Francis/Bright bⁿ/April 3ᵈ/1766' and 'SuSan [*sic*]/Bright bⁿ/July 25/1772'. A legend outside the main design records that they were married on 27 December 1797 and in the apples on the tree are written the birthdates of their children, Susan (June 1798), Sarah, Marshal, Nathaniel, Lucretia (1807), Jane and Elizabeth.

Although samplers are generally the work of younger persons, sophisticated 'needlepaintings', in which threads simulate brush strokes, were popular with all ages. Sometimes fabric was already marked with a design similar to an engraving: alternatively 'printwork', the direct copying of an engraving on to plain fabric, usually cream silk, could be employed, and sometimes embroidery was complemented by areas painted in water-

In about 1820 Lucretia Bright of Watertown, Massachusetts, designed her family record as a 'stitched tree'.

One of the tombstones on the Newcomb panel records the names of Caroline's maternal grandparents, and the other her dead brothers and sisters.

colour. Finished items were often mounted and glazed, perhaps in *églomisé* style, with a black or white and gilt glass surround, and backed with wallpaper or newspaper, which may afford help in dating.

Until the end of the eighteenth century many American women had been wholly occupied in running their households and helping their menfolk with business affairs. Free time was, however, becoming more generally available and since, following the Revolution, trade with China had increased to the extent that imported silks were more readily obtainable, adults were able to turn their hands to perfecting the fine needlework that their daughters were learning in schools. Washington's death in 1799 stimulated women as well as such young needleworkers as nine-year-old Mary Wilson of Trenton, New Jersey, to work memorial pictures, sometimes *en grisaille*, with motifs of urns, plinths, weeping figures, willow trees and other funerary symbols accompanied by suitable inscriptions. At first such pictures were intricately formed but as the pace of early nineteenth-century life quickened needlework standards fell and by the second decade of the century fewer stitches were generally worked over a lesser area of fabric.

Many embroiderers recorded personal bereavements, often distressingly frequent. In 1817 Caroline Litchfield Newcomb, a farmer's eighteen-year-old daughter from Pleasant Valley, New York, and a student at Sarah Pierce's Female Academy in Litchfield, Connecticut, worked a memorial to her maternal grandparents and six brothers and sisters (*see Plate 7*). After painting it in watercolour, she then partly stitched it in silks to show an urn on a tall plinth with the main inscription, 'Sacred / To the memory / of / Isaac & Mary Bloom'. Behind the stone a veiled lady, her head bent in grief, weeps by another tomb recording the names of the siblings: Sally, Phebe, Adeline, Zacheus, George and Richard Newcomb.

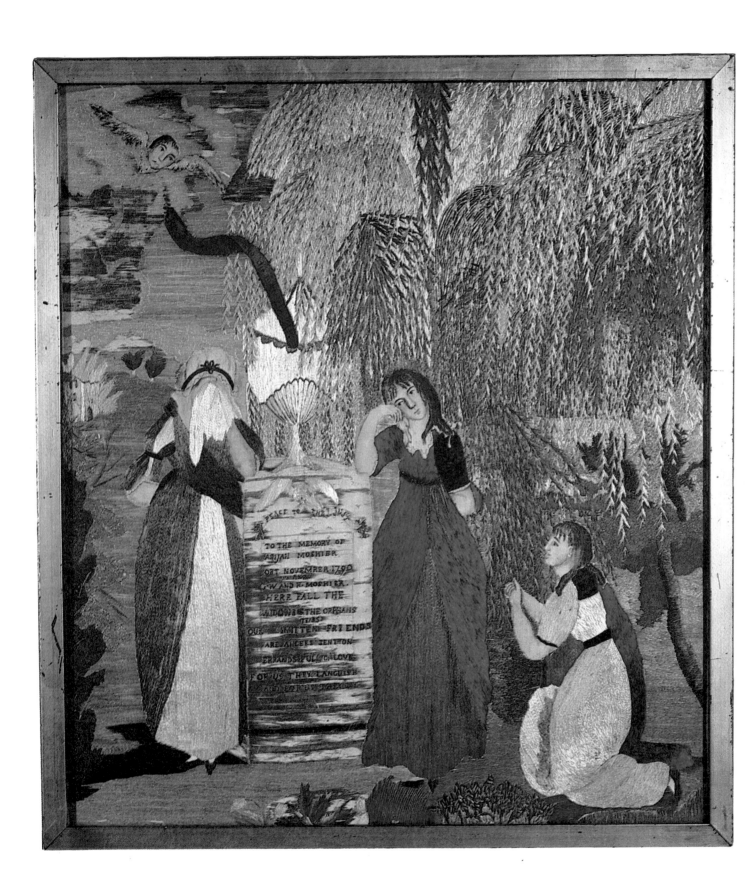

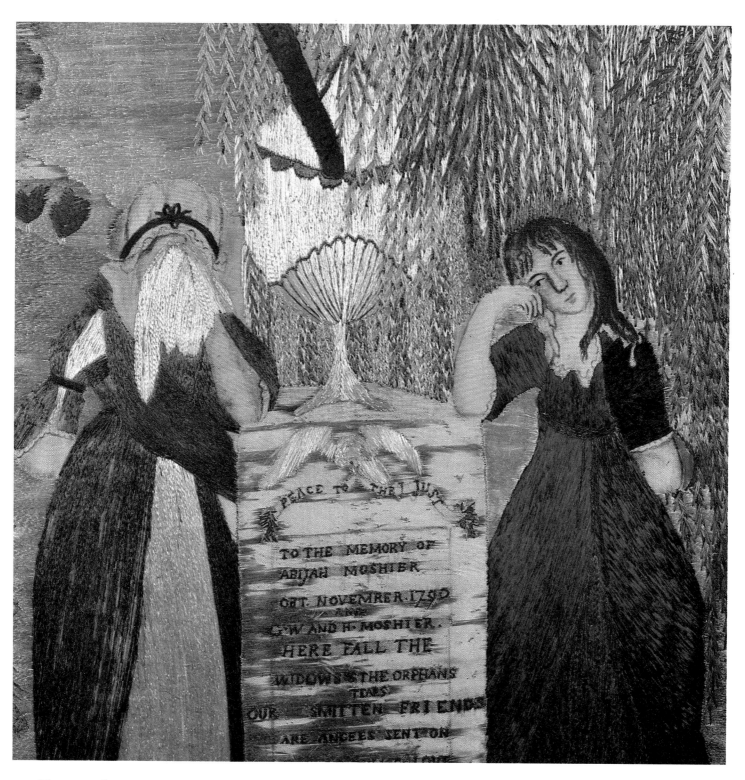

Plates 8 and 9 Bowed heads and handkerchiefs convey
the emotion portrayed in this panel from the Daughters
of the American Revolution Museum, worked as a
memorial to Abijah Moshier and G. W. and H. Moshier.

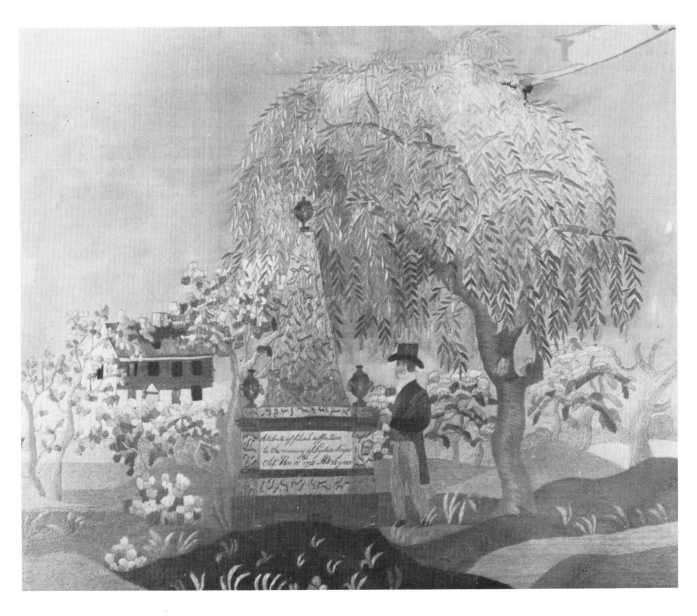

ABOVE AND OPPOSITE Martha
Noyes' memorial to her
mother, c. 1806.
*silk painted in watercolour and
partly embroidered in silk satin
and stem stitches and seeding,
22⅜ × 25¾ in, 56·8 × 65·4 cm,
framed*

Above hangs a weeping willow, its branches similarly bent in respect. (As partial relief from this melodrama, it can be mentioned that Caroline herself later married a New York farmer, Filkins Cheeseman of Clinton, and lived until 1850.)

Other embroiderers sometimes included colours in their memorial designs. The anonymous hand that painted a panel to the Moshier family, for instance, subsequently embroidered much of it in blues, greens and golds. Here a widow in a mob cap and holding a handkerchief in front of her face leans dejectedly on one side of the by-now ubiquitous plinth. On the other side, one daughter also leans in sorrow on the stone while another kneels. The lachrymose text, beneath the homily 'Peace to the just', reads: 'To the memory of / Abijah Moshier / Obt. November 1790 /

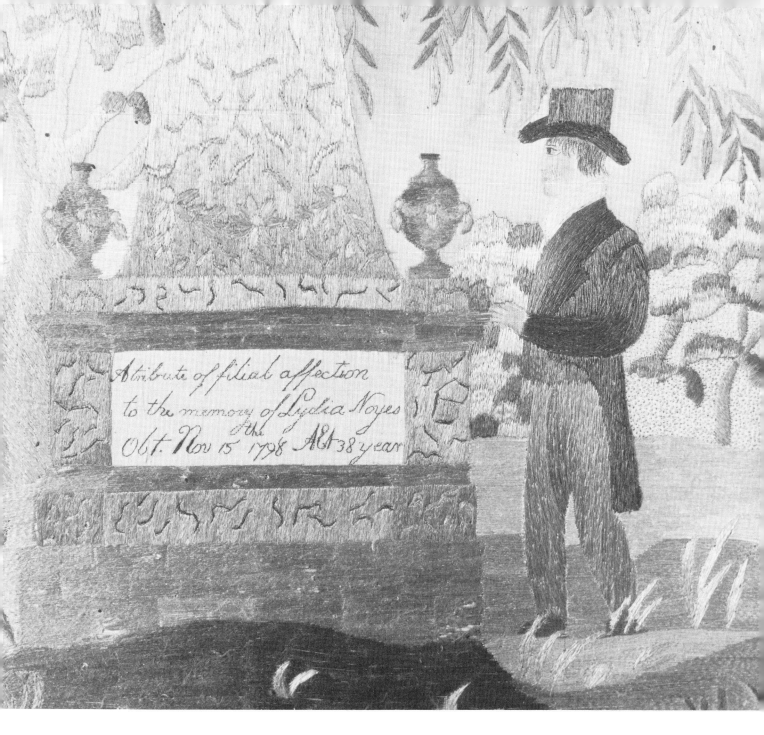

The embroidered inscription reads: *A tribute of filial affection to the memory of Lydia Noyes Obt. Nov 15 the 1798 Æt 38 year*

and/G W and H Moshier/Here fall the/Widows and the orphans/ Tears/Our smitten friends/Are angels sent on/Errands of love/For us they languish/And for us they die.' (*See Plates 8 and 9.*)

Sometimes, as if to relieve such depths of despair, embroiderers incorporated elements of wishful thinking into their patterns, as evidenced by a young student who worked the motif of a funerary urn inscribed with the name of her headmaster, then still alive! In the main, however, bereavement was all too painfully real. In about 1806, when she was fifteen, Martha Noyes dedicated a sampler to the memory of her mother, Lydia Rogers Noyes, who had died in Westerly, Rhode Island, leaving her husband with eight children under sixteen. Mr Noyes is shown, top-hatted and upright, standing next to an elaborate marble tomb inscribed,

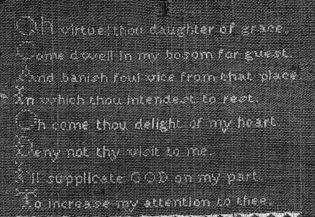

Oh virtue! thou daughter of grace,
Come dwell in my bosom for guest.
And banish foul vice from that place.
In which thou intendest to rest.
Oh come thou delight of my heart.
Deny not thy visit to me.
I'll supplicate GOD on my part.
To increase my attention to thee.

Julia Ann Crowley

Washington City the 14th of April 1813.

Plate 10 (left) Julia Ann Crowley's father was ships' carpenter at Washington Navy Yard and the building shown here may have been razed by the British the year after this 1813 sampler was worked.

Plate 11 (below) Another building on a sampler in the Daughters of the American Revolution Museum collection is recognizable as St Patrick's Church, Baltimore; Mary Ann Craft was nine when she worked this picture sampler in 1822.

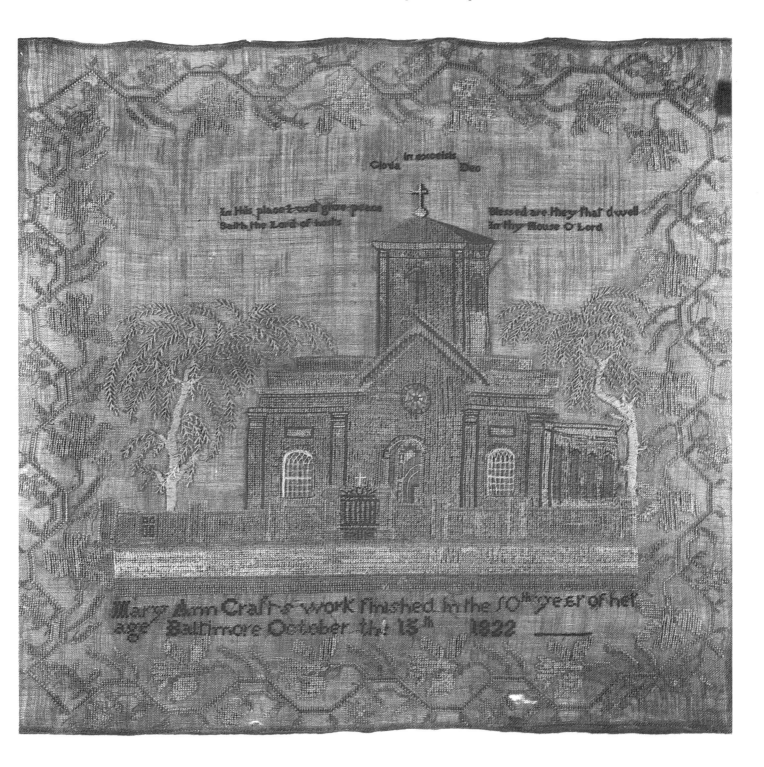

A detail of Mary Ann Craft's sampler: the interior of the church is seen through the open door.
linen embroidered mostly with floss silk cross stitch, overall $20\frac{3}{8} \times 22\frac{1}{4}$ in, 51·8 × 56·5 cm, framed

'A tribute of filial affection / to the memory of Lydia Noyes / Obt Nov 15[the] 1798 Aet 38 year'. Through trees behind, the upper storey of what might have been the family clapboard house can just be seen.

Identifying buildings in needlework pictures can be a difficult exercise, as illustrated by Julia Ann Crowley's sampler (*see Plate 10*), now in the Idaho Room. Inscribed 'Washington City the 14th of April 1813', the panel is particularly interesting for its motif of a church or school with tower. Perhaps this was Julia Ann's interpretation of her own local building, but identification is complicated by the fact that it may have been among those

which suffered when, in 1814, British forces razed Washington Navy Yard, where Julia Ann's father was ships' carpenter. The church on nine-year-old Mary Ann Craft's 1822 sampler, on the other hand, has been identified as representing St Patrick's church in Baltimore, at the junction of Bank and Broadway (Market). Mary Ann exercised artistic licence in her version of the 1806 church, the fourth building on the site and itself torn down in 1897, by omitting two of the three storeys of the tower and by simplifying the porch so that a panorama of arches is visible within (*see Plate 11*).

One of the challenges facing needlework historians is that embroidered facsimiles do not always adhere to the original. The two versions of a 'View near Exeter' (*see Plates 12 and 13*) are exceptional. The 'original' is a hand-coloured engraving by Cartwright after the Irish artist Thomas Walmesley (1763–1805) and its replica is a watercolour on silk carefully embroidered by Rebecca Rooker (born in Birmingham, 1 October 1793), who travelled across the Atlantic to Baltimore where, with her sister, she ran the Misses Rooker Academy until 1837. Rebecca Rooker may well have embroidered her picture as a souvenir of her homeland. Other needleworks were certainly worked as reminders of local places and events. An embroidery which incorporates a view of Trenton with ceremonial arches decorated by local ladies in honour of Washington's visit to the city in April 1789 on his way to New York to take the oath as President was probably made locally; it later passed to the Museum from the New Jersey State Society. Entitled 'Liberty, in the form of the Goddess of Youth; giving Support to the Bald Eagle', the design is taken from an engraving by Edward Savage (1761–1817), published Philadelphia 1796. Liberty, wearing a golden and brown dress, reaches upward to offer the eagle a drink from her goblet, here formed of a tiny applied piece of mica. Her right foot is, significantly, about to crush England's Garter and the key of the French Bastille and, behind, the view of the Trenton arches symbolizes a country then barely twenty years old.

Patriotism is an emotion that is evident elsewhere in this book – in the Ohioan coverlet by Mary Borkowski now kept by that State's Historical Society and, from an earlier time, in seventeenth-century likenesses of Charles I to be found at Dearborn and Parham. An especial concentration of emotion is, however, apparent in the family records and other needleworks at the museum of the Daughters of the American Revolution.

Drawing of 'Liberty', taken from the needlework picture 'Liberty, in the form of the Goddess of Youth; giving Support to the Bald Eagle'. As she reaches up to feed the Bird of America, Liberty is about to step defiantly on England's Garter and the key of the Bastille.

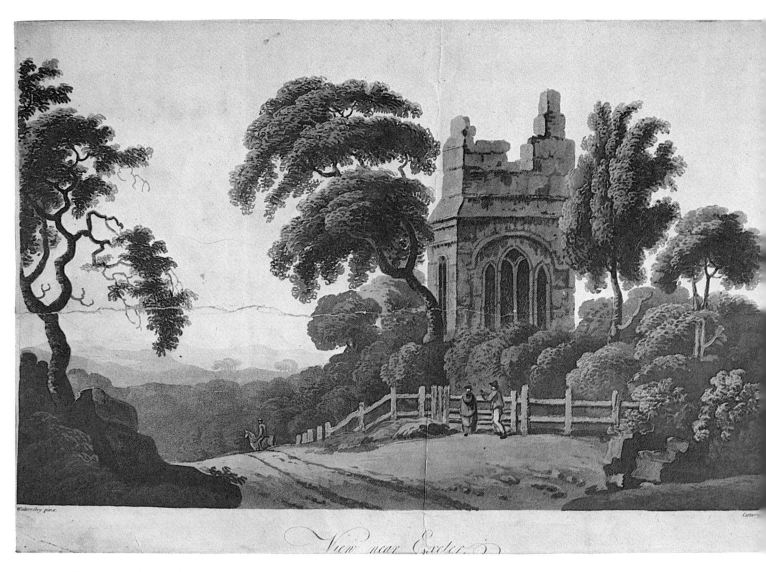

View near Exeter

Plates 12 and 13 Embroiderers sometimes worked
pictures as facsimiles of such hand-coloured engravings
as this 'View near Exeter', by John or Joseph Cartwright
after the Irish artist, Thomas Walmesley. It and its
replica, embroidered by Rebecca Rooker, born 1793, are
both in the Daughters of the American Revolution
Museum collection.

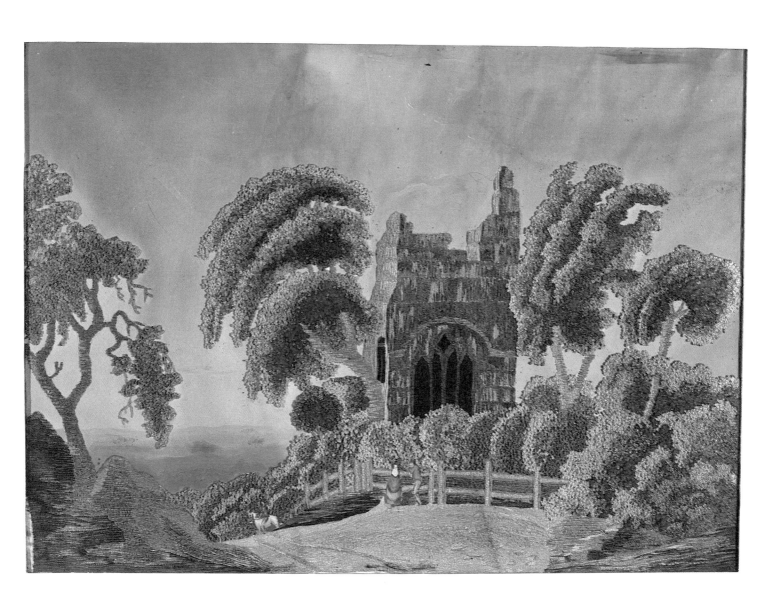

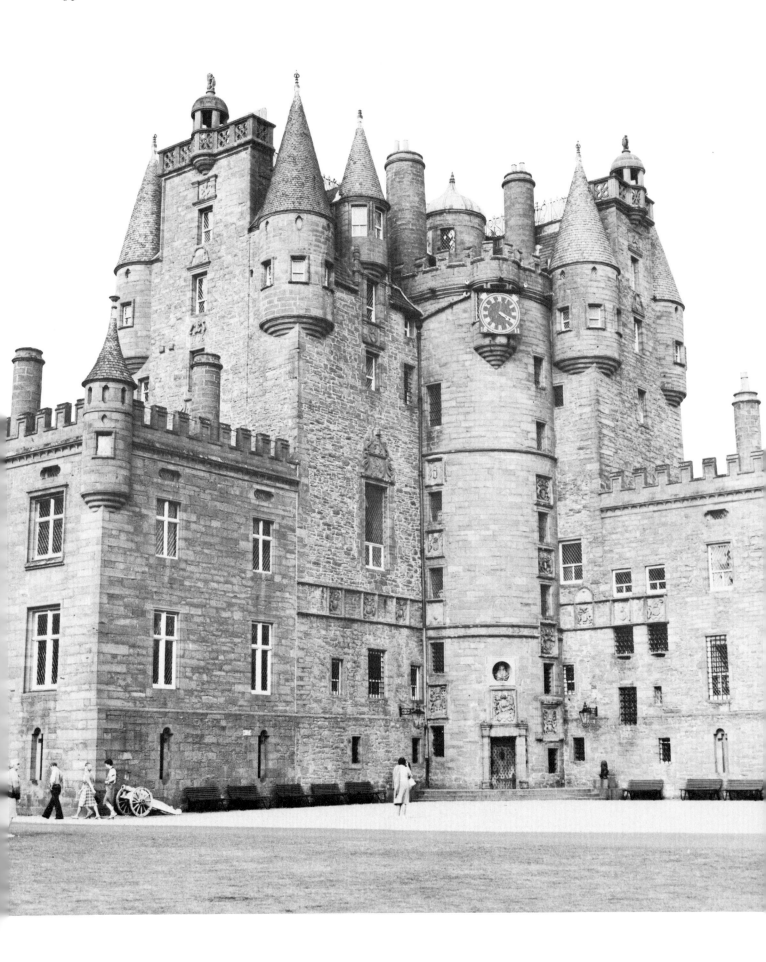

5

Glamis Castle

A Royal Miscellany

EEDLEWORKS associated with one family are discussed later in this anthology; here a miscellany is compiled of embroideries connected with some past and present members of the British royal family, especially those associated with Glamis Castle, Tayside, childhood home of Her Majesty Queen Elizabeth the Queen Mother.

Named from the Gaelic *glamhus*, a wide gap or vale, Glamis is built of soft sandy-red local stone on lowlands in the Vale of Strathmore. Tradition has it that it was to be built at Fiery Pans nearby but as soon as stones were laid they were removed by the 'little people'. The exact date of construction is unknown but the Scottish king Malcolm II (*c.* 953–1034) supposedly died in a room now named after him and a successor, Macbeth (died 1057), is known to have been at one time thane of Glamis. Sir John Lion of Forteviot, known as the 'White Lion' because of his complexion, was granted thaneage in 1372 by Robert II (1316–90), whose daughter Joanna he later married. From them are directly descended, to the present day, the Earls of Strathmore and Kinghorne, titles bestowed in 1606 and 1677 respectively; their heirs use an older title, that of Lord Glamis, which dates back to 1445. The family name, Bowes-Lyon, is taken from the 9th Earl's wife, Mary Bowes.

At many times in the past Glamis, like Blair Castle, has been host to royal visits. James V (1512–42) and Mary of Guise (1515–60), parents of Mary Queen of Scots, held court at the castle during the period when the widow of the 6th Lord of Glamis and her young son were imprisoned for treachery and witchcraft. (Lady Glamis was burnt alive on Castle Hill in Edinburgh in 1540 'with great commiseration of the people, being in

Glamis Castle, Tayside.

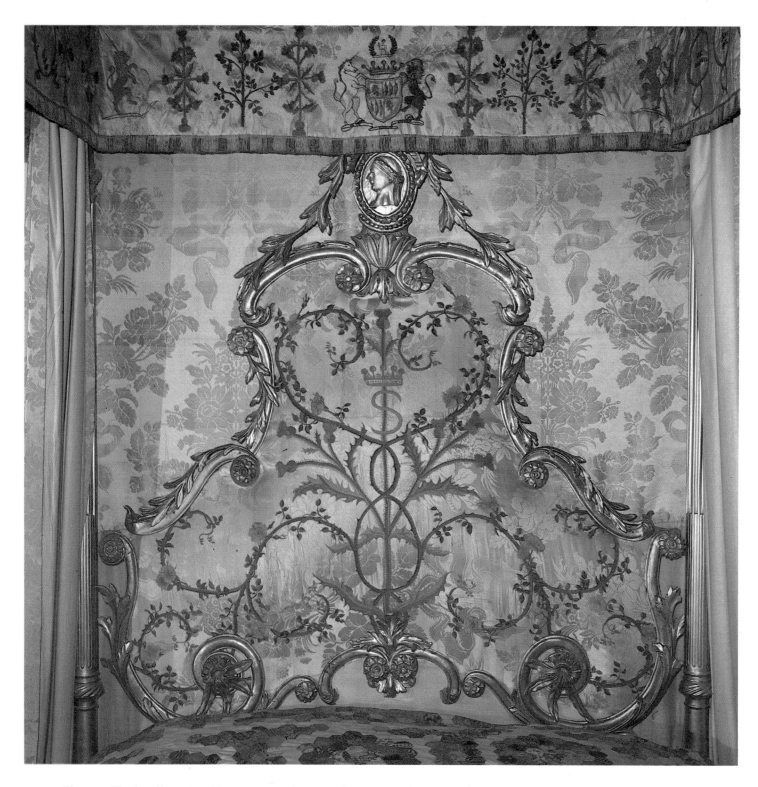

Plate 14 The headboard and inner tester valance on this bed at Glamis Castle were embroidered in 1904 by the 14th Countess of Strathmore and Kinghorne, mother of Her Majesty Queen Elizabeth the Queen Mother. As well as the Bowes-Lyon crest, the valance is embellished with thistles and other flowers and birth details of Her Majesty and nine brothers and sisters.

Plate 15 (right) Another 'royal' item at Glamis Castle is this portrait of Arabella Stuart, grand-daughter of Bess of Hardwick and herself a possible claimant to the English throne. As in so many outstanding portraits from this period, embroidered costume details are intricately shown.

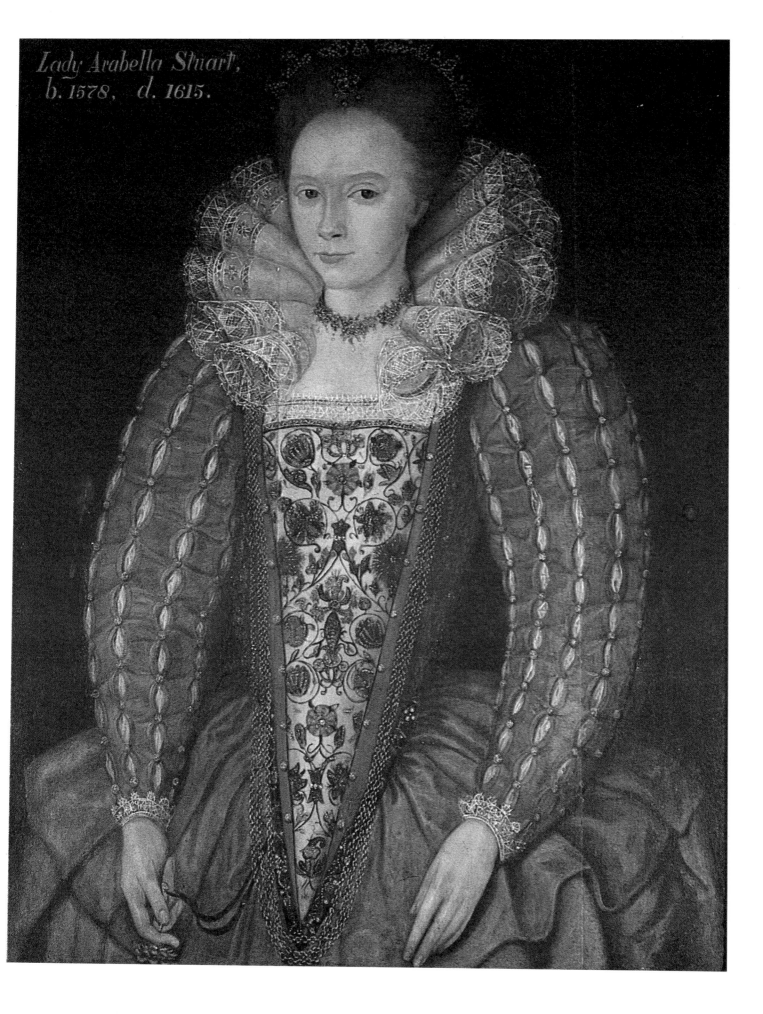

Lady Arabella Stuart,
b. 1578, d. 1615.

the prime of her years'.) The 8th Lord entertained Mary Queen of Scots here on her way to Huntly to quell the Gordons in the summer of 1562 and perhaps during their short stay she and some of her 'Marys' (Mary Beaton, Mary Carmichael, Mary Livingston and Mary Seton) worked on their embroideries. Tradition has it that they were embellishing a canvaswork chair cover but it has not survived.

Various items now in collections throughout the British Isles are said to be by the Scottish queen, although most are labelled erroneously. She learnt her needlework skills in France, whither she had been sent in 1548, at the age of six, so that she could prepare for marriage to the Dauphin, who ruled briefly as Francis II (1544–60). During her time at the French court Mary is said to have founded a school of needlework and when she returned to Scotland as a young widow she probably included in her retinue at least two professional embroiderers. Pierre Oudry, a painter to whom her likeness now at Hardwick is attributed, is one artist known to have been with her during some of the years of her captivity from 1567, first at the hands of her own nobles and then at the behest of her cousin, Elizabeth I (1533–1603), until her execution in 1587.

The first ten months of her imprisonment were passed at Lochleven Castle, during which time one of her parcels included eighteen 'little flowers painted on canvas and outlined in black silk, together with six hanks of twisted black Spanish silk and several hanks of other colours'. This description suggests floral 'slips' (individual motifs) similar to those to be studied at Traquair House. What happened to the Queen's is not certain although it is possible that they were later applied to the bed hangings now belonging to the Earl of Mansfield at Scone Palace.

During the period 1569–84 Mary was under the care of George Talbot, 6th Earl of Shrewsbury (c. 1528–90), fourth husband of Bess of Hardwick whose own embroideries will be studied in the following chapter. Mary was moved around the various Shrewsbury properties although there is no record of her ever having stayed at the manor house that then stood at Hardwick. The prisoner and her Marys passed some of their time with their needlework: Lord Shrewsbury wrote in March 1569 that 'with the Lady Leviston [Livingston] and Mrs Seton she useth to sit working with the needle in which she much delighteth and in devising works'. Similarly, at the examination of the Bishop of Ross at the time of the Ridolfi plot (6 November 1571), mention was made of 'a Cushyn, wrought with the Queenes own Armes and a Devyse upon it with this Sentence, VIRESCIT VULNERE VIRTUS [assaulted virtue gains in strength], and a Hand with a knyfe cuttynge downe the Vynes, as they do use in the Sprynge time; all which work was made by the Scots' Queenes owne Hand'.

Mary must have felt understandable satisfaction as she worked on, for instance, components of three large hangings known as 'the Oxburgh hangings' after the Hall in which they are displayed. Formed of

The crane that appears on another motif is copied from *Icones avium omnium quae in historia avium Conradi Gesneri describuntur, cum nomenclaturis*, by Conrad Gesner (1516–65), the second edition of which was published in Zurich in 1560 by Cristoph Forschauer.

RIGHT The Shrewsbury panel, one of 'the Oxburgh hangings' attributed in part to the needle of Mary Queen of Scots, whose monogram MR appears on the cruciform panel of a milkmaid and reindeer.
green velvet decorated with applied tentstitch canvaswork, centrepiece 22 × 23 in, 55.9 × 58.4 cm

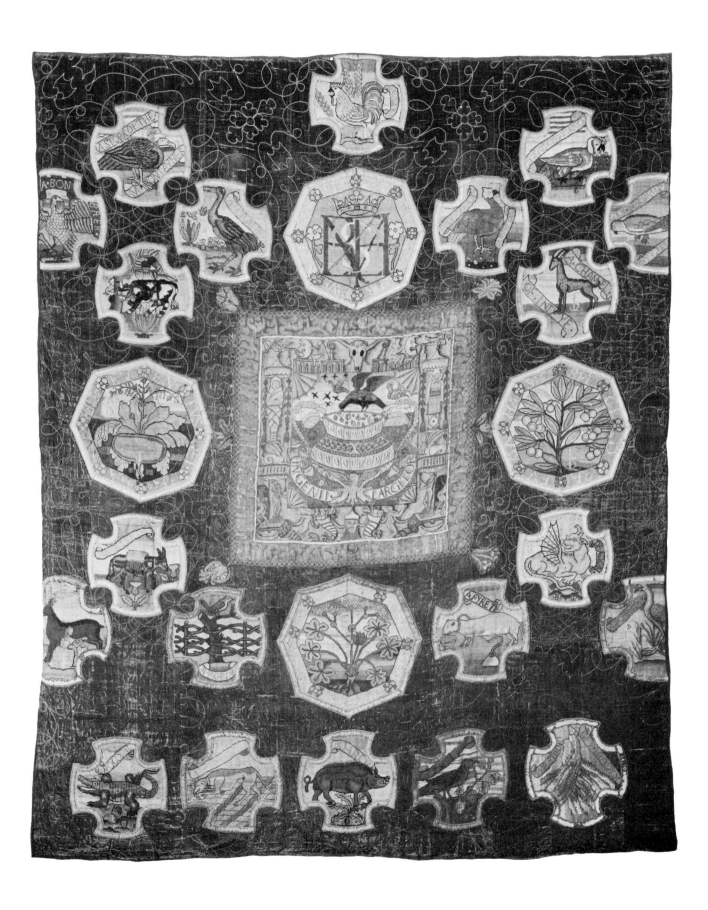

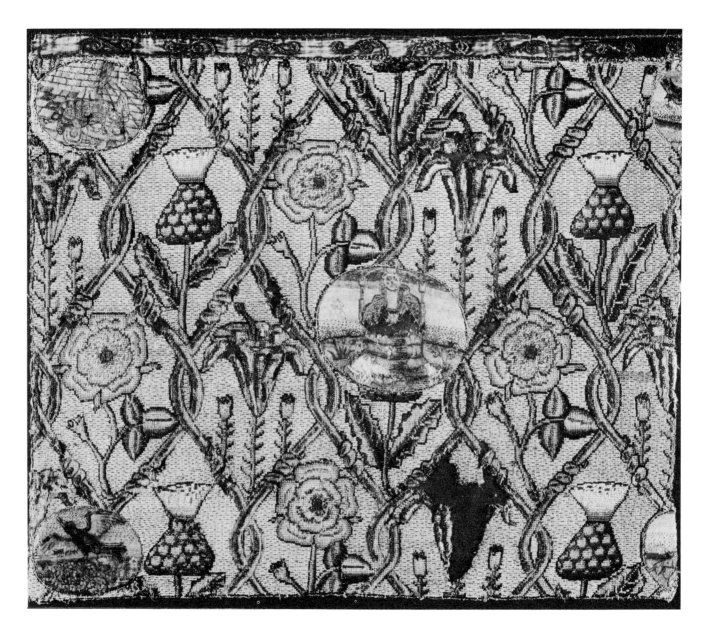

canvaswork on velvet, the Cavendish, Shrewsbury and Norfolk panels, called after their central motifs, are a fascinating amalgam of lore and symbolism associated with the Queen, especially evident in two smaller and less complicated cushion-cover panels now at Hardwick Hall. These three panels are formed of linen canvas worked in braid stitch and with a tentstitch scrolled design of French lilies, a reminder that Mary had been Queen of France, thistles of her own country, Scotland, and roses of England, indicating her claim to the throne south of the border. On these grounds roundels of finer tentstitched canvas (thirty-six threads to the inch) have been applied; three more or less complete medallions and two parts now remain.

TOP One of the cushion cover panels now at Hardwick probably worked by the Scottish queen. Thistles of her native Scotland, lilies as reminders of her first marriage to the Dauphin, later briefly Francis II, and roses as an indication that she claimed the English throne, are all scrolled over the main ground: to this have been applied fine tentstitch roundels with more symbolic designs taken from Gabriel Faerno's version of *Aesop's Fables*.
linen canvas worked in silk braid and tent stitches,
18½ × 22 in, 47 × 55·9 cm

BOTTOM The corresponding design from the *Fables*: two frogs on a well-head. These were used by Mary Queen of Scots to illustrate a maxim signifying that during the years of her captivity she was continually tempted to escape.
engraving 2¼ in, 5·7 cm square

Designs on the roundels are taken from Gabriel Faerno's version of *Aesop's Fables*, published in Antwerp in 1573. Best-known of the extant medallions is the picture of two frogs on a well-head illustrating '*Negotiorum jubeo spectare exitium eos, qui inchoare quid volunt*' (I bid those who want to begin anything to look what the end of the matter will be), a vignette probably signifying that during her captivity the Scottish queen was continually tempted to escape. Another roundel illustrates '*Vim qui inferre parat, cupidus, certusque nocendi frustra illum ratione premas, aut jure refellas*' (the man who is ready and eager to apply force and who is sure that he will inflict injury, him you would in vain hold back with reason or refute with law). A cat and cock indicate that no amount of argument could make the English queen relax her hold on her prisoner, and a similar thought is expressed by a crow and snake roundel: '*In fausta multis sunt sua ipsorum lucra*' (for many even their own gains bring ill fortune), as if the English queen would suffer for her deeds.

At Glamis, the site of this royal miscellany, troops were lodged in the castle by that pseudo-royal, Oliver Cromwell (1599–1658) and later the 4th Earl entertained James Stuart, the Old Pretender (1688–1766), claimant to the thrones of Scotland and England as James VIII and III respectively. The royal connection has continued intermittently to the present day. In 1881 the 14th Earl (1855–1944) married nineteen-year-old Nina Cecilia Cavendish-Bentinck, a descendant of Bess of Hardwick. They had ten children, the second youngest of whom, Lady Elizabeth Bowes-Lyon (born 1900) married the Duke of York (1895–1952), afterwards George VI, and their younger child, Princess Margaret, was born at Glamis in 1930.

The Queen Mother (a title she adopted after the accession of Elizabeth II in 1952) has rooms at Glamis arranged by the 14th Countess for her daughter and son-in-law in which she stays whenever she is at the Castle. The bedroom is dominated by a four-poster with cream satin outer tester curtains and inner pleated canopy, and with cream damask side and head curtains, headboard and inner tester curtains. Embroidered by the 14th Countess in 1904, the padded headboard has a scrolled design with thistles worked in soft heather colours, and the needlework around the inner tester valance shows family details (*see Plate 14*). A monogram 'SK' (Strathmore and Kinghorne) is inscribed 'Claude and Cecilia' and either side are five shields listing the children of the marriage: 'Violet, born 1882, – 1893, Mary, born 1883, Patrick, Lord Glamis, born 1884, John, born 1886' and 'Alexander, born 1887, died 1911' (the last date added later) are to the left of the monogram; to the right are 'Fergus, born 1889, Rose, born 1890, Michael, born 1893, Elizabeth, born 1900' and 'David, born 1902'. The Bowes-Lyon arms are worked on the tester valance above the pillow; the rest of the curtain is embellished with sprigs of thistles and other flowers. In front of the fireplace in the Queen's Bedroom is one of a pair of gilded firescreens with basketweave tentstitch panels. This screen

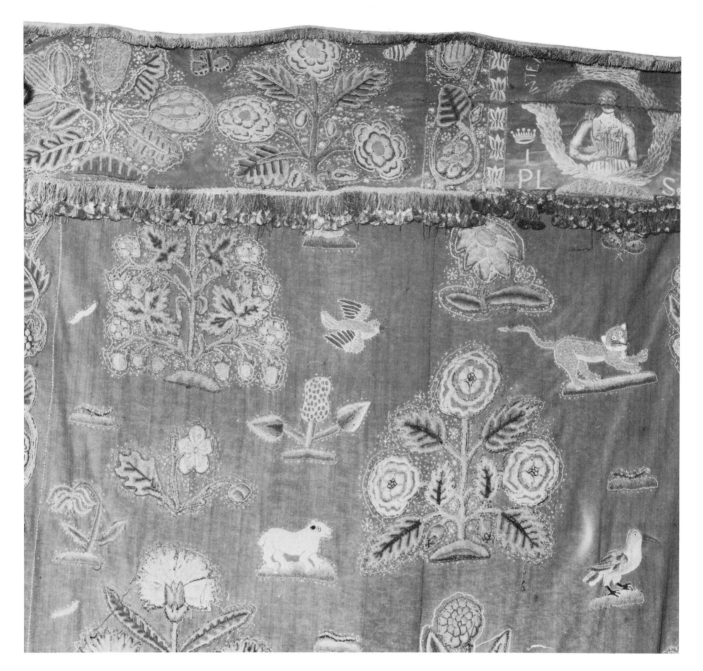

King Malcolm's Room is
marvellously decorated with
wall curtains made from two
sets of bed hangings worked by
the 3rd Countess in 1683.
*blue linen curtains embellished
with applied canvaswork
motifs and also embroidered*

is embellished with the initials GB, 1720 and the arms of the 13th Earl
of Strathmore and Kinghorne.

The companion firescreen, in the King's Bedroom next door, has the
more simple Bowes-Lyon arms (literally bows and lions) and the date 1820.
Here the room is furnished with a heavier state bed with sturdy moulded
tester. Known as the 'Kinghorne bed' after the 1st Earl for whom it was
made early in the seventeenth century, it has three red velvet outer tester
curtains with central panels of applied silk decorated with straight stitches
and couching: a technique which implies thread, often thick and un-
wieldy such as the metal in this instance, held to the ground fabric with
retaining stitches of a more manageable thread.

Couching is much in evidence too in King Malcolm's Room, its walls
lined with marvellous blue linen hangings partly decorated, in 1683, with
floral tentstitch motifs hemmed to the fabric, the application stitches sub-
sequently having been obscured by couched silk and wool cord. These

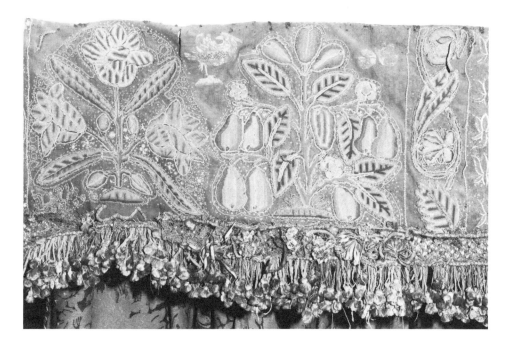

Long widths of tester valances, deeply fringed, are now displayed along the walls: as with the main curtains, these items too are liberally decorated with embroidery and applied canvaswork designs similar to, but more complex than, those to be seen on floral panels at Traquair House. *depth of valance* $10\frac{1}{2}$ *in, 26·7 cm*

hangings are formed from a pair of bed hangings of which six full-length curtains and two tester valances, which each would have gone round one bed, are on general view. The curtains are made of linen eighteen inches (45·7 cm) wide joined selvedge to selvedge and backed with navy cotton, and they were obviously made up before any decoration was added since seams are straddled by the appliqué. Vertical edges of curtains are embellished with applied floral bands about four and a half inches (11·4 cm) wide and parts of the rest of the fabric are spotted with canvaswork motifs mostly about ten and a half inches (26·7 cm) high, outlined in dark brown and with flowing designs more complex than earlier canvaswork motifs to be seen at Traquair House. Delightful birds, animals, caterpillars and other motifs have been fitted in the reserves, worked straight to the linen; strawberries and oyster-catchers are just two of the reminders of the environs of Glamis.

The two tester valances, deeply fringed, are set with many pairs of applied floral and fruit motifs set side by side and relieved by monograms worked straight to the linen in straight stitches and couching. Crowned indications:

$$\begin{array}{ccc} \text{L} & & \text{E} \\ \text{P} \quad \text{L} & \text{and} & \text{S \& K} \end{array}$$

denote that the 3rd Earl, born Lord Patrick Lyon, had become Earl of Strathmore as well as Kinghorne under the 1677 charter, and, similarly,

$$\begin{array}{ccc} \text{L} & & \text{C} \\ \text{H} \quad \text{M} & \text{and} & \text{S \& K} \end{array}$$

are reminders that Lady Helen Middleton (*c.* 1645–1708) was later the Countess. It was Lady Helen, indeed, a skilled and artistic needlewoman, who worked this pair of bed hangings.

Royal ladies have for many centuries practised embroidery. In 1544 the eleven-year-old Princess Elizabeth worked a silver and gilt plaited braid-stitch cover for *The Miroir or Glasse of the Synneful Soul* that she had herself copied from the Queen of Navarre's original as a New Year's gift

Carpet worked by the Queen
Mother's mother-in-law,
Queen Mary, in 1950.
*tentstitch panels, dimensions
of carpet 63¼ × 43¼ in,
160·7 × 109·8 cm*

for her step-mother, Catherine Parr (1512–48), and as an older princess
she had worked fine baby linen when her sister Mary (1516–58) was
thought to be carrying the child of her husband, Philip II of Spain (1527–
98). (This set of baby linen was temporarily publicly displayed during the
Church Education Society's needlework exhibition held in Northampton
in 1879.) Later, as queen herself, Elizabeth often displayed the fine embroi-
deries of others. Among New Year gifts presented to her, for instance,
were embroidered handkerchiefs and 'one skarfe of white cypres,
embrothered all over with flowers and leaves of silke of sondry colors'.
She wore such embroidered clothing as a satin travelling cloak
embroidered with silk pansies and other flowers given to her by Bess of
Hardwick in 1576. A portrait now at Hardwick Hall shows the queen
wearing a sumptuous stomacher and petticoat of cream silk worked with
brightly coloured motifs of flowers, birds and animals: this painting, attri-
buted to the school of Marcus Gheeraerts the Younger (*c.* 1561–1636),
is one of a large number of similar works in other stately homes attributed
variously to this artist or to the Italian Federico Zuccaro (*c.* 1540–1609).
In general royal ladies have preferred to work embroideries as gifts or for

decorative purposes rather than for costume or other practical use. George III's wife, Charlotte of Mecklenburg-Strelitz (1744–1818), practised knotting, a technique of forming small knots at regular intervals along a cord subsequently couched to a ground fabric. Another famous embroiderer is George V's queen, Mary (1867–1953), whose tentstitch carpet with twenty-one groups of flowers adapted from Elizabethan patterns was included in a 1954 exhibition of her art treasures. And, in turn, it was her daughter-in-law, Queen Elizabeth the Queen Mother, who executed items of canvaswork that will be seen across the Atlantic in the National Cathedral: which brings this miscellany back to her childhood home of Glamis.

One of the castle's most striking portraits (*see Plate 15*) is of Arabella Stuart (1578–1615), herself a claimant to the English throne. Daughter of Charles Stuart, nephew of the Lady Glamis burnt for witchcraft and brother of Mary Queen of Scots' second husband Darnley, and Elizabeth Cavendish, child of Bess of Hardwick, she was orphaned at a few years and put under the guardianship of her ambitious grandmother. As the focal point of a persistent movement to place her on the throne, Arabella grew up in almost hysterical fear of Bess. She was befriended and taken to the London court by her relative James VI of Scotland (1566–1625) when he came to the English throne as James I, but because she married another possible claimant to the throne, the Earl of Hertford, in 1610, she was sent, to prevent her having issue, to the Tower of London where she died five years later. In the Glamis portrait, Arabella, not surprisingly, looks tight-lipped and determined. She wears an upstanding lace neck ruff above a dress with full sleeves slit vertically to reveal a delicate undershirt, and her long pointed stomacher is exquisitely embroidered in many differently coloured bright silks in a graceful floral design with big flowers and simple linear stems that constituted one type of sixteenth-century needlework. The following chapter on Hardwick Hall furnishes some further examples from this period.

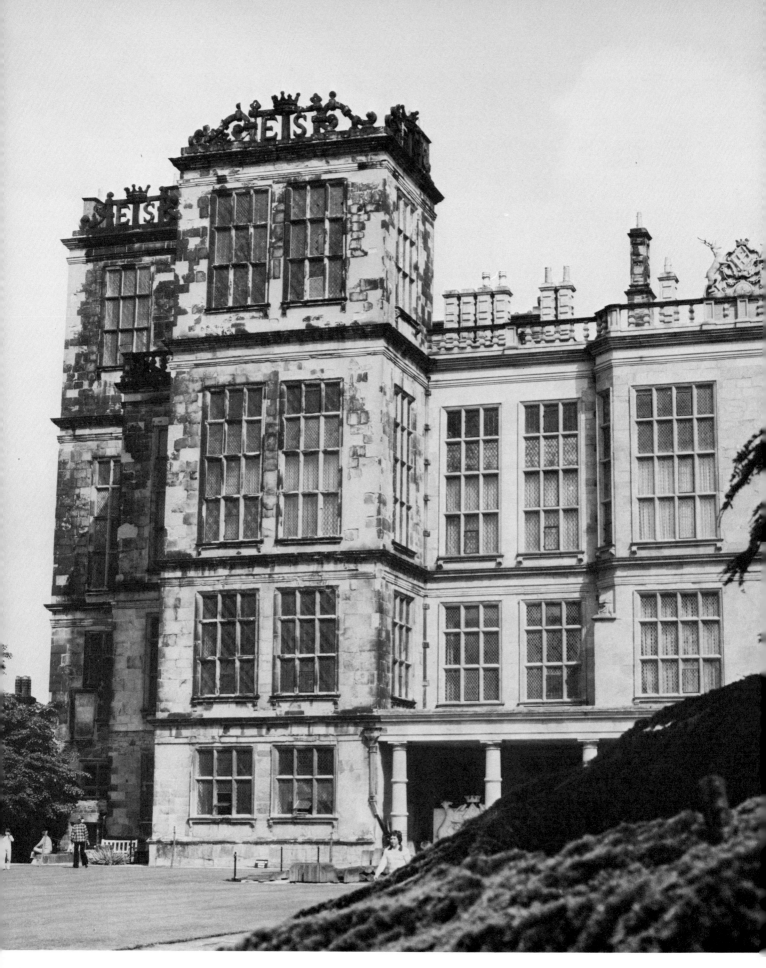

Hardwick Hall, Derbyshire, designed for Bess of Hardwick
by Robert Smythson.

6

Hardwick Hall

Bess of Hardwick's Embroideries

 T was Arabella Stuart's grandmother, Bess of Hardwick (*c.* 1527–1608), who probably commissioned and in some instances may have helped to embroider many of the exquisite late sixteenth-century needleworks reflecting her personality and life which can be seen in the house she built, Hardwick Hall, Derbyshire.

Bess was described, a hundred and sixty years after her death, as 'a woman of masculine understanding and conduct, proud, furious, selfish and unfeeling. She was a builder, a buyer and seller of estates, a money-lender, a farmer, and merchant of lead, coals and timber.' She was born in about 1527, fourth of the five children of John Hardwick and Elizabeth Leake, and was brought up in a small manor house where the Old Hall of Hardwick is today. After her father's death she moved into service in the London house of a near neighbour, Lady Zouche, perhaps to look after the children. In May 1543 she married another member of Lady Zouche's household, thirteen-year-old Robert Barley or Barlow. Widowed after eighteen months, she was then involved with the Court of Wards from whom she did not receive jointure until 1553, by which time she had already been married for six years to Sir William Cavendish (*c.* 1505–57), a twice-married widower twenty-two years her senior.

Since her husband was one of ten auditors on the Court of Augmentation dealing with sale of church lands, Lady Cavendish for the first time tasted affluence, to which she soon became accustomed. In 1548 she persuaded Sir William to pay six hundred pounds for a small house at Chatsworth, near her home in Derbyshire, buying it from Francis Agard who had purchased it from Bess's own brother-in-law Francis Leche. Almost

Bess of Hardwick, Countess of Shrewsbury (*c.* 1527–1608), *c.* 1590, shortly after the death of her fourth husband. *oil on canvas, after Rowland Lockey, 49 × 39½ in, 124.5 × 100.3 cm, framed*

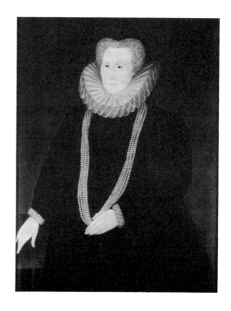

immediately Bess began to enlarge the house into the great mansion it is today. This ten-year Cavendish marriage produced Bess's only children: Frances (born 1548), Temperance (born 1549), Henry (1550–1616), William (1551–1626), later to become Baron Cavendish and Earl of Devonshire, Charles (1553–1617), Arabella's mother Elizabeth (1555–82), Mary (born 1556) and Lucretia (born 1557). Temperance and Lucretia were the only infant fatalities.

Cavendish died in the year of his youngest child's birth. It was discovered that he had been diverting royal revenues for which he had been responsible in another capacity, that of Treasurer of the King's Chamber, and, as his widow, Bess had to forfeit five thousand pounds to the Crown. Partly in order to meet these debts, she came to court and was appointed a lady-in-waiting to Queen Elizabeth, but within two years she had, in 1559, married another court official, Sir William St Loe (c. 1520–65), Grand Butler of England and a considerable landowner in the west of the country. Bess deployed some of her newly acquired wealth to expand Chatsworth (though she took a few months off to spend an enforced short stay in the Tower because she had supposedly supported Catherine Grey, sister of Lady Jane).

On St Loe's death Bess acquired his lands, indentured jointly in her name. She could now afford to be extremely selective in her choice of husband; her high demands were met in 1567 by George Talbot, 6th Earl of Shrewsbury, Lord Lieutenant of Derbyshire, Nottinghamshire and Yorkshire and with properties also in Shropshire, Chelsea Village and London, and a widower with six children. The following spring further links between the two families were secured when her eighteen-year-old son Henry married Shrewsbury's eight-year-old daughter Grace Talbot, and fourteen-year-old Gilbert Talbot wed Mary Cavendish, aged twelve.

After Shrewsbury was entrusted with the custody of Mary Queen of Scots, his wife became an intimate friend of the prisoner, but Bess's relations with the Scottish Queen and with Shrewsbury later deteriorated. Unknown to her husband, in 1574 she arranged for her daughter Elizabeth to marry Charles Stuart (1555–76), a union that produced Arabella, a plausible claimant to a throne that Mary thought should be hers; Bess therefore began to harbour malice towards the imprisoned Queen. Shrewsbury became irritated too by his wife's continual 'unnecessary' expenditures for Chatsworth and her shrewish temper. (This was particularly evident one night in 1577 at Sheffield Lodge when his steward William Dickenson supposedly ordered Bess's embroiderer to be locked out. Whether by intent or error, this act sparked off a row that led the Earl to complain about Bess's groom and her embroiderers, at which juncture she 'scolded like one that came from the Bank'.)

Bess and her sons began to spread malicious rumours about Shrewsbury and Mary and in 1584 Lady Shrewsbury moved away from her husband

(after a brief reconciliation they finally parted in 1586). She returned to the manor house at Hardwick, which she had bought in 1583 from her brother James for nine and a half thousand pounds, and began remodelling it. A few weeks before Shrewsbury died in November 1590, however, she had already had the foundations laid for another building, the main house as it is today. This, the New Hall, was designed by Robert Smythson (*c.* 1536–1614), one of the geniuses of English architecture who combined symmetry with fantasy. His design has often been described as 'Hardwick Hall, more glass than wall' because of the large areas of expensive fenestration. It included six towers on top of which he placed open-fret cresting with the initials, ES (Elizabeth Shrewsbury), of his patron. Although Hardwick Hall was not wholly complete until 1599 Bess moved there in October 1597. She employed craftsmen to decorate her new home and also to repair items removed from Chatsworth. Textiles, for instance, were especially vulnerable because of their fragility and a statement on 24 October 1600 allocated payment of '4 oz sewing gold at vjs [6s] the oz' that may have been used in repair work.

Among textiles removed to Hardwick were thirteen tapestries purchased from Sir Christopher Hatton's heir and other enormous hangings applied with cut-up vestments bought for Bess by her second and third husbands after the 1540 Dissolution of the Monasteries. It has already been mentioned that Bess loved luxury, and she brought to Hardwick a bed with 'postes being Covered with scarlet layd on with silver lace, bedes head, tester and single vallans of scarlet, the vallans imbrodered with golde studes and thissells'. Bess and her ladies helped to decorate her home, working with the professional embroiderers who included Thomas Lane, who rented accommodation in Cromford for an annual rent of 13s 4d. Bess paid Lane well: on one occasion he received 40s for working bed furnishings and another time he was paid 30s 3d for embroidering a 'livery cloake'. Other embroiderers were housed in servants' quarters on the ground floor of the Hall, and some may have been apprenticed through such agents as Josine Graunger, a London widow whom another house-proud lady, Lady Katharine Petre, enjoined in 1597 to provide her with an apprentice, a Clerkenwell surgeon's daughter, bound to her employ for ten years.

At Hardwick Bess's embroiderers worked with their canvas or fabric held taut on large frames, nine pairs of which were at one time kept in a first floor wardrobe. Many of the Hardwick needleworks specifically associated with Bess illustrate the use of canvaswork, to be studied in more detail at the Henry Francis du Pont Winterthur Museum, and appliqué. Bess obviously commissioned or bought such professionally worked items as 'an other long quition of nedleworke, silke & Cruell of the sacryfice of Isack with frenge and tassells of blewe silk & lyned with blewe damaske, an other long quition of nedleworke, silke & Cruell of the storie of the

LEFT Drawing of two figures in fashionable French court dress of the 1570s.
drawing taken from a canvaswork panel in the Entrance Hall at Hardwick

RIGHT Penelope, the main figure of one of five applied hangings portraying the Virtues, four of which now survive. The hangings are decorated with applied pieces of former vestments perhaps bought for Bess by her second and third husbands.

Judgment of Saloman betwene the too women for the Childe'. Both these pieces, now hanging in the Entrance Hall, belong to a group known as the 'Franco-Scottish Ovid' pictures, typified by crowds richly dressed with pseudo-classical features. Every inch of the canvas is designed as part of the whole and evenly worked tentstitch is highlighted with subsequent fine buttonhole and satin stitch to simulate the collars, cuffs, buttons and jewellery of figures dressed in French style.

At the end of the Hall are two applied hangings from a quintet that portrayed the Virtues, as exemplified by heroines within arches possibly adapted from architectural details of Serlio. The Cleopatra panel has been lost; Artemesia and Zenobia are upstairs, and here are Penelope and Lucretia, the last likened to a Flemish painting, *c.* 1530. Lucretia, committing suicide with a sword after having been raped by Sextus Tarquin, is flanked by personifications of Chastity and Liberality. This portrayal of the rape of Lucretia, a story vividly told by Ovid (Publius Ovidius Naso, 43 BC–AD 17), is an indication of the type of education given in the sixteenth century. Ovid was a particularly popular author with teachers in schools and with private tutors, one of whom may have suggested the theme of this panel to its designer.

On the reverse side of a screen in the Hall hang a pair of panels from the 'Virtues and Contraries' set. One shows Mahomet (Muhammad) at the feet of Faith and the other illustrates Temperance being reproached by Sardanapalus, an Assyrian king famous for his sybaritic life. Yet more classical knowledge can be gained by studying a folding screen with applied portrayals of Justicia, Magnanimitas, Fortitudo, Fortuna, Abondencia and Esperencia, and another screen with Aqua, Napea, Odaratus, Justice, Soll, Palles, Daphne, Concordia, Charitie, Chastete, Intelligencia,

Usuria, Fides, Derisio, Prudentia, Verecondia, Sobrietas, Prodicio, Libido, Vana Leticia and other versions of Perseverantia and Magnanimitas!

By contrast, other plum-coloured velvet screen folds have been embellished with thirty octagonal applied crossstitch panels similar to some of the motifs on the Oxburgh hangings. These panels show botanical designs probably from Pietro Andrea Mattioli's *Herbal* (Lyons, 1572 edition); with the exception of a laurel motif bordered by the words '*Virtutis Praemium*', all are surrounded by Latin inscriptions from the *Adagia*, a 1508 collection of over three thousand classical proverbs compiled by the scholar Desiderius Erasmus (c. 1466–1536). Twenty-eight of the octagons include Bess's initials, ES, and although it is most unlikely that she could have embroidered all the items bearing her stamp, the motifs could have been started by her ladies and herself and finished by professionals.

Another, individual, appliqué panel is known as 'the fancie of a fowler and other personages' and is possibly loosely based on a seasonal engraving from a Flemish studio. Canvaswork motifs have been applied to black velvet: beneath a flowering tree a lady in a tall hat sits holding a large strawberry plant and among other devices is a small castle to the upper right that might be nearby Bolsover, rebuilt in 1608 by Smythson's son John for Bess's son Charles; if this is a true identification the motif would have been added after the panel was finished as other devices are c. 1570.

Classical themes appear on a trio of mainly tentstitch panels telling more stories from Ovid, as illustrated by Bernard Salomon (c. 1510–61) in *La Métamorphose de l'Ovide figurée* (published Jean de Tournes, Lyons 1557). In the rape of Europa, or Europa and the bull, Jupiter, in the guise of a bull, carries out to sea Europa, daughter of Agenor, King of Tyre (a similar rendering, worked on yellow satin applied to a bed hanging, can

LEFT One of thirty octagonal panels embellished with designs from Pietro Andrea Mattioli's *Herbal*, published Lyons 1572. All but one of the panels have an inscription from Erasmus's *Adagia*: this panel suggests 'a very small shower creates a rainstorm'. Twenty-eight of the panels are monogrammed ES (Elizabeth Shrewsbury). *tentstitch panel 15 in, 38·1 cm, across*

RIGHT Drawing of another panel, surrounded by the homily '*Caeca fortuna est et suos effecit caecos*' (Fortune is blind, and has made her own favourites blind too).

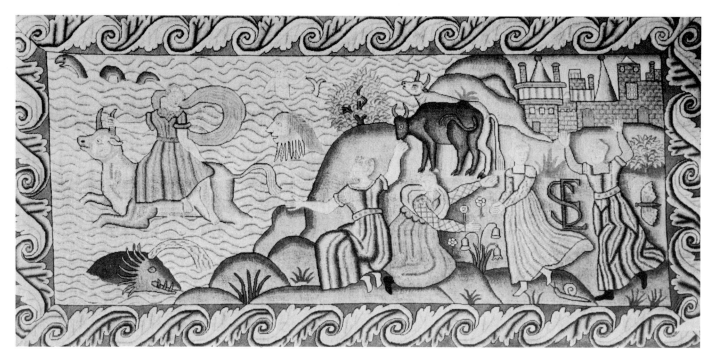

ABOVE 'Europa and the bull', one of three fascinating canvaswork pictures with designs taken from illustrations in Salomon's *La Métamorphose de l'Ovide figurée*, published 1557. Parts of the panels may have been worked by Bess, whose initials ES are once again in evidence. *silk tentstitch panel with subsequent stem stitches for the figures' hair, 22½ × 47 in, 57·2 × 119·4 cm*

RIGHT 'The fancie of a fowler and other personages', a design possibly copied from a Flemish engraving. Applied canvaswork motifs include, in the upper right corner, what could be Bolsover Castle, rebuilt in 1608, in which case this device would have been added later as the panel is dated *c.* 1570. *black velvet applied with canvaswork motifs, mostly tentstitch, 20 × 44¾ in, 50·8 × 113·7 cm*

be seen in the Metropolitan Museum of Art). A seagod watches, his hair long and his neck fringed. On dry land, to the right of this picture, four ladies in simple rural dresses throw up their hands in panic while, behind, a pair of bullocks, one with a small tree apparently sprouting from his back, appear unconcerned. The story of Diana and Acteon is staged in a realistic woodland scene. The young prince Acteon, out hunting, comes across Diana bathing naked with her nymphs and, in revenge for the invasion of her privacy, she turns him into the stag seen on the right being savaged by his own hounds. The main story of Phaeton's fall is set within an arch containing nine signs of the Zodiac. The upper area inside the arch shows Phaeton, son of Helios, the sun god, in his father's chariot as it is dragged by four stampeding winged horses. Jupiter, appearing from

a small cloud above, throws a thunderbolt which stops the stampede but kills Phaeton, seen falling from the vehicle. Beneath clouds formed in a cotton-wool-like mass Phaeton's sisters, the Heliads, weep beads of amber in lament and are turned, most graphically, into poplar trees: greenery sprouts from their fingers and hair and one woman, indeed, is already half transmogrified.

It is perhaps ironic that the woman for whom these classical pictures were designed and worked evokes something of the same awe today as mythological figures did in the people of her own time. Her house and its treasures stand as a reminder of an extraordinary lady.

The third 'after Salomon' panel, the fall of Phaeton, shows his sisters, in lament, being turned into poplar trees. Here chain stitch is used for the horses' manes.
$22\frac{1}{2} \times 46\frac{1}{2}$ in, $57 \cdot 2 \times 117 \cdot 5$ cm

Helen Allen (1902–68).

7

The Helen Allen Collection

Internationalism and Variety

T is thanks in no small part to such enthusiasts as Lord Middleton and Richard Cranch Greenleaf, whose collections can be seen in the Castlegate Museum, Nottingham, and in New York's Cooper-Hewitt Museum respectively, that outstanding embroideries are now available to researchers. One of the highest accolades for the formation of a fascinating collection must, from all points of view, surely be awarded to Helen Allen (1902–68), who brought together over fifteen hundred examples from all over the world. Now housed in the Environment, Textiles and Design Program of the University of Wisconsin at Madison, these form the largest such educational resource in any American university.

Helen Louise Allen was born in Ann Arbor, Michigan, in 1902, the daughter of the Professor of Engineering at the State's university. When she was four the family moved to Turkey as Professor Allen was to establish the engineering programme at Roberts College, Istanbul, and Helen was introduced to the delights of exploring different cultures, a fascination that was to remain throughout her life. She studied as an undergraduate at Carnegie Institute of Technology and after pursuing graduate courses at the Universities of Michigan, Chicago and New York she joined the Madison Faculty of the Department of Related Art, School of Home Economics, in 1927. For the next forty-one years she taught weaving, decorative textile techniques, design in general and the history of European interior design in particular.

Helen Allen felt strongly that related arts 'applied to daily life for greater enjoyment of living rather than for personal expression and communication to others ... students should learn that the people of the past were

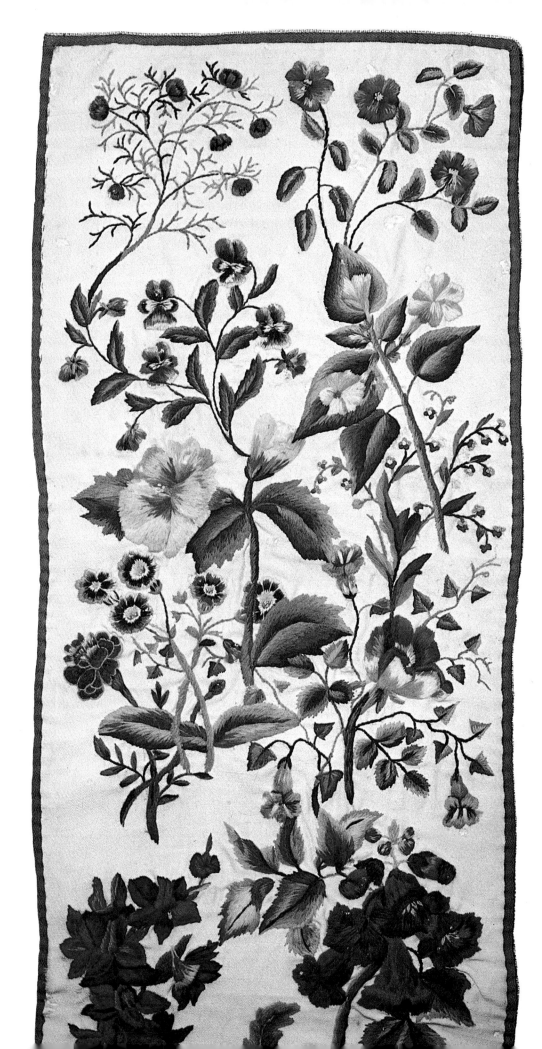

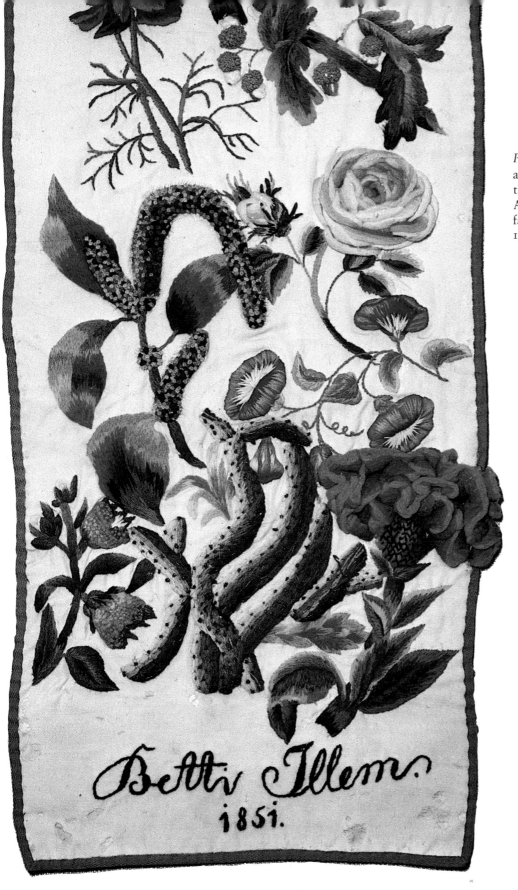

Plates 16 and 17 Bright colours and unusual materials make this embroidery in the Helen Allen collection particularly fascinating. It was worked in 1851 by Betti Illem.

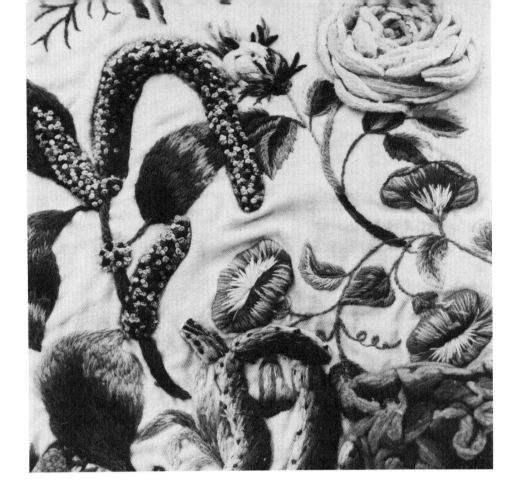

Cactus thorns on the Illem hanging are formed from human hairs.

similar to us and to appreciate their ways of solving the same problems in costume and interiors that we meet'. She never married and she had sufficient private income to enable her to spend her vacations travelling to find out more of that vast world of different peoples to which she had been first introduced as a child in Turkey. She brought home treasures and expanded her many collections, which included buttons, pieces of horn and tortoiseshell, hollow glass canes, paperweights, books, mineral specimens, snuffboxes – and textiles. All these were displayed in her Madison home, generously shared with students and colleagues (and at one time as many as twenty-three cats). She was at all times intellectually curious and throughout her life she continued to add to her vast store of information about the decorative arts.

A few years before her death in 1968, Helen Allen moved some of her needlework collection to her Department; she subsequently left the remainder, with an endowment, to the University. A paper circulated by her Department recorded in gratitude:

Miss Allen frequently pointed out that one of the finest cultural records of the history of man lies buried in his textiles. From the earliest history of mankind textiles have been an intimate part of man's life, and because of their nature historic textiles have been preserved in many parts of the world where other artifacts of man have fallen to decay ... this legacy [the Helen Allen Textile Collection] should continue to be devoted to the education of students in the textile arts, both through creative design and through study of its historical significance.

Under a full-time curator, the collection is now accessible to students of the University of Wisconsin at Madison. Undergraduates can gain access

to study it through their faculty members and graduates can themselves research specific problems, working either on the embroideries or in the accompanying library. Items are loaned from time to time to outside museums; other interested persons can make appointments to view *in situ* (no group numbering more than a dozen can be accommodated and applications must be made in writing in plenty of time).

The collection concentrates on ethnographic items from all over the world as well as berlin woolwork and late nineteenth- and early twentieth-century American items, with some works by Mariska Karasz and Nik Krevitsky. There are also many drawers of batiks, especially from Indonesia, screen prints, laces, coverlets and woven textiles. The ethnographic embroideries reflect Helen Allen's travels, especially in Central America, sub-Saharan and northern Africa and the Near and Far East. The source of some of her home-produced pieces is less obvious, as illustrated by a wall hanging marked 'Betti Illem 1851'. Formed of wool and silk backed with green and lined with white plain-weave cotton, it is exquisitely embroidered with a design of roses, morning glories, violets, marigolds, pansies, heliotrope and forget-me-not. Some of the flowers are worked with needleweaving, literally by a threaded needle weaving in and out of other threads, stems are made of couched bundles of thick thread and, in contrast, fine details such as cactus thorns are composed of individual human hairs (*see Plates 16 and 17*).

One of the most comprehensive facets of this eclectic collection is the North American coverage, for as well as beadwork and other forms of Indian stitchery Helen Allen bought almost anything worked by anyone at any time. She bought extensively from dealers and sometimes she found late nineteenth- and early twentieth-century items in local garage sales: at the time it was probable that no-one else would have thought a white tablecloth with a single embroidered monogram worth more than a cursory glance.

Although she did sometimes come across earlier examples, most of her needlework treasures are post-1810, the era of berlin woolwork. These brightly coloured canvaswork designs were copied from coloured patterns on graph paper. They originated in about 1810 when Mme Wittich, wife of a Berlin print seller, encouraged her husband to commission embroidery designs similar to those which had been produced in limited numbers for the previous five or six years by Herr Philipson, another print seller. Essentially a ladies' pastime, berlin woolwork's charm was twofold. Firstly, following a clearly marked graph pattern coloured in different shades was a fairly simple exercise requiring little talent and only minimal concentration and patience. Women could therefore gather together and possibly even converse while embroidering! Secondly, it was especially pleasurable because of the loosely twisted soft worsted thread employed, known variously as Berlin or German wool or zephyr merino, first produced in Gotha

Drawing of a black velvet bag, the fabric here denoted by shading, embellished by North American Indians with many different coloured beads.

Plate 18 (left) Cleverly-worked flowers on a late nineteenth-century velvet runner collected by Helen Allen.

Plate 19 (above) Erudition abounds in any study of decorative needlework, as evidenced by another cloth in the Helen Allen collection that illustrates such opera scenes as the first act of Puccini's 1896 work, *La Bohème*.

Berlin woolwork sampler
neatly decorated with many
flamestitch patterns.
*white linen canvas bound with
pink silk ribbon and
embroidered in silks and wools,
$75 \times 5\frac{7}{8}$ in, $190 \cdot 5 \times 14 \cdot 9$ cm*

and dyed in Berlin and then, particularly after the introduction of aniline dyes in 1856, in many other places.

Berlin woolwork varied in its effect from crude and garishly coloured simple motifs to more controlled use of colour, often worked in intricate stitching. By 1840 some fourteen thousand different patterns were available and ladies passed them to one another, often simply working one small area of a design before giving its pattern to someone else. This means that many surviving berlin woolwork items can be termed 'samplers' in ·that dozens of sometimes outrageously coloured geometric designs are worked on strips of white linen canvas typically bound with silk ribbon.

Two of the berlin woolwork samplers that Helen Allen collected are especially attractive. One, signed PB, is typically decorated with brightly coloured silks and wools in many different flamestitch patterns and the

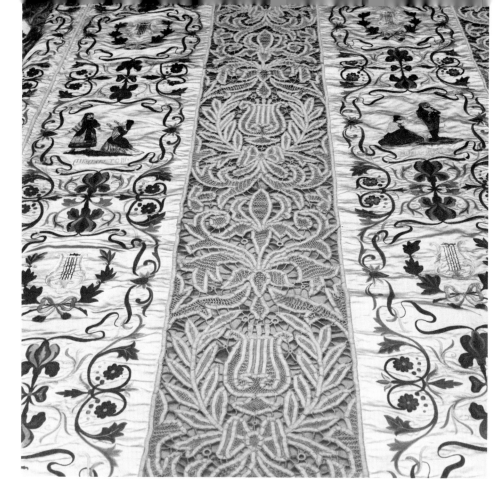

An extraordinary cloth formed of six lengths of gold satin separated by tape lace; the satin is embroidered in silks with motifs of opera scenes and scrolled flowers.
$102\frac{1}{2} \times 119\frac{1}{4}$ in, 260.3×302.9 cm, overall

other, worked by HH in 1869, is particularly outstanding for a motif of a pansy worked in cut turkey work, a knotted canvaswork technique, and so delicately shaded that the three-dimensional effect is remarkably realistic. Both items date from the zenith of berlin woolwork which suffered a decline accelerated in 1876 when Mrs Candace Wheeler, closely involved with the Centennial Exhibition in Philadelphia, helped promote artistic needlework. A new fluidity was thus brought into American embroidery: curvilinear designs were often executed regardless of warp and weft alignment of the ground fabric or, alternatively, such a matted material as felt was employed.

One such item (*see Plate 18*) is a velvet runner worked in closely couched chenille and floss silks with large uncut loops simulating flower petals and, as balance, more precisely proportioned loops forming daintier flowers. Accurate dating of this runner is difficult. By contrast, deductions can be made about another cloth (*see Plate 19*), donated in 1975. An enormous piece with main proportions of $102\frac{1}{2} \times 119\frac{1}{4}$ in (260.3×302.9 cm), its area is formed of six long strips of golden satin one foot (30·5 cm) wide separated by bands of the same tape lace which forms a frilled outer border to three sides of the whole. Each satin strip is embroidered in a design, repeated every sixteen inches (40·6 cm) or so, with scrolled flowers and scenes from six operas, the most recently composed of which is Puccini's *Tosca*, first performed at the Teatro Costanzi, Rome, in 1900. It therefore seems plausible that the cloth could have been embroidered, perhaps in a European convent, for an opera enthusiast at the beginning of the twentieth century.

TOP Late nineteenth-century splasher worked in popular 'red on white', red pearl cotton on white linen, mostly in stem stitch.
$17\frac{3}{8} \times 28\,in$, $44\cdot1 \times 71\cdot1\,cm$

BOTTOM Panel worked from a *Craftsman* design, with some stencilled areas intentionally left unstitched.
$15\frac{3}{4} \times 23\frac{3}{8}\,in$, $40 \times 60\cdot6\,cm$

Other pieces in the collection can definitely be attributed to American hands. From about 1890, for instance, many women across the country worked tablecloths and napkins, antimacassars and other household items characteristically embellished with red pearl cotton stitched on white linen already stamped with designs ranging from the purely whimsical to the elementary and practical. To take one of the dozens of 'American red and white' needleworks that Helen Allen purchased, a splasher is embroidered with a bird bath surrounded by tall grasses: birds frolic and fly overhead and the item is labelled, as if explanation were needed, 'morning dip'.

Helen Allen, therefore, was not above collecting seemingly the most

pedestrian of needlework styles and it is thanks to her catholic tastes that such a representative collection of American needlework can now be studied in Madison. She had several excellent examples of 'craftsman needlework' emanating from ideas in *Craftsman* magazine, which advocated designs of Aestheticism rather than Art Nouveau. *Craftsman* offered a variety of stencilled fabrics, sometimes with accompanying silks. Some parts of a design were embroidered and others left, decorated merely by blocks of stencilled colours, as illustrated by a pillow case which has green stencil around daisies formed of satin stitch and french knots.

Forerunner of a new generation of embroiderers was Hungarian-born Mariska Karasz (1898–1960), a dressmaker by profession who often included embroidered motifs, some adapted from her own national costumes, in her designs. Gradually she veered away from formal dress production to an explosion of colour and theme *per se*: for Karasz, freeform stitchery became an art form and techniques and the relative quality of stitching became irrelevant. Of the nine Karasz pieces in the Helen Allen collection, one has applied head combs and another has applied bits of bark surrounded by stitched outlines of sixteen fleeing animals, both works illustrating the courageous versatility of the artist. Texture is similarly important to Nik Krevitsky (born 1914, Tucson, Arizona), whose works are typified by a kaleidoscope of materials, threads and stitches contributing to a broad palette of colour. His 'Sky Picture', for instance, consists of golden furnishing fabric applied with a potpourri of nets, plastic, chiffon, wood, string and velvet subsequently stitched with many different shades of blue, yellow and brown threads.

Helen Allen was quick to appreciate the talent and the future reputation of both Karasz and Krevitsky and she was constantly alert to the need to keep her collection up to date. To her it was always only obvious that she should buy anything she liked and that included 'modern stuff' as well as the historic. She thus established a personal memorial which continues to provide an essential research centre for embroidery students.

Work by Nik Krevitsky, early 1960s.
nets, plastic, velvet, string and chiffon applied to gold fabric, 29½ × 18 in, 74·9 × 45·7 cm

The Henry Ford Museum,
Dearborn, Michigan.

8

The Henry Ford Museum

Faces of the Past

T is tempting, when looking at old needleworks, to marvel at their overall design and execution and overlook such important smaller details as faces and their expressions. In painted portraits, by contrast, it is facial expressions which usually dominate. Here, in the rather incongruous setting of a centre of the motor industry at Dearborn, Michigan, embroidered faces are brought into focus.

In 1919 Henry Ford (1863–1947), a farmer's son from Wayne County who built the 1896 Quadricycle and with his Model T production line revolutionized the world of transport, began to preserve the two-storey clapboard house in which he had been brought up. He later moved the entire house and its contents to Dearborn, and visitors can now see, in Greenfield Village, his bedroom workbench and the family's Sunday Parlor, with its impressive cast-iron stove and a rocker with an antimacassar similar to many in the Helen Allen collection.

Ford's idea in removing this and many other houses to Dearborn was to provide a reminder of the past in the form of indoor and outdoor museums: 'When we are through, we shall have reproduced American life as lived, and that, I think, is the best way of preserving at least a part of our history and tradition.' Accordingly, in 1928 the corner-stone of the large brick building that is today the Henry Ford Museum was laid by another inventor, Thomas Alva Edison (1847–1931), and the following year the museum and its accompanying outdoor area, Greenfield Village, were dedicated in the presence of President Herbert Hoover, Marie Curie, Orville Wright and John D. Rockefeller Jr, who had himself been closely involved with preservation at Colonial Williamsburg.

Facial details are often overlooked when studying embroideries. In one of two versions at Dearborn of the story of Christ with the Woman of Samaria, expressions are vital to the impact of the whole. *églomisé framed needlepainting displayed in the Webster house*

The visitor today may approach the museum along a short walk lined with flags representing America's history. Here are Cabot's Cross of St George, the British Union flag, John Paul Jones's naval ensign (sometimes called the Cambridge or Grand Union flag), Colonel Gadsen's snake flag, the British Red Ensign, the Continental flag, Betsy Ross's, the Fort McHenry and the current Stars and Stripes. From this avenue the visitor can look to the right and see some of the two hundred and sixty acres of rural pasture which form the setting for the village. Here there are now nearly a hundred historic buildings, including a typical Cotswold cottage transported stone by stone across the Atlantic. Abraham Lincoln's Court House stands elegantly to the east of the village green; the house in which Orville Wright was born in Dayton, Ohio, in 1871 has been brought to Cheapside, where it now stands next to the bicycle design shop at one time owned by him and his equally talented brother Wilbur.

Dearborn's needleworks are set in various village buildings as well as in the main museum. In the Dining Room of the Susquehanna house, for instance, originally at Tidewater, Maryland, occupied in the middle of

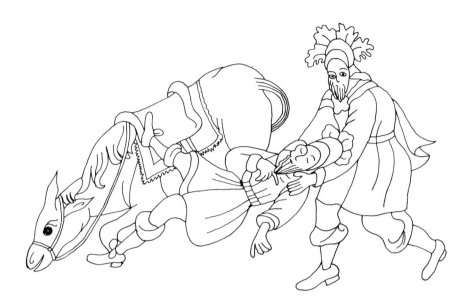

BELOW A finished seventeenth-century panel, in the Fitzwilliam Museum, Cambridge, vividly illustrates the death of Uriah the Hittite. *section of a white satin item embroidered in silks in a variety of techniques,* 21½ × 21¼ in, 54·6 × 54 cm

the seventeenth century by Christopher Rousby, tax collector for Charles II, there now hangs a contemporary canvaswork picture of the Queen of Sheba in a style typical of the biblical needleworks that will be discussed later at Parham Park. The collection also includes two closely similar late eighteenth- or early nineteenth-century *églomisé* pictures with the New Testament story of Christ with the Woman of Samaria at the Well probably taken from the same, perhaps Italian, design; one of these versions is in the main museum, the other hangs in an upstairs bedroom of the 1822 New Haven, Connecticut, home of Noah Webster (1758–1843). Christ is seen sitting under a shady tree with his arm raised in greeting to a richly dressed courtesan holding a pitcher as she leans against Jacob's Well. Behind, the buildings of Sychar can just be seen. Only incidentals differ in the two versions of this scene; the Webster house picture portrays Christ in a brightly striped robe and the museum version includes a foreground floral motif. The faces and hands of the subjects have in both instances been left unstitched: the sheer delicacy of the watercolour is left to balance the heavier effect of stitched hair, haloes and clothes, and emotion is portrayed simply by the painting.

As has already been suggested, indeed, in many cases fabric was so carefully marked with painted or inked details that it is little wonder that embroiderers did not always obscure those expressions with stitching. An unfinished seventeenth-century panel in Dearborn's museum shows the conversion of Saul. Bewilderment is conveyed in a minimum of linked lines in a manner similar to that expressed by the stitching on Uriah's face in a detail from the story of David and Bathsheba illustrated from the Fitzwilliam Museum. Sometimes faces were embroidered direct to the ground fabric with little or no guidance from marked lines. Another method of indicating expressions, particularly popular in England during the latter

OPPOSITE This face, in the Victoria and Albert Museum, is demulcent and calm. The cherubs' heads are formed of raisedwork.
satin embroidered in long and short stitch, couching and french knots, medallion edged with padded satin braid couched with silk and embellished with metal purl, overall size 13½ × 11¼ in, 34·3 × 28·6 cm

ABOVE LEFT Portrait of Charles I by Sir Anthony van Dyck (1599–1641), painted to aid the Tuscan sculptor, Bernini (1598–1680).
33½ × 39¼ in, 85·1 × 99·7 cm

ABOVE RIGHT A stitched portrait of King Charles I, from the Metropolitan Museum of Art.
satin worked with floss silk and silver thread split stitch and couching, 4 × 5 in, 10·2 × 12·7 cm

part of the seventeenth century, was the technique of raisedwork that will be described in more detail in the chapter on Milton Manor House. Raisedwork faces could be formed with noses or whole heads padded or formed of appliqué of pieces of leather, parchment and wood, a method to be seen on the face of a late seventeenth-century lady in the Dearborn collection. Embroidered within an oval medallion, she wields a fan and a stick as she turns to face the viewer, her eyes the while studying her hands. (Interestingly, embroidered portraits are rarely worked in profile.) Her entire face has been padded and her nose is formed of a miniscule paper appliqué: contours of eyebrows, eyes and mouth are worked with tightly pulled back stitch.

This oval portrait is one of four, mostly in beadwork, embellishing a looking-glass surround, a use which probably dates the embroidery to after 1663 when the Duke of Buckingham established a plate-glass manufactory in Vauxhall which helped to popularize looking-glasses. And since the very nature of a mirror indicates a certain degree of vanity it is not surprising that many an item decorating a lady's table should be embellished with enviable likenesses, perhaps of a royal person.

Royal portraits, indeed, continually appear in needlework faces. Not surprisingly the easily discernible features of Charles I (1600–49) recur with great frequency, even on items worked long after his execution. Reproductions of van Dyck's famous triptych, now the property of Her Majesty the Queen, or the 1661 Hollar engraving were used as patterns by embroiderers who worked miniature portraits, including those now to be seen in the Zouche and Lady Prendergast Collections of the Victoria and Albert

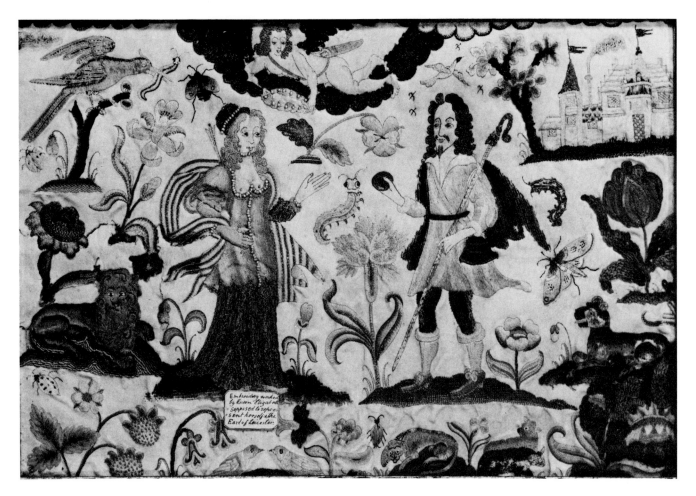

Museum, in the Pierpont Morgan and Untermyer Collections of the
Metropolitan Museum of Art and in the Wallace Collection, London.
Earlier versions of these miniatures were worked either as little pictures
or as medallions to highlight covers of books laid on altars, desks and
tables: later pictures, by comparison, were larger in format and more elab-
orate in style. Charles I was also portrayed in the guise of Solomon,
Pharaoh or other biblical subjects.

Recognizable features such as the English king's moustache, shoulder-
length hair, pointed beard and earring may greatly facilitate identification
of an embroidered subject. Less reliance may be placed on labelling, for
instance of a wall hanging at Dearborn that states 'embroidery worked
by Queen Elizabeth'. The picture is supposedly a portrait of Elizabeth and
her favourite, Robert Dudley, Earl of Leicester (1531–88) but, since the
pair are clothed in late seventeenth-century dress and the moustachioed
gentleman sports Charles I-type hair, the attached attribution in this case
is undoubtedly inaccurate. Around 'Elizabeth' and 'Leicester', motifs are
dotted at random: a caterpillar, one of the *impresa* of Charles I, substanti-
ates later dating of the item and, nearby, a tall carnation has flowing leaves
emulating the fall of the lady's shawl. A lion, that king of beasts, turns

a raised head as he lies in peace. Probably copied from *A Booke of Beast*,
published anonymously by Thomas Johnson in 1630 (pages of a copy of
which can be seen at Mellerstain), this lion more than any other animal
was stitched by amateur needlewomen decorating panels for looking-
glasses, pictures or needlework boxes. He appears, for example, on

Three portraits of Queen Anne: (below) as portrayed on a sampler worked in 1719; (right) as painted in the studio of John Closterman (1660–1711); (far right) a version taken from a panel in the Metropolitan Museum of Art.

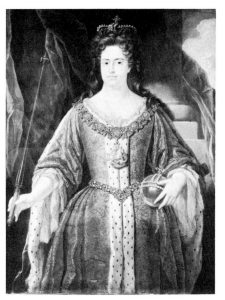

another seventeenth-century needlework at Dearborn: here, on a cushion cover, he wears an unconfident, worried expression, appearing as an incidental addition to a scene of a man crowning a shepherd.

Animals' faces therefore should not be overlooked when reflecting on embroidered expressions. But in the main such a study primarily constitutes perusal of the human form. As well as faces embellishing household furnishings, portraits have occasionally been incorporated into such samplers as one 1719 item now at Dearborn. Here, surrounded by bands of inscriptions and motifs, two flying putti crown Queen Anne, the monarch who is sometimes said to have taken a long time to go. She finally died in 1714, and so this later sampler, which cannot have taken more than a couple of years to make, provides yet another example of a mourning portrait. It is probable that the head is a fair likeness, for it can be compared with a silkwork picture in the Metropolitan Museum of Art and, in turn, with a painting from the studio of John Closterman (1660–1711). A stolid determination is visible in both stitched impressions, a reminder that personality can be expressed by a few simple lines.

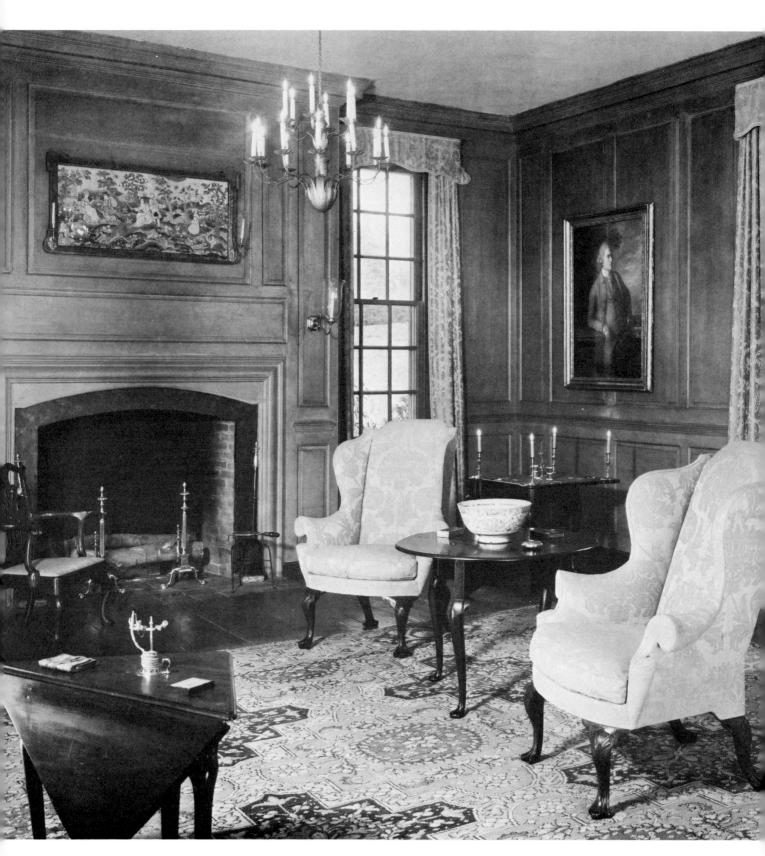

The Marlboro Room at Winterthur, Delaware,
is culled from two interiors from Patuxent Manor,
built in 1744 in Lower Marlboro, Maryland.

9

The Henry Francis du Pont Winterthur Museum

Canvaswork

HE peaceful haven of Winterthur is set within a nine hundred and fifty acre estate in Delaware. Here a relaxed study can be made of those canvasworks included in this collection of over six hundred textile items, the largest assembly of American decorative arts, much of which is publicly displayed in nearly two hundred rooms furnished in different styles.

In 1802 Eleuthère Irénée du Pont founded a black powder manufactory by the side of Brandywine Creek, a few miles inland from Wilmington. One of his European investors was a man of Swiss heritage whose son, James Antoine Bidermann, married du Pont's daughter, Evelina Gabrielle, in 1816. The younger Bidermann worked for his father-in-law for more than twenty years and in 1837 purchased from him a parcel of land so that he could become a gentleman farmer. Bidermann called his estate Winterthur after his family's Zurich Canton home and two years later he built a three-storey house, in classical Greek style, on a wooded slope overlooking a small stream, the Clenny Run. Nearly thirty years later he sold the estate back to the du Pont family, and in 1875 Colonel Henry Algernon du Pont took up residence. He instigated various alterations and expansions, a policy that was to be continued by his son, Henry Francis (1880–1969), who lived in the house as its last private owner from 1927 to 1951. (In 1929, for example, the addition of one new wing specially intended to house the growing collection of Americana multiplied available display space threefold.) Henry Francis du Pont bought panelling and other interior fittings from houses throughout the eastern seaboard and he furnished each of his rooms with suitable contemporary furniture, silver,

pewter, glass, china, paintings and other items from the mid-seventeenth to nineteenth centuries. He was a meticulous student whose concern for authenticity boded well for the quality of Winterthur as it is today.

There is so much for the visitor to see. Here is the Port Royal Parlor, containing furnishings from the country house built in 1762 on Frankford Creek, north of Philadelphia, for Edward Stiles, who called it after the Bermuda parish of his birth. Much is in the style of Thomas Chippendale (1718–79), indicative of the fact that his *Gentleman and Cabinet-Maker's Director*, first published 1754, had soon made a marked impact on Philadelphia furniture makers: there are two sofas once owned by John Dickinson, author of *Letter From a Farmer in Pennsylvania* (1768), and chairs now upholstered in the same imported golden damask as that used for festoon draperies.

More Philadelphia furniture can be seen in the elegant blue-grey pine panelled Marlboro Room, from a Maryland plantation built for Charles Grahame in 1744. Here also are walnut easy chairs probably made in the second quarter of the eighteenth century in Fredericksburg, Virginia, for the Lewises, who appear later in the chapter on the Washington family. This room is lit by wood and tin chandeliers such as those sometimes used in ballrooms and churches: they throw enough light to illuminate paintings by Charles Willson Peale (1741–1827) of Captain Richard Bennett Lloyd, an ardent loyalist, and of his brother, Colonel Edward Lloyd, who supported independence, with his wife Elizabeth Tayloe playing a cittern.

A canvaswork pocket book lies on a folding corner table, and above the mantelpiece is Sarah Warren's canvaswork picture, worked in 1748, near a similar item finished by Priscilla Allen two years earlier.

It is time to look in detail at canvaswork, variously called 'needlepoint', a term historically implying needle-lace, or, less plausibly, 'tapestry', which should be reserved for woven textiles. Worked on a firm meshed canvas ground rather than a soft finer-weave fabric, canvaswork has been popular in the western world since the days of such skilled British needle-women as Mary Queen of Scots and Bess of Hardwick. With the increased leisure that became apparent in America in the eighteenth century, canvaswork was employed to decorate furnishings, book and chair coverings and panels for pole screens and pictures, and other items such as pockets. People worked on single thread or mono canvas, with eighteen to fifty-two warp and weft threads woven across each inch of canvas. Because single canvas, unlike double or penelope canvas which has pairs of threads woven together, tended to distort during embroidery, it would be laced into a frame, usually a trestle-based floor standing model.

Much of the canvas and silk thread used for subsequent stitching was imported, although locally produced crewel and other wools were less expensive. Some popular stitches were gros point or cross stitch and tent-stitch, a diagonal stitch worked over one thread on canvas and, depending

on the way the stitches are formed, alternatively known as petit point, or basket weave, canvas, continental, cushion, half cross or needlepoint stitch. Rococo stitch was then often called queen's stitch.

Flamestitch, then known as irish stitch, was, however, perhaps the most employed technique. (It was to be known, particularly after the 1880s, as bargello, florentine or hungarian stitch, as a Hungarian princess is one of the people credited with the invention of a technique subsequently employed to cover chairs now in the old Bargello Palace in Florence.) A fast-moving technique worked mainly on the surface, flamestitch is characterized by regulated geometric patterns of vertical stitches placed in a prearranged horizontal alignment to each other and parallel to rows above and below, thus forming carefully shaded zigzag patterns: alternatively, rows of stitches can form outlines of exactly spaced and sometimes interlocking carnation or diamond motifs which are subsequently infilled in required colour sequences. Most flamestitch items *are* embroidered but it should be pointed out that a few larger hangings may be woven. Especially in the seventeenth and early eighteenth centuries, some lesser nobility compensated for lack of sumptuous Aubusson or Gobelin tapestries by purchasing areas of fabric which were already decorated by using floats to weave wool in with each shoot of coarse hempen fibre to produce a zigzag effect 'in flamestitch technique'.

Whatever the embroidery technique employed, canvaswork in the past was usually executed without regard to how neat the item looked on the reverse. Embroiderers similarly sometimes cut corners and expense by working only alternate stitches of the reserves of a design. Canvases could be purchased on which the design was already marked but embroiderers often preferred to ink their own, as illustrated by the announcement in the *South Carolina Gazette*, 30 January–6 February 1753, that John Thomas, a boys' school teacher, undertook to instruct half a dozen young ladies 'to draw and shade with Indian ink pencil' designs that could subsequently be embroidered. Alternatively, instead of inking an entire design, one small motif of a repeating pattern could be drawn on the canvas and the rest of the design carefully counted stitch by stitch from that motif. If this last method was used the key motif was generally drawn in the centre of the canvas and the design repeated outwards in each direction.

With an understanding of what canvaswork implies, it is possible now to look in detail at some of the items at Winterthur, and what could be a more suitable starting point than a bible with which that great polymath Benjamin Franklin (1706–90) is associated, in this instance probably as publisher. Printed by John Baksett and D. Leach, the book is inscribed 'John Gillingham His Bible Bought ... Benjamin Franklin Mayc 20d 1740'. (Gillingham was a prominent Philadelphia cabinetmaker to whom the chair near the bible is attributed.) The book has a linen canvas cover worked in woollen flamestitch with motifs outlined in brown and infilled

Sometimes such time-saving practices as only working alternate stitches of reserves are employed.

detail of a linen scrim panel probably worked 1760–90 by Hannah Nichols who mainly used silk tentstitch, although small blocks of rococo stitch form fruit on the left tree and the shepherdess's robe is partly embroidered with whipped stitching, $5\frac{11}{16} \times 4\frac{3}{8}$ in, $14\cdot4 \times 11\cdot1$ cm, detail

BELOW Flamestitch cover for a bible inscribed 'John Gillingham His Bible Bought ... Benjamin Franklin May^c 20^d 1740'. The cover was probably worked by a female member of Gillingham's family.

linen canvas cover stitched with wools, $15\frac{3}{4} \times 10\frac{1}{2} \times 3\frac{7}{8}$ in, $39\cdot9 \times 26\cdot7 \times 9\cdot8$ cm

with shades of indigo-green or gold or orange to produce an effect of diagonal lines of different colours. The embroiderer's identity remains a matter of conjecture but it was probably a Gillingham lady.

Other items in the extensive Winterthur collection are at least initialled and dated. A useful ribbon-bound wallpocket, for instance, embellished mostly in woollen flamestitch, has the letters M and H flanked by the figures 17 and 66 in blocks worked in minute cross stitches with the uppermost diagonals worked in haphazard array. Lined and backed with paper, this little wallpocket has a hook at the apex of its back panel so that it could be hung up to hold papers or an almanac. There are in all some forty-eight canvaswork portable pocketbooks in the collection and many are carefully set out, protected by clear acetate wrappers, for visitors to see

Flamestitch hanging
wallpocket signed MH 1766 in
blocks of cross stitch with no
regard for direction of the
uppermost diagonals. The
main part of the embroidery
does not extend to parts of the
item that do not show.
*linen canvas backed with
cotton and paper and
embroidered in wools,
10⅜ × 8 in, 26·4 × 20·3 cm*

as they progress around the house. One of the most beautiful of all these
fascinating items must surely be another flamestitch item resplendent for
its deep reds inside the inner carnation-shaped motifs and subsequent
shading through blues to golden: nothing is known, alas, about the em-
broiderer's identity but she probably worked the pocketbook for a man
as it has two pockets, a distinguishing characteristic explained within the
context of Old Sturbridge Village.

Well known among the Winterthur needleworks are examples of
'Boston Common' or 'fishing lady' tentstitch pictures, from a group of
items, totalling nearly sixty in all known collections, worked in the eight-
eenth century in New England, mostly by girls at boarding schools in
Boston. All these panels include vignettes of fashionably dressed country

Priscilla Allen's shepherdess
picture, worked in 1746.
*linen canvas decorated mainly
in wool tentstitch*, 21 × 15⅜ *in*,
53·3 × 39·1 cm

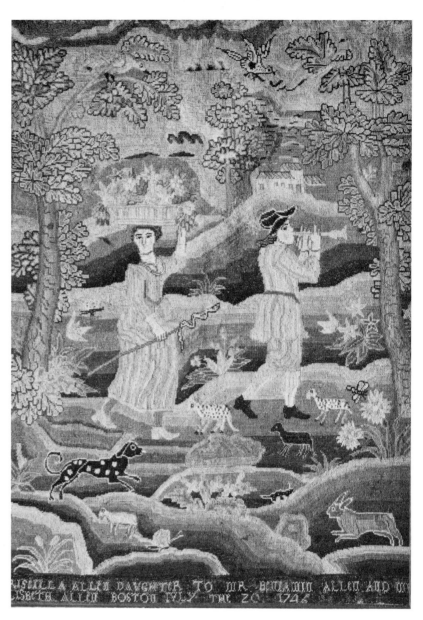

BELOW Sarah Warren's 1748
panel epitomizes the best
'Boston Common' or 'fishing
lady' pictures worked in New
England from 1725–75.
Characteristically, smartly
dressed people are seen set in
wooded parkland thought to be
part of the Common.
*linen canvas worked with silk
and wool tentstich,*
23⅜ × 52⅜ in, 59·4 × 133 cm

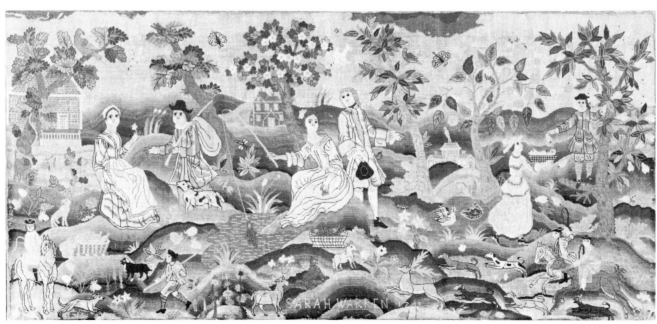

people. A lady might be fishing, a popular genteel hobby of the time, as her escort watches intently; another lady might be spinning, or holding garlands or fruit while her gentleman picks more; in others a traveller is seen, a floppy bag over one shoulder.

In most of the pictures more than one grouping is shown: scenes are linked by landscapes that include parkland and woods dotted with animals, birds and houses in no proportionate scale. On at least one known canvas, John Hancock's house, built on Boston Common in 1737, can easily be recognized: it was on this common that a one-day Grand Exhibition was held in 1753 'to encourage industry and employ the poor' and in addition to spinners and weavers demonstrating their skills more privileged ladies may have displayed 'Boston Common' or 'fishing lady' needleworks.

Priscilla Allen inscribed her panel, one of the pair now to be seen in the Marlboro Room, 'Priscilla Allen daughter to Mr Benjamin Allen and M ... Elizabeth Allen Boston July the 20 1746'. Within a typically rural setting a shepherdess bearing a fruit basket follows a piper similar to the central figure of '*Le Soir*', an engraving by C. Stella (Claudine Bouzonnet) after a painting by her uncle, Jacques Stella of Lyon. In the other picture, worked by Sarah Warren in 1748, three couples are to be seen: on the left a seated lady, holding a flower, is approached by a traveller with a spotted dog; in the centre the lady fishes, half turning to talk to a bewigged gentleman holding his hat; and to the right a lady holds a basket as her escort passes down an oversized pear in a manner that has suggested Phyllis and Corydon, fictitious shepherdess and shepherd in such works as the *Eclogues* of Theocritus or Virgil.

The fishing lady in the centre of Sarah Warren's picture is a mirror image of an early eighteenth-century playing-card in the Mary Flagler Cary Collection at Yale and it is possible that both were based on the same engraving. Sarah might have worked her design on a marked canvas bought from such an establishment as that run by Mrs Jeremiah Condy (died 1747) who advertised in the *Boston Evening Post* in 1742:

MRS CONDY opens her [needlework] School next Week and Persons may be supply'd with the Materials for the Works she teaches, whether they learn of her or not. She draws Patterns of all sorts, especially ... Screens, Pictures, Chimney Pieces ... for Tent-Stitch in a plainer Manner and cheaper than those which come from London.

Sarah Warren's panel is similar to an anonymous work in the Winterthur collection and also to one by Mrs Sylvanus Bourne of Barnstable, Massachusetts, now in the Museum of Fine Arts, Boston. Mrs Bourne's left-hand lady is spinning, a trio of sheep behind her; her central couple is positioned as Sarah Warren's but their clothing is different and her right-hand couple shows the man descended from the tree and escorting his lady, now carrying her wicker basket. In the anonymous Winterthur picture, the motif of fishing lady with escort is moved to the left of the picture, the central

A fishing lady, drawn from Mrs Sylvanus Bourne's panel, now in the Museum of Fine Arts, Boston.

Another rural scene in the Winterthur collection, initialled LI, from about the middle of the eighteenth century. *linen canvas screen panel worked in wool tent stitch, 24 × 21 in, 61 × 53.3 cm*

space is filled with a quartet dancing and it is the man on the right of the picture who holds the fruit, both on his head and under his left arm. In both of the other pictures Sarah's hunt scene is omitted altogether: Mrs Bourne filled this area with a duck pond while the anonymous embroiderer preferred two sheep on dry land. Birds share sky space with a butterfly in Mrs Bourne's picture; in the other they have replaced the butterflies; and in all three pictures the houses are different, as if illustrating the great variety of architectural styles of the middle of the eighteenth century.

The spinning lady in Mrs Bourne's picture is seen also on another Winterthur panel, dated 1745–55 and sometimes attributed to Nancy Coombs although it is initialled LI. Here a lady working with a hand-held drop spindle turns as, behind, a traveller passes with a spotted hound. A delightful panel, this work is unusual in that the design has obviously been specially accommodated to the shape of a screen panel with two semi-circular protuberances atop: since no major motif is guillotined the design was carefully planned to fill this unusual area. Unlike other 'Boston Common' or 'fishing lady' items there is a sense of proportion and perspective with no feeling of clutter: oak leaves are particularly carefully executed, some with darker shading outside and others with darker colours within, a delicate variation that indicates proficient workmanship.

A prolific output of canvasworks in the past and the immense popularity of this needlework form today mean that only the best pieces warrant attention. At Winterthur, the designs, the quality of stitching and the delicacy of shading all contribute to the high standards which make many of its canvasworks deservedly treasured.

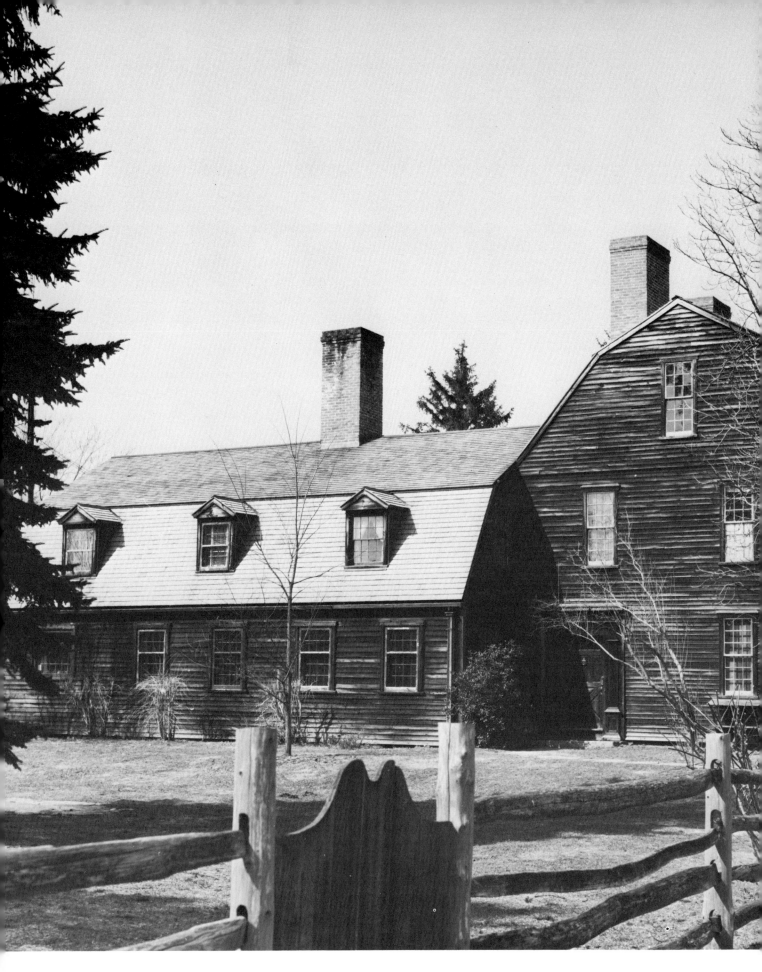

The Ashley house at Deerfield, Massachusetts, built in the
early 1730s for the Rev. Jonathan Ashley.

10

Historic Deerfield

Crewel Embroidery

 REWEL embroidery, another major needlework technique generally associated in America with New England, is to be seen in splendid profusion at Historic Deerfield, a township of eighteenth- and early nineteenth-century buildings mostly flanking a straight road on a mile-long plateau in western Massachusetts near the Connecticut and Deerfield Rivers. Once the home of Pocumtuck Indians, the area was settled in 1669 and was for some years thereafter the target of such destructive attacks as the 1675 Bloody Brook Massacre, when Indians ambushed a group of Deerfield farmers eating grapes beside a stream. Another famous attack was the Deerfield Massacre on Leap Year's Night, 1704: two tribes of Canadian Indians accompanying French soldiers overran the town's stockades, killing 48 residents and capturing 112 whom they took back to Canada via a harrowing march (recounted in *The Redeemed Captive Returning to Zion* by the Rev. P. John Williams, whose wife was scalped as she was too ill to travel quickly).

Although the French and Indian Wars continued until 1763 and Deerfield was a vital supply point, in the main the town enjoyed comparative peace. It was primarily a beef-farming and trading community and leading townspeople built imposing houses. Deerfield Academy, coeducational until 1940, was established in 1797 in a red brick building, now the home of the Pocumtuck Valley Memorial Association, organized in 1870 to record local history. The preservation cause was strengthened considerably after Mr and Mrs Henry N. Flynt's son entered the Academy in 1936. Realizing that timely action could accomplish the maintenance of buildings as records of the past and at the same time provide housing for the

Academy's faculty, the Flynts first expanded the Deerfield Inn and then purchased and restored houses which they partly furnished with their own collections of early Americana, which included outstanding items of furniture, silver, pewter, glass, ceramics and textiles. Of the last category, crewel, best seen in the Ashley house and the Helen Geier Flynt Fabric Hall, is most noteworthy.

The Ashley house, a forceful-looking timber building at the northern end of the west side of the street, was constructed for the Rev. Jonathan Ashley, a Tory Minister who lived here from 1733. Some years after his death in 1780, the main part of the house was removed and used as a tobacco barn; now restored to its original site, the Ashley house is furnished with many treasures, of which one of the first seen by visitors is a New England walnut wing chair, *c.* 1735, covered with sections of a contemporary coverlet worked in crewel embroidery.

Crewel, known variously as cruel or jacobean embroidery, is technically any form of needlework executed with lightly twisted two-ply worsted thread. The term is usually reserved, however, for floral designs worked in wool thread in a variety of stitches which includes buttonhole, long-and-short, running, satin and stem stitches, french and other knots and many couching and infilling forms. English settlers had brought with them to America sets of bed hangings which were sometimes decorated with crewel embroidery. English needlewomen had used twill ground fabric with linen warp and cotton weft and they embroidered particularly dense patterns, sometimes covering a large area with well-balanced branching trees arising from rolling terrain known as 'terra firma'; other designs were copied from such a pattern book as *A Schole-house For the Needle*, published by Richard Shorleyker (died 1639). It has already been suggested that at first women in America had little time for decorative needlework but by the early eighteenth century crewel was enjoying a certain following among embroiderers who decorated bed hangings, adults' and children's clothes and other items made of imported fabric or home-grown flax and locally produced wool. They dyed their own woollen threads, sometimes using indigo and yellowed ends from sheep's coats to produce the blue-green characteristic of much crewel embroidery.

At first American needleworkers emulated English designs, which they drew on fabric with ink often made of oak gall and rusty iron which sometimes subsequently rotted the fabric. Gradually, however, characteristics of American crewel began to emerge, especially in New England. 'New england couching' – also known as deerfield or self couching or flat or romanian stitch – was popular, the same thread used for working a straight stitch and then couching it. Surface, also known as one-sided satin stitch, was often employed: in this technique the beginning of a new satin stitch starts at the nearest point to the end of the last stitch rather than, say, parallel with the beginning of that stitch.

The bed in the north chamber of the second floor of the Ashley house is covered with late seventeenth-century English crewel hangings. *overall height of bed 84 in, 213.4 cm*

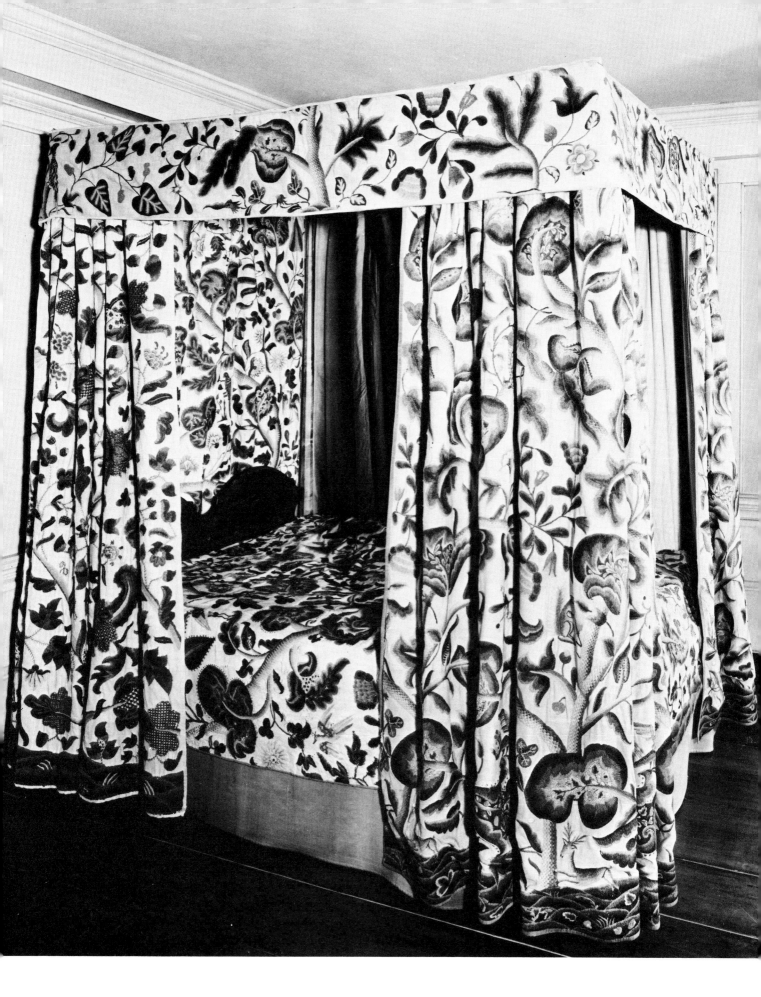

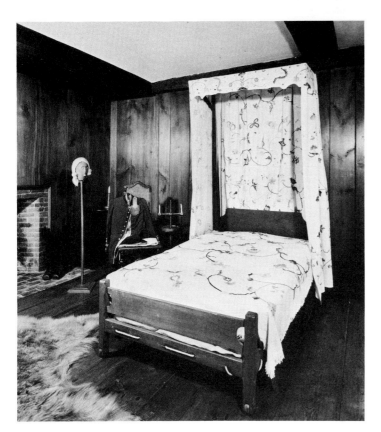

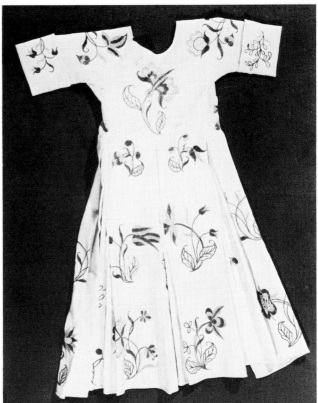

ABOVE LEFT The bed in the south chamber has half-tester curtains, headcloth and coverlet worked in America, mostly embroidered by Mrs John Ashley some time after 1769. The uniform hanging nearby, with buttons impressed 'Royal Marines Light Infantry', was taken from a British officer by a Whig nephew of the Rev. Jonathan Ashley.
bed 90½ in, 229.9 cm, high

ABOVE RIGHT Dress made in the eighteenth century for a girl of about six: after it was constructed thirteen larger and fourteen smaller floral sprigs were worked in two shades of indigo in stem stitch, couching, seeding and french knots.
length of white handwoven linen dress 24¾ in, 69.2 cm, at centre, side lengths are 26¾ and 27 in, 67.9 and 68.5 cm

OPPOSITE LEFT The seam of the dress is covered by embroidery, which indicates that the item was made up before being embellished.

In design, too, it is generally possible to distinguish crewel worked in New England from contemporary English items by a lightness of pattern with much of the basic ground uncovered, a difference that can be seen to advantage in two sets of bed hangings in rooms on the second floor of the Ashley house. A late seventeenth-century English set, for instance, comprising coverlet, headcloth, one tester valance and four side curtains, is elaborately worked in wools on linen and cotton twill in a variety of stitches that includes chequered brick filling to give shading to gracefully curving tree trunks growing up from neatly sectioned terra firma with frolicking deer. Eighteenth-century American hangings for a folding or press bed in another chamber, however, appear somewhat sparsely decorated; these were embroidered by Mary Ballantine, wife of Major General John Ashley (a relative of the Ashley house's first owner), whom she had married in October 1769. Mrs Ashley worked the main part of the embroidery but it appears, interestingly, as if another hand has executed the tester valance and a motif of a bird feeding babies found on one side curtain.

Looking hard at embroidery to determine whether or not it was worked by one person provides a challenge that is also offered by determining the order in which an item has been made up. In the Child's Room of the Ashley house, for example, is a six-year-old's dress obviously made before any embellishment was stitched because, as in the case of the Glamis hangings, the embroidery straddles seams.

Because wool can be ticklish it may seem extraordinary that such a young girl's dress should be elaborately decorated in this way, with thirteen large and fourteen smaller floral motifs worked in a variety of stitches. Even baby clothes, however, were sometimes embellished with crewel, as evidenced by a twill bonnet, now in the Sheldon-Hawks house: two small

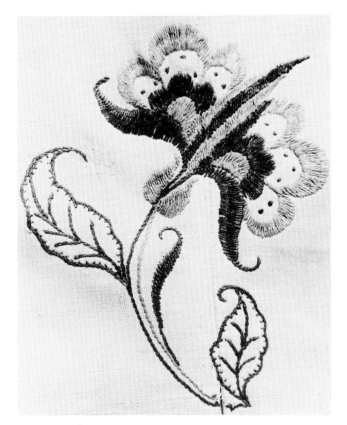

lappets extend from the main crown (which is decorated with little flowers), joined to the bonnet by a seam covered with a pair of rows of herringbone stitches worked one on top of the other.

One of the most attractive of the crewel pockets in the Deerfield collection can be seen in the Hall Tavern. Made by Molly Johnson Hawkes, a local lady who married in October 1779, the apron, initialled in tiny cross stitches worked on either side of the pocket slit which is bound with checked calico, has a front panel worked in two shades of indigo and cream in a roughly drawn scroll design. Another crewel example in the Tavern is a little drawstring reticule still holding tightly twisted skeins of different-coloured crewel wool, illustrating the meticulous care of an embroiderer who decorated even a simple holdall for her embroidery threads.

It has already been said, at Colonial Williamsburg, that larger areas such as bed curtains were sometimes re-employed as curtains. Another example of economy is provided by a coverlet in a second-floor bedroom of the Allen house: the coverlet has obviously been formed from a larger item as two left-hand spot motifs are both only half within the area. The embroidery is thought to have been wrought in about 1750 by the Rev. John Williams's grand-daughter, Esther Meacham Strong, wife of the Rev. Mr Strong of North Coventry, Connecticut.

Other coverlets in the Deerfield collection have more recently attracted re-employment or repair. Betsy Clark's 1767 work, for instance, now to be seen in the Dwight-Barnard house, was found discarded at the end of the nineteenth century. A new area of handwoven linen has been applied to its reverse and the replacement of missing motifs in three shades of brown, blue and green, almost indistinguishable from the original, mean that the coverlet is now resplendent with its overall design of flowing

Diagram of a motif from the centre of the Strong coverlet showing roses, carnations, tulips and berries growing from one root.

LEFT Detail of a headcloth worked in the early twentieth century by members of the Deerfield Society of Blue and White Needlework: the characteristic signature of a capital D within a spinning wheel can be seen.
linen head curtain embellished in three shades of indigo and one of yellow in cross stitches, stem stitch and couching, 77 × 62 in, 195·6 × 157·5 cm, overall

RIGHT Ellen Miller and Margaret Whiting, founders of the Society, travelled widely around the Deerfield area buying and sketching old examples of crewel embroidery. Here an old cheque book turned upside down has been used to support drawings of possible patterns.

foliage and urns. A veritable spread of coverlets can be seen displayed vertically in the Fabric Hall. Here is a bedspread worked by Abbiah Thomas of Duxbury, Massachusetts, with a delightful pattern that includes two peacocks with brightly coloured fully displayed tails. Nearby is a coverlet with a central design, executed in scraps of crewel wools, surrounded by patchwork of printed pink and white cotton pieces.

Although in general crewel embroidery lost most of its following earlier in the century, there was a specific local revival in 1896 when two women with strong social consciences, Ellen Miller (1854–1929) and Margaret Whiting (1860–1946), established the Deerfield Society of Blue and White Needlework to organize outworkers to help relieve considerable poverty in the area. To this end, they decided to 'get a return which should make the effort profitable; to produce the best possible work and to keep it up to that standard'. They worked out their costs so that 'the full price of each piece is divided into ten parts; five parts go to the embroiderer [who would be paid twenty cents an hour]; two parts to the designer; two parts to the "fund" which is used to pay running expenses of the Society and the one remaining part covers the expense of materials used'. Miller and Whiting decided to work with flax rather than wool thread to prevent possible moth damage. At first they worked with natural linen fabric from Kentucky costing fifty to sixty cents per yard but later they resorted to more plentiful Russian supplies. Their threads came from Scotland and were dyed by Deerfield women who, following tradition, first mastered the art of dyeing with indigo and later progressed to working with logwood, fustic and madder sometimes bought from Hartford chemists for ten cents an ounce.

Deerfield blue and white needlework was used to form small mats and

larger items, including coverlets, which can be identified by their colouring, generally blue on white, and also by distinguishing meandering patterns signed with a capital D surrounded by a spinning wheel. Miller and Whiting studiously researched the designs for these items, and after driving through surrounding countryside they were frequently invited into some home for refreshment and conversation, where perhaps they would be shown family heirlooms that they would buy or at least copy, sometimes paying up to ten dollars a time in order to make a tracing. They continually made notes, drawing on whatever bit of paper was at hand. They took actual embroideries to pieces, minutely examining the stitching with a magnifying glass. During a search through an old trunk in an attic they came across a small watercolour inscribed 'Olive Curtiss, Granville, Massachusetts 1798' and also an area of grey paper marked in charcoal with a flowing design, probably for a bed rug. Margaret Whiting enthused especially over this pattern, in which a plant springs from a large heart with an outer border of flowers and hearts: 'Nothing could be better or more individual than this fine and simple design. . . . The Society will copy the design exactly, but with a careful consideration of the best manner of displaying its richness of invention in the choice of material and needlework.' True to her predictions, a copy of the bed rug designed at the end of the eighteenth century was worked over a hundred years later and sometime afterwards it was given for display, with accompanying side curtains, in the Frary House, where it can still be seen in the South Chamber.

The Deerfield Society of Blue and White Needlework was disbanded in 1926, partly because Margaret Whiting was losing her sight and also because both she and Ellen Miller felt standards of commercially produced work had in general considerably improved. They had as far as possible completely recorded the heritage of crewel embroidery in Deerfield and they and their outworkers had produced a prolific supply of twentieth-century items, providing ample research material for future students.

Drawing of a motif on a coverlet now in the Frary House and worked by the Society from a paper pattern probably drawn by Olive Curtiss Baker pre-1800.

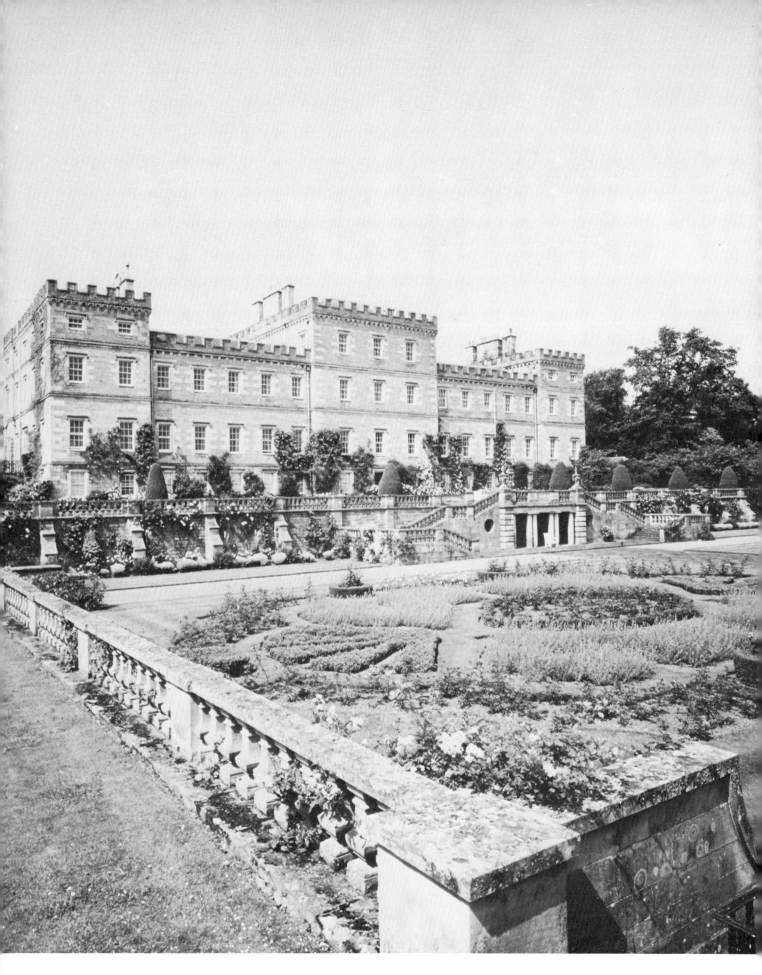

Mellerstain, Berwickshire.

11

Mellerstain

A Children's Masterpiece

HE work of children may attract more than a merely emotional interest. In the unique silk and wool tentstitch picture known as 'the Mellerstain panel' (*see Plate 20*) it is possible to study the exercise of two young girls and their governess who in 1706 transposed designs from a pattern book which now belongs to their descendants.

The scene is set at Mellerstain, Berwickshire, one of the most beautiful houses in Scotland. Architecturally unusual in that its outer wings were designed by William Adam (1689–1748) in 1725, nearly half a century before his second son Robert (1728–92) built the core of the house for Lord Binning, some of Mellerstain's glorious rooms may sound outrageous but in practice they are utterly exquisite. In the Library, for instance, a moulded green, pink and white ceiling is, according to Adam's design, highlighted with oil representations of Minerva, Teaching and Learning. A decorated frieze beneath is foil for plaster busts by Roubillac (1695–1762): two busts are of especial interest within the context of this anthology as they are of Lady Grisell Baillie (1665–1746) and her elder daughter, Lady Grisell Murray (1693–1759), who with her sister Rachel (1696–1773) and their governess, May Menzies, worked the Mellerstain panel, brought into the Binning family when Rachel married Charles Binning in 1717.

The girls' mother was a fascinating character. Daughter of Sir Patrick Hume, later first Earl of Marchmont and Lord Chancellor of Scotland, she had as a child to help support her family while her father was in hiding in the Netherlands under the ban of the Test Act. Sir Patrick returned to Britain with the Prince of Orange (1650–1702) when the latter accepted an invitation to rule Great Britain as William III in 1688, and Grisell later

Grisell, Lady Murray, by Maria Verelst (1680–1744). *portrait 49½ × 40 in, 125·8 × 101·6 cm*

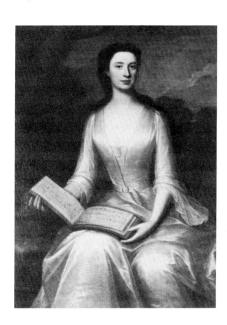

The title page of Thomas Johnson's *A Booke of Beast, Birds, Flowers, Fruits, Flies and Worms, exactly drawne with their Lively Colours truly Deſcribed*, published 1630: it shows Orpheus surrounded by beasts.
hand-coloured engraving
$6\frac{3}{8} \times 8$ in, 16·2 × 20·3 cm

married one of her father's companions, George Baillie of Jerviswood (1664–1738), whom she had first met when she was twelve. It was because of her experienced note-taking for her father that Lady Grisell Baillie was subsequently able carefully to document the accounts of her busy family, for Baillie was elected to parliament as Member for Lanarkshire. Since she was also a creative writer of some renown (she is listed in the *Concise Universal Biography* as a 'writer of prose and verse') she was well equipped to provide the notes that today aid elucidation of the canvaswork panel.

May Menzies, daughter of William Menzies of Raw, eight miles south-west of Mellerstain, was appointed in 1705 to 'wate on' Grisell and Rachel (Lady Grisell's first child, a son, had died in infancy) at a salary of eight pounds per annum. Their new governess found that the children were already acquainted with strict discipline. Their daily routine included

To rise by seven a clock and goe about ... duty of reading etc. etc. and be drest and come to Breakfast at nine, to play on the spinet till eleven, from eleven till twelve to write and read French, at two a clock sow ... till four, at four learn arithmetic, after that dance and play on the spinet again till six and play herself till supper and be in bed at nine.

The children were, therefore, already drilled in some of the accomplishments required of gentlewomen at the beginning of the eighteenth century.

Their new governess brought with her a wealth of ideas contained within one loosely bound leather-covered volume, $7\frac{1}{4} \times 9\frac{1}{2}$ in (18·4 × 24·1 cm), containing twenty-one pages, nineteen of which are formed of hand-coloured engravings neatly numbered, pages fifteen and sixteen transposed, and all but one, page twelve, marked 'May Menzies'. The leather cover is embossed back and front with the initials of Katheren Logan, Miss Menzies' maternal grandmother, to whom the volume had once belonged. Further inscriptions inside the front cover record: 'May

Menzies aught this book / which contains 19 painted / leaves ... five people; prints and / flowers ... 1732' and 'originaly [*sic*] belonged to my grandmother / Katheren Logan' and, also, 'this book doth appertain to Katharin [*sic*] Logan / Julie 27 1635'. Single sheets of engravings could be purchased and the book must have been put together sometime between 1630, the date of one of the engravings, and 1635, the earliest inscription. Many of the engravings were at some point hand-coloured: red segments in particular have been applied with considerable smudging in some instances.

The first five pages are engravings 'Sould by Thos. Ienner at the Exchange', of the five Senses shown as women in country dress in the style of Wenceslas Hollar (1607–77) and thought to be copied from a Dutch prototype. 'Taste' is represented by a woman with a pipe and the legend:

> *Som with the Smoaking Pype and quaffing Cupp*
> *Whole Lordſhips oft have swallow'd and blowne upp:*
> *Their names, fames, goods, strengths, healths & lives still waſting*
> *In practising the Apiſh Art of Taſting.*

This page, indeed, offers a suitable foretaste of the erudition being offered to Grisell and Rachel Baillie through the contents of their governess's book. 'Vanity' comes next, inscribed:

> *To See a Churle, a Bawd, a Theife, a Whore*
> *Or Drunkard, People oft goe out of Dore*
> *When as they neede not from their Chambers passe*
> *But Early may See them in their Glasse.*

The third engraving, 'Smell' (*see Plate 21*), is of direct interest to a study of the needlework panel. This design, similar to but less curvaceous than a lady on a seventeenth-century Mortlake tapestry now at Haddon Hall, Derbyshire, is annotated:

> *There are a Crew of fellowes I Suppoſe*
> *That angle for their Victualls with their nose*
> *As quick as Beagles in the Smelling Sense*
> *To Smell a feaſt in Paules 2 miles from thence.*

After the two final Sense pages, 'Smell' and an old lady, 'Feel', pleading 'O pitty mee, my Bird hath made mee bleede', comes the title page of *A Booke of Beast, Birds, Flowers, Fruits, Flies and Wormes, exactly drawne with their Lively Colours truly Deſcribed*, inscribed 'Orpheus / Ar to be sould / by Thomas Johnson / in Brittaynes / Burse / 1630'. Interestingly, among the many beasts surrounding Orpheus is a lion similar to that described at Dearborn. Thereafter follow thirteen engravings from the *Booke* and two clean sheets of white paper.

May and her young charges must have planned their needlework panel

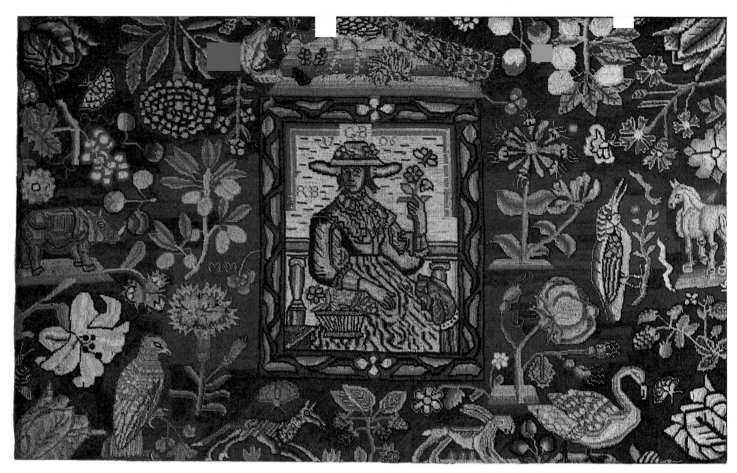

Plates 20, 21 and 22
(above) 'The Mellerstain panel' is named after the superb Adam house owned by the descendants of Rachel Binning, one of the two little girls who, with their governess May Menzies, worked this unique tentstitch canvaswork in 1706. The centre design was copied from a hand-coloured portrait (right), 'Smell', possibly a Dutch engraving and one of nineteen plates in a loosely-bound volume that had belonged to May Menzies' grandmother as early as 1635. Another of the clearly-numbered pages in the pattern book (left) includes the stalwart rhinoceros stitched on the panel.

There are a Crew of fellowes I suppose,
That angle for their Victualls with their nose
As quick as Beagles in the smelling sence
To smell a feast in Paules 2 miles from thence.

LEFT With two exceptions all the motifs around the central 'Smell' lady are taken from the other thirteen pages of engravings in May Menzies' pattern book. Corners of the panel are filled with tulips copied from page 19.
all these engravings are
$5\frac{5}{8} \times 8\frac{1}{8} in$, *14·3 × 20·5 cm*

RIGHT Page 8 of the book provided the peacock at the top of the panel; it must have been a reminder of the bird the two girls' mother had bought the previous year.

very carefully. They probably transposed motifs by placing the canvas on top of the pages, for the embroidered motifs are the same size as the engraved patterns, some of which, anyway, show signs of linear indentation as if canvas had been laid above and drawn on. The embroiderers would then have put the canvas in a frame, for there is no sign of distortion, and outlined the pattern in dark brown before infilling in brightly coloured silks and wools and working the reserves in different shades of dark blue-green wool.

The centre of the panel is occupied with a representation of the 'Smell' lady framed by a delightful scrolled border. She smells one flower, holds others in her basket and, above the dog copied from the engraving, the Baillie girls and their governess added a charming butterfly as accompaniment. The four outer corners of the canvas are occupied by tulip heads, and the rest of the area is mostly filled with motifs also taken from the book and fitted in at whatever angle was most convenient. The two pariahs, at either side of the bottom of the central Smell panel, are a dog and hare. More crudely drawn than their companions around, and not taken from the pattern book, they may have been copied from a finished needlework (there is a similar dog, for instance, on the Milton Manor needlework box) or, everyday sights, they may have been drawn from life.

The other motifs, however, can all be identified from the book. A turtle dove watches the dog while, above, a rhinoceros just makes his way into the picture (*see Plate 22*). On the right side a graceful swan (*see Plates 23 and 24*) is set beneath a kingfisher fitted into the available space. A small horse, his head turned, and a carnation illustrate the fact that some motifs have been reversed from the pages of the pattern book. In one instance, at the top of the panel, a whole vignette including a splendid peacock (a reminder of the bird that Lady Grisell had purchased the year before) is a complete facsimile of the book's eighth page, which also provides the design for the 'Dubble french Marigold Flos Aphricane', trans-

formed into a cream flower placed upside down on the panel, and '*Olea Latenae Oluies*', next to the governess's initials. A whole garden of flowers is portrayed. In nearly every case they represent flora of a typical elegant Scottish garden at the beginning of the eighteenth century; the two exceptions, the olive and vine, could have been included to symbolize peace and concord or, in contrast, the sins of gluttony and drunkenness. Among the few queries that remain about this panel is why the lion, so popular with other embroiderers, is surprisingly excluded.

Grisell and Rachel must have learnt much while working on the panel but doubtless, as with young embroiderers everywhere, they would have been relieved when they were able finally to embroider their initials, GB and RB, along with those of their talented governess, MM, and the date 1706. Through the execution of this canvaswork, so full of interest and worthwhile study, they had however furthered their knowledge of flora, fauna and Latin and prepared themselves for their future roles as educated ladies. Heiress to her father's fortune, Grisell married, at the age of seventeen, Alexander Murray, son of Sir David Murray of Stanhope and Lady Anne Bruce, daughter of the Earl of Kincardine. Murray had been educated overseas but, as his wife later wrote, 'it was soon discovered that under a pleasing exterior there lurked a dark, moody and ferocious temper'. May Menzies broke the news of Murray's uncontrollable moods to Lady Grisell Baillie; Grisell Murray was granted a divorce when she was twenty-one. Thereafter she spent most of her time with Rachel, who had married Charles Binning in 1717. Literate and erudite, Grisell numbered among her friends at this time that great woman of letters Lady Mary Wortley Montagu (1689–1762) and the poet John Gay (1685–1732) who described her as 'the sweet-tongu'd Murray'.

After George Baillie's death in 1738 Grisell succeeded to his lands 'subject to the life-rent of her mother, Lady Grisell Baillie ... for the special love, favour, and affection he had, and bore to her, and in consideration that she had been to him a most loving, affectionate and useful wife'. Her mother died in 1746 but thereafter Grisell continued to live with Rachel and her family, which included May Menzies who looked after Rachel's children in turn, and on her own death, in 1759, the estates passed to Rachel's second son George, who assumed the name of Baillie and built the main part of Mellerstain.

Plates 23 and 24 Another page from the Mellerstain pattern book (below) includes a swan, copied on the right-hand side of the panel shown here in detail (right). All but two of the motifs used by Grisell and Rachel and their governess have been exactly identified.

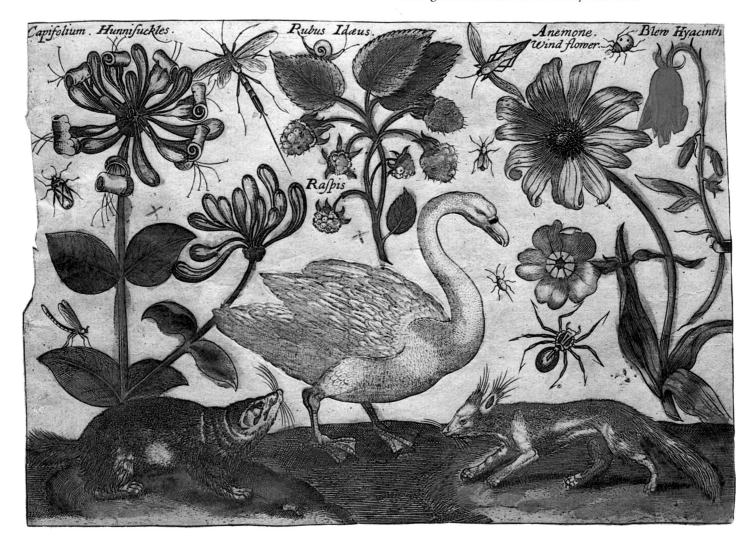

Capifolium. Hunnifuckles. *Rubus Idæus.* *Anemone. Wind flower.* *Blew Hyacinth*

Rafpis

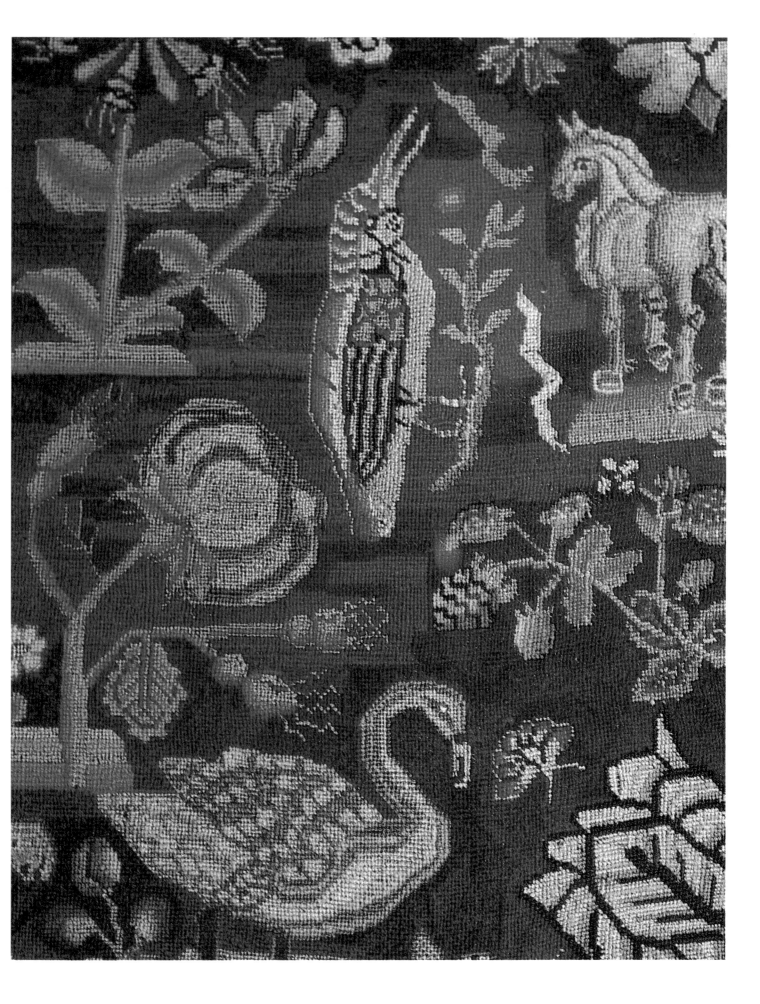

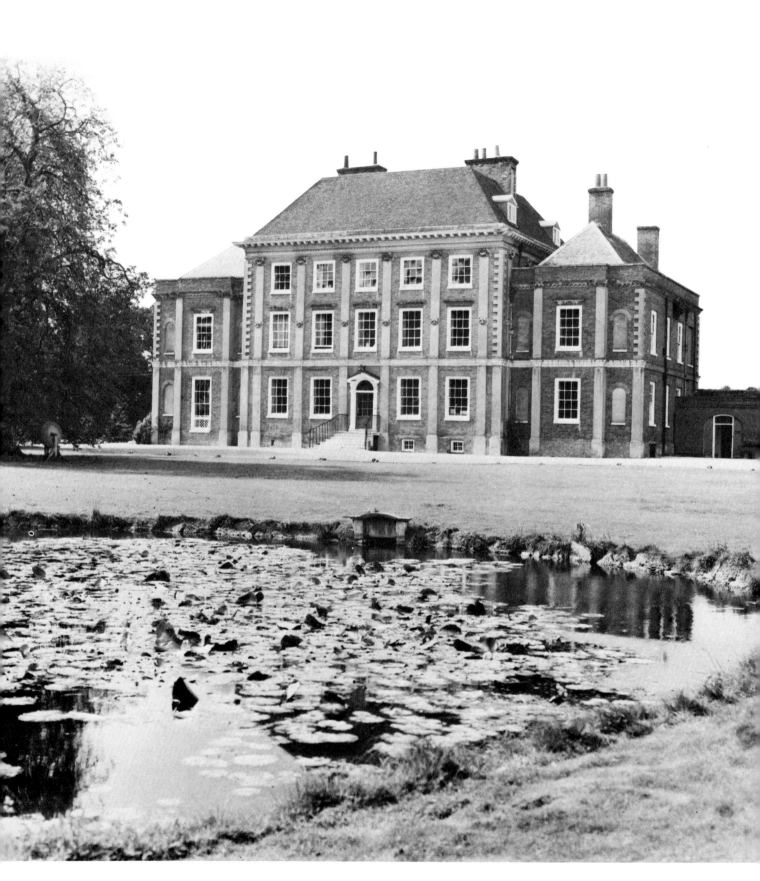

Milton Manor House, Oxfordshire.

12

Milton Manor House

An Exquisite Needlework Box

EEDLEWORK boxes, miniature chests or cabinets, some-
times known as caskets, with embroidered panels
generally on every facet, are especially associated with
the seventeenth century. Such a box, worked in about
1670 and now belonging to the Mockler family at Milton
Manor House, Oxfordshire, is a supreme example of this
art and, furthermore, it has a fascinating story to tell.

Milton Manor House, in flat English pastureland twelve miles south
of Oxford, was built in 1663, possibly from plans drawn up by Inigo Jones
(1573–1652). A hundred years later, the elegant three-storey brick house
was purchased by a London lacemaker, Bryant Barrett, who used nearly
three-quarters of a million bricks to construct two wings and outbuildings.

Still very much the private home of a Barrett descendant and her family,
Milton Manor House is especially beautiful for its Gothic library, with
elaborate ogee arches and pediments, and its late eighteenth-century first-
floor chapel, conveniently near to the master bedroom and still regularly
used by the family.

The fact that owners of beautiful houses today usually care passionately
about their possessions is a vital element of the heritage of embroidered
and all decorative arts: in this instance, Marjorie Mockler enthuses over
her memorable teapot collection, started in 1967 and numbering over a
hundred and fifty examples from all parts of the world. She is equally
enthusiastic about her needlework box, its panels probably embroidered
by an English girl in about 1670. One of the loveliest examples of needle-
work boxes, it is 6⅝in (16·8 cm) high, 13⅜in (34 cm) wide and 9⅜in (23·8 cm)
deep. The 1½in (3·8 cm) high lid opens upwards, held in place by two silver

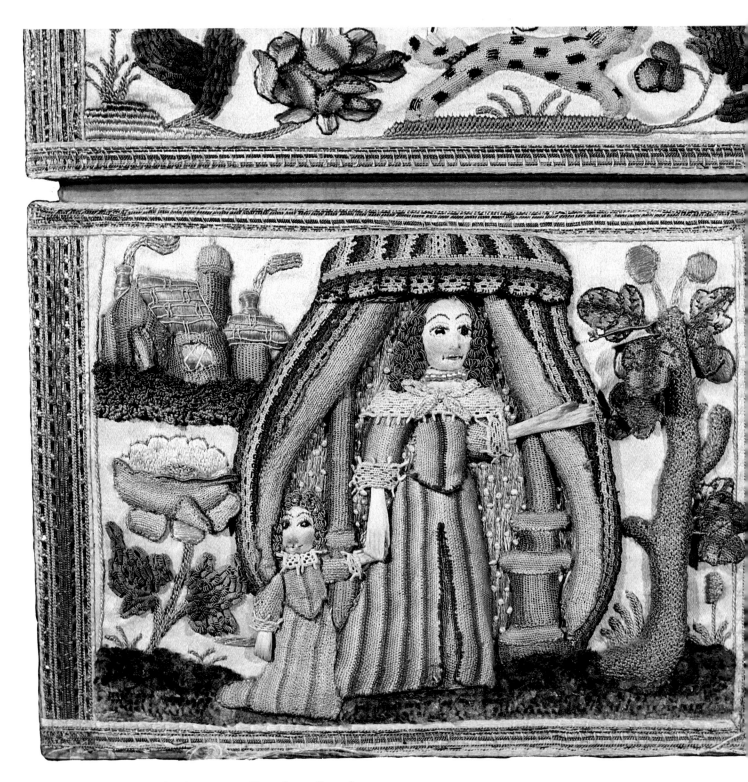

Plate 25 The front of Milton Manor House's needlework box, worked *c.* 1670. The lid and two hinged doors open to reveal pink velvet interior fittings, and all outside facets are embellished with white satin panels which may have been embroidered by a young English girl. The two door panels are formed of raisedwork (stumpwork). Here the story is told of the banishment of Hagar and Ishmael: Sarah, her young son Isaac peeping from behind, watches Abraham send Sarah's maid Hagar and her son Ishmael into the desert of Beersheba.

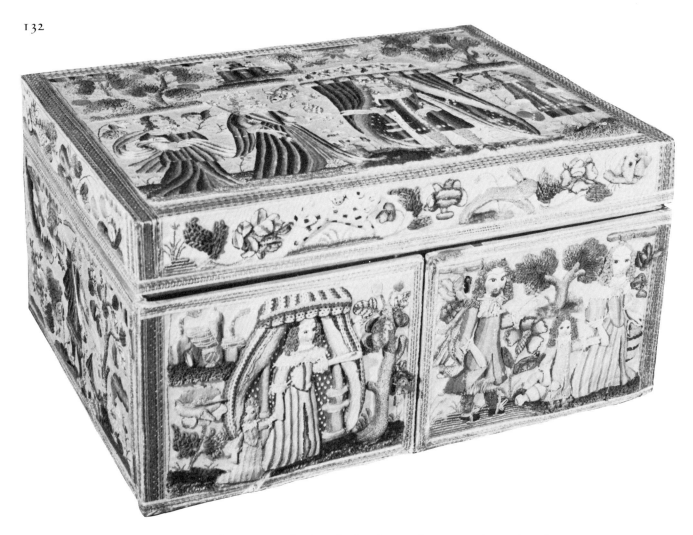

The needlework box or 'casket', worked *c.* 1670. *exterior facets covered with embroidered white satin panels, overall dimensions* $6\frac{5}{8} \times 13\frac{3}{8} \times 9\frac{3}{8}$ *in,* $16 \cdot 8 \times 34 \times 2 \cdot 38\, cm$

hinges attached to the back panel, to reveal two bottle compartments, perhaps for perfume, and other storage. The front facet of the main body of the box is formed of two doors with side hinges which open to show three drawers, their fronts (like the insides of the lid, doors and other interior fittings) covered with pink velvet. In all there are ten different panels of needlework attached to the outside of the box: five panels embellish the lid and the rest are on the main body. They are all formed of white satin liberally embroidered and held peripherally to panels of the wooden box with silver braid.

A needlework box was mentioned in 1614 when the Inventory of the Earl of Northampton included 'a riche embrodered Cabinett in colours' valued at ten pounds. Earliest examples are usually tall, sometimes with trapezoidal lids and standing on four bulbous feet of painted wood or metal. The lid may open to reveal a deep cavity decorated with a mirror, a coloured engraving or even an upstanding miniature garden of silk and metal trees and flowers. Front doors of the main body invariably open tò show the small drawers seen in the Milton Manor House box and there may be a secret compartment behind: embroidered panels possibly attached to the insides of doors and to the fronts of drawers are sometimes embellished with family crests. Gradually styles of boxes changed. Possibly in order to cut down the labour involved both in painstaking embroidery and also in making up the item, complicated proportions were eschewed

in favour of simpler rectangular boxes with less elaborate decoration outside and in. Boxes dating from the later part of the seventeenth century, therefore, are usually flat-topped and, as in the case of the Milton Manor House piece, there is no embroidery inside.

Dating of boxes can also be facilitated by the style of embroidery employed. Many are decorated with raisedwork, not usually practised in England until *c.* 1640. Popularly called 'stumpwork' (a name probably coined by Lady Marian Alford, 1817–88), raisedwork is characterized by miniature motifs, generally of people or animals, preformed and applied to a ground of white satin already stamped, 'on the stamp', with an outline design. Motifs could be formed over wood or over a padding of wool or hair held to linen held taut in a small frame. Padding would be covered with needle-lace (fine buttonhole) or burden stitch, a technique which implied long parallel stitches couched at right angles with neat stitches worked over one, two or three of the couched threads in regular interlocking formation. Free-standing segments could be formed from open buttonhole stitch worked within thin wire frames barely attached to main motifs. Linen was then carefully cut a short distance outside the edges of finished motifs; the raw linen edges could then be waxed to prevent fraying before being turned under so that motifs could be applied within outline designs stamped on the satin, held in another frame.

Raisedwork can be formed in the following manner: (left) the outline of a motif is drawn on muslin or calico which is then held taut in a frame, and parts of the shape are padded (see shaded areas), say with cotton wool held in place with long retaining stitches; (right) stitching is then worked over the padding. Here the woman's face, neck and arms are executed in split stitch and her hair in french knots. The gown is worked in one form of burden stitch (see enlarged detail): long parallel stitches are laid above the surface aligned with the flow of her robe and these stitches are then secured with rows of couching stitches as illustrated. Strips of lace are applied for collar, cuffs and bow, and pearls are sewn around her neck. When all the decoration is complete, the muslin is cut about a quarter of an inch outside the edge of the motif, small V-shaped slits are made to accommodate curves and the surplus is turned under before the motif is applied to a white satin ground.

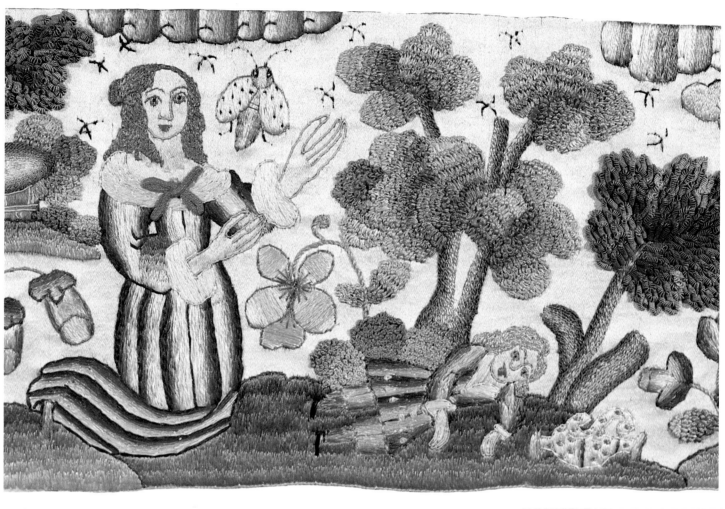

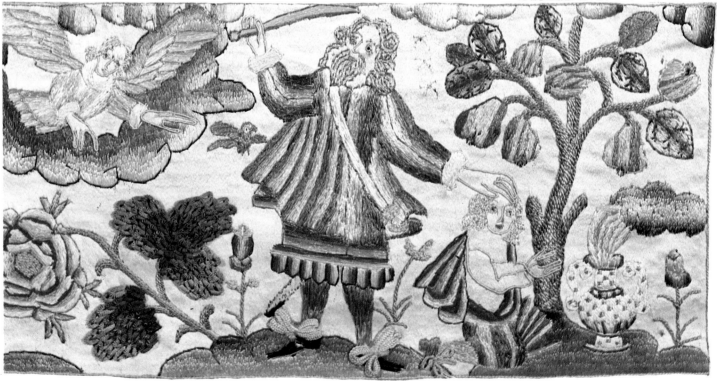

Plates 26, 27 and 28 Continuing the Genesis story, the back panel of the Milton Manor House box (opposite top) shows the banished couple in a lush-looking desert. One of the end panels of the box (opposite bottom) is after an engraving of Abraham about to slay Isaac, published by Gerhard de Jode in 1585, evidence of embroidery's interrelation with other art forms. (below) This smartly dressed lady stands in front of a castle highlighted with windows made of tiny bits of applied mica. The lion behind her is one of a breed of friendly beasts often portrayed by embroiders in the past.

Subsequent embroidery would then be worked direct on to the satin, partly infilling reserves around applied motifs.

It is thought possible that nuns at Little Gidding popularized the art of raisedwork embroidery, adapting the style from high relief embroideries from Spain, Germany and Italy, the last of which were sometimes so elaborate as to look like gilt gesso. Whatever the source, it is plausible to assume that, from about 1640 onwards, girls in England were taught to work rich designs following the edicts of William Laud (1573–1645), the Archbishop of Canterbury who will be seen, at Parham Park, to have had such an effect on English needlework.

When a set of raisedwork panels was completed, it might be taken to a professional cabinetmaker to be made up into a box highly prized by its owner: alternatively it could be framed as a simple picture or as a looking-glass surround. Many raisedwork examples have fortunately been treasured but most have suffered over the years, for it is always more difficult to preserve a three-dimensional item than a flat picture. The Milton Manor House box is without doubt one of the most beautiful of its kind still in private hands. The marvellous coloured embroidery has retained its glory for over three hundred years (*see Plates 25, 26, 27 and 28*), and each panel of the item has an intriguing tale to recount.

The two front-opening doors are decorated with raisedwork illustrations of the banishment of Hagar and Ishmael (one of the biblical stories told in detail at Parham Park). On the left, by the striped tent ubiquitous in raisedwork pictures, Sarah is watching as her son Isaac peeps from behind her skirts. Both wear long striped gowns embellished with needle-lace collars and cuffs and their hair is abundantly curly. A large cream rose, one wire-framed petal scarcely attached to the whole, rises to half the tent's height and, behind, smoke rises from the chimneys of a little house. Sarah and Isaac are watching as Abraham, seen on the right door, banishes her handmaid, Hagar, with her son, Ishmael. Abraham sports a curled wig and cravat tied in box-style; his grey knee-length coat with tiny pearl buttons is slightly open to show golden fringes around the bottom of his knee breeches, evoking memories of satirist William Wycherley's gentleman dancing-master in his play of that name: 'While

Drawing of another version of the banishment, now to be seen in the Victoria and Albert Museum: Abraham wears a black hat and loose robes as he bids farewell to Hagar, carrying bread and water, and her son Ishmael.

A deer motif on the Milton Manor House box.

Another version of Hagar and Ishmael in the desert, drawn from a panel in the Victoria and Albert Museum. The saving well can be seen behind Hagar.

LEFT Another facet of the box shows Abraham about to sacrifice Isaac.

RIGHT The design for the sacrifice of Isaac has been traced to a 1585 engraving in Gerhard de Jode's *Thesaurus sacrarum historiarum veteris testamenti.*
engraving 10⅛ × 8¼ *in,* 25.7 × 21 *cm*

you wear pantaloons they make thee look and waddle (with all those gew-gaw ribbons) like a great fat slovenly water dog.' Hagar is wearing a golden brown and cream striped dress like that worn by Isaac, and Ishmael is clothed as a miniature Abraham. According to the story, Abraham took 'bread and a bottle of water and gave it unto Hagar, putting it on her shoulder, and the child, and sent her away: and she departed, and wandered in the wilderness of Beersheba' (Genesis 21:14). Here the embroiderer has preferred to have Hagar carry the bread in a basket.

All the other panels on the box are formed of flat embroidery worked direct to the white satin. The Genesis story is continued on the back panel, where Hagar is seen praying while Ishmael sleeps. Water and bread all spent, God appears from a cloud and points to a well. Hagar, incongruously, appears by now to have changed from the golden to a blue striped dress, although her son wears his former attire. His water pitcher, now empty, has been transformed from a blue and white striped jug to one with blue spots. And, indicative of the fact that young embroiderers of the late seventeenth century knew little of either foreign terrain or its animals, the desert is lush with green grass and foliage, with deer and a resplendent lion (perhaps distantly related to the beast at Dearborn!).

On the left end panel Abraham is seen about to offer Isaac in sacrifice. He stretches forth his hand and an angel appears to prevent the slaughter of the small boy, seen here as a chubby blond-curled fellow partly covered by a floating red striped scarf. The design alignment of Abraham, Isaac and the angel in a magnificent blue cloud is more or less identical to an unfinished panel at Dearborn and also to a magnificent picture in the St Louis Art Museum, Missouri, which has been identified as being taken from Gerhard de Jode's *Thesaurus Sacrarum Historiarum Veteris Testamenti*, published Antwerp 1585.

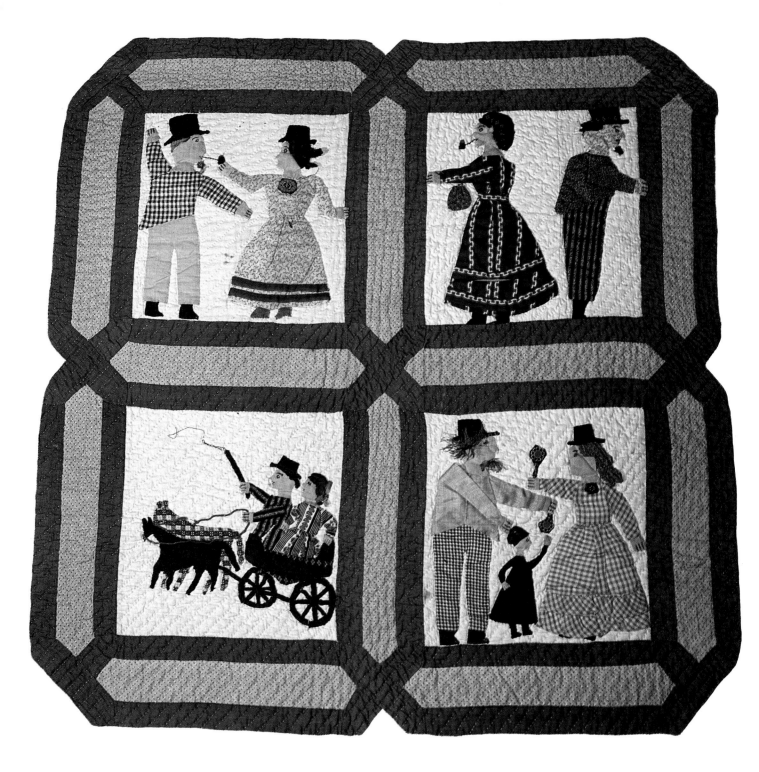

Plate 29 (above) Embroiderers sometimes portray everyday scenes such as these, captured in Morrow County in the early 1870s and immortalized on a coverlet now belonging to the Ohio Historical Society.

Plate 30 (right) 'The Pride of Ohio', a coverlet finished in 1962 that includes recognition of a State son, John Glenn, whose birthplace in Muskingham County is marked with a star. State seals, birds and flowers can also be seen.

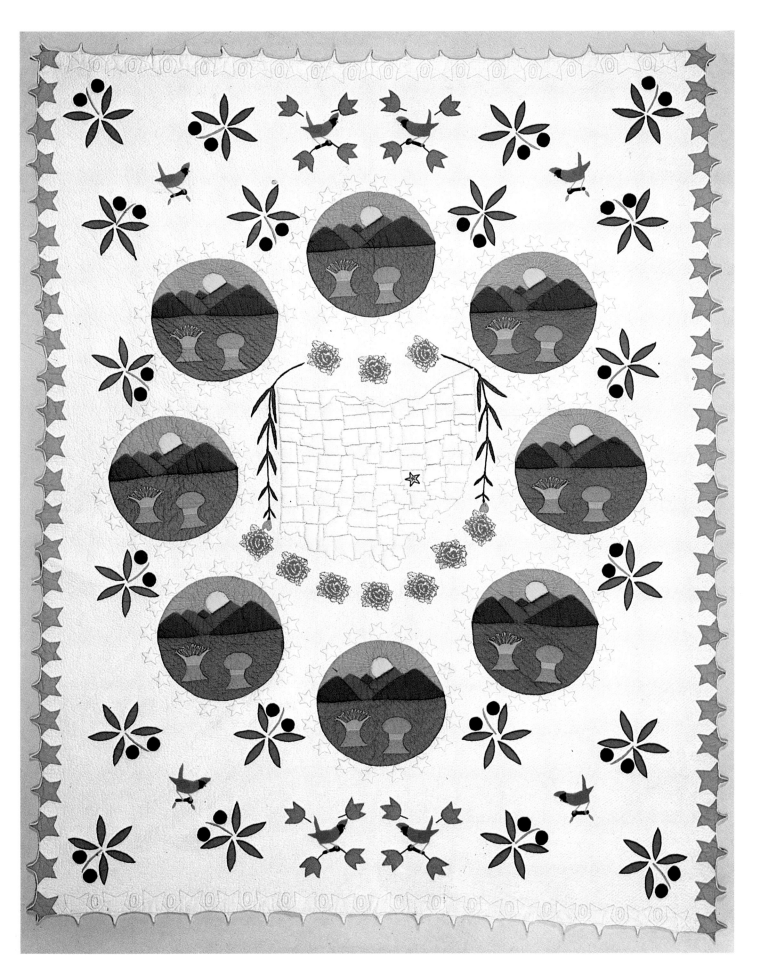

RIGHT One end panel of the
Milton Manor House box is
mostly occupied with the
meeting of a lady and
gentleman who holds over his
arm extended hangings from
the tent behind him.

BELOW The top of the lid of the
box portrays a meeting
between Charles II and
Catherine of Braganza, or
Solomon and the Queen
of Sheba.
lid 9⅜ × 13⅜ in, 23·8 × 34 cm

Other designs on the box, not necessarily following Genesis, are likewise familiar to embroidery historians. The right-hand panel, for instance, shows a gentleman and lady in fashionable clothing meeting before another blue and white striped tent in front of a house. On the box's lid two other people, more regally dressed with pearl-studded crowns and sceptres, could signify a meeting between Charles II (1630–85) and his queen, Catherine of Braganza (1638–1705), or, to return to biblical association, between Solomon and Sheba. Whatever his identity, the king wears a short brown and cream coat as he stands within a bright green striped tent to greet the queen, who is clothed in a blue striped gown with golden petticoat and long red and white striped train held by an attendant.

The four facets of the box's lid sides are, typically for their proportions, filled with random motifs that complement the designs on larger panels without offering too much diversion. Here flowers, birds and animals moving to the right are set in formation around the box as if to form a frieze. Working rabbits, dogs and strawberries on these smaller panels must have been particularly enjoyed by the embroiderer of the box. She, whoever she was, retains her anonymity, but it is safe to assume she was English, young and from a prosperous family that enabled her to acquire biblical and biological (if not geographical) learning. She had time and patience to work all the panels for, despite an inconsistency in some of the motifs' clothing, there is throughout a uniformly high standard of stitching.

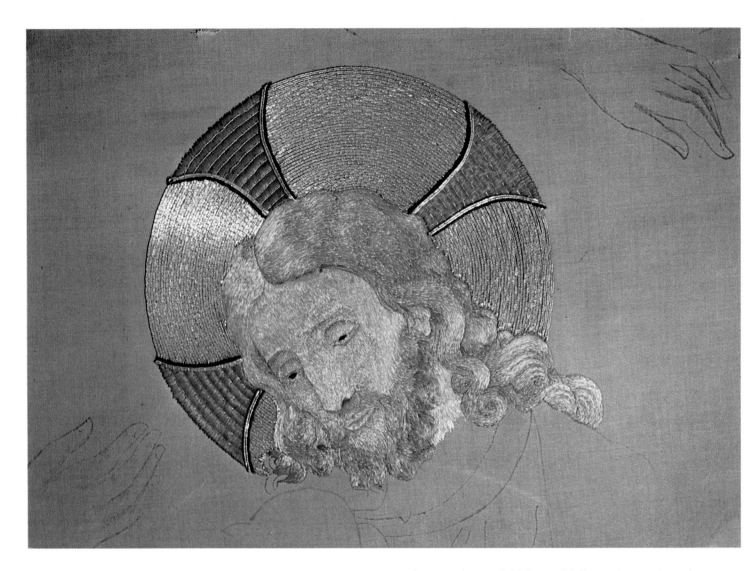

Plate 31 (above) Skilful use of different forms of couching is illustrated on this portrayal of Christ which decorates a burse in the National Cathedral. Church embroidery plays an important role in the heritage of decorative needlework.

Plate 32 (right) This bicentennial frontal for the National Cathedral's high altar was designed and worked by Connie Eggers. Leading up to it is a basketweave canvaswork carpet designed by the Misses Tebbets and worked by Pittsburgh embroiderers.

South view of the National Cathedral, Washington D.C.

13

The National Cathedral

Ecclesiastical Decoration

ROM the beginnings of its history in the western world embroidery has been intricately linked with religion. It seems appropriate, therefore, to concentrate now on the needleworks within Washington DC's Episcopal Diocesan Cathedral of St Peter and St Paul, the National Cathedral of America.

Standing proudly on Mount St Alban at 676 feet (206 metres) above sea level, the highest point in Washington, the Gothic-style building built of limestone from south-east Indiana physically dominates much of the city. When finished, it will be the sixth largest cathedral in the world. A liberal charter was granted by the United States Congress in 1893 and the purchase of fifty-two acres was completed in 1905. Architects George Frederick Bodley and Henry Vaughan, a Boston student of Englishman Sir Henry Scott, collaborated on a project designed, like cathedrals of the past, to involve separately constructed areas. The first, a girls' school, was begun in 1899 and in 1905 the corner-stone was laid for a boys' school, Lane Johnston Cathedral Choir School, later to become St Albans. Two years later the foundation stone of the main cathedral was laid, and building continued according to plan, although after Vaughan's death in 1917 the firm of Frohman, Robb and Little took over and in 1921 Philip Hubert Frohman was appointed sole architect, a position he was to retain until his death in 1972.

Perhaps paradoxically this is a both serene and active cathedral: tall Gothic vaultings effectively absorb much of the noise, and guides in purple robes show round visitors from all parts of the country without causing an intrusion. The National Cathedral is an embodiment of tradition that

establishes a heritage for all art forms, including needlework. Traditionally crosses and many other symbols have been employed to decorate Christian vestments, fine linen altar frontals and other hangings, including banners, chair, pew and stool covers, kneelers and carpets. Much of the early needlework specifically executed for the cathedral was organized by Lucy Vaughan Hayden Mackrille (1863–1954), head of the Cathedral Altar Guild from 1900 until 1948. She had studied with the Community of St Mary the Virgin in Wantage, Berkshire, an Order renowned for careful intricacy in many art forms, in Kilburn, north London, and with the All Saints Sisters in Baltimore. She felt strongly that 'as a daughter of the Mother Church, the Church of England, this glorious heritage is ours. Let us claim it; and retrieving the lost years make for the American Church a name for the beauty and order of worship.'

She was, accordingly, instrumental in establishing a high standard of embroidery. She concentrated on marrying fabric and colour by marvellously delicate stitchery, personally helping to decorate chalice veils, altar frontals, banners, vestments, exquisite whitework altar cloths and napkins, and burses, including four with symbols of the evangelists. Another of her burses shows the Agnus Dei, Lamb of God, portrayed on a sky-blue background and standing on flowers and grass. Here her particularly subtle use of stitches is illustrated by long-tailed french knots providing a curly fleece for the lamb and by reserves filled with italian couching in which close parallel threads are held by other widely spaced threads laid across at right angles and themselves subsequently neatly couched with another thread. (A rich technique employed in western European ecclesiastical decoration especially from the sixteenth century, this form of

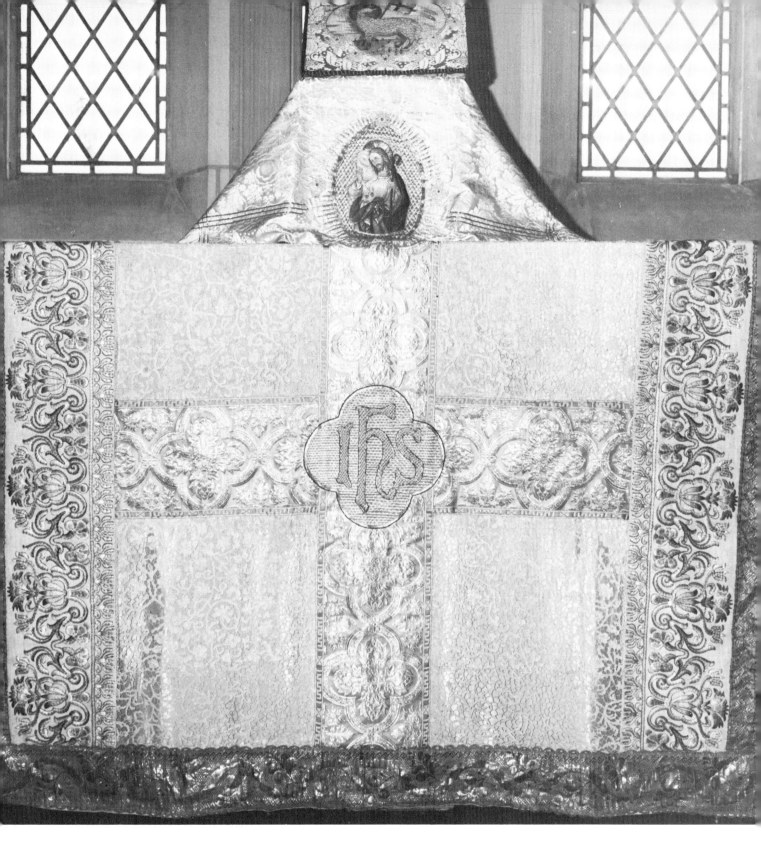

couching gives a particularly dense effect.) Around the edges of the medallion, thick gold threads are simply laid in close parallel formation and couched with silk; a finishing touch is provided by four scrolls in the corners of the medallion, also worked with couched gold thread.

Miss Mackrille made extensive use of couching in most of her metal thread and polychrome silk needleworks, as evidenced by another panel,

a roundel placed in front of a cross, also edged with close lines of couched gold thread. Here the figure of Christ is seen about to offer bread and wine to a man bent in obeisance; Christ's halo, both heads and the edges of the figures are formed of couched threads and careful shading is achieved through other design segments worked in silk with long vertical straight stitches separated from one another by shorter vertical stitches in thinner silk. Skilful colouring of these straight stitches indicates clearly the folds of the suppliant's shoulder-fastening cloak and, from not too far away, the emotion on his face.

Appliqué was another technique in which Miss Mackrille was highly skilled, as illustrated by a kneeling angel on an altar cloth worked, according to her, in the following manner:

The design of the figure of the saint or angel is first stamped on the framed linen and then on the material to be used for the robes. The design in the frame is then pasted over with starch, almost liquid, having no lumps in it. Cut out the stamped fabrics and lay them on the starched surface and press down gently with a dry brush.

Such motifs were sometimes exquisitely embroidered before being cut out and applied: in 1977 boxes discovered behind the Cathedral's high altar were found to contain linen panels set on frames. One piece is partly embroidered with a head and two hands and the other, a larger area, has an embroidered body on to which the other motifs, when cut out, would subsequently have been applied.

A finished appliqué of St Catherine of Alexandria (died 310) is a reminder of Miss Mackrille's association with the Wantage Sisters; one

Drawing of an applied figure of St Catherine holding symbols of her martyrdom.

OPPOSITE LEFT A favourite method of shading was the skilful working of close parallel lines of vertical straight stitches in different colours. Outlines of figures, hair, halo and the border of this roundel are couched.

OPPOSITE RIGHT A kneeling angel is similarly shaded with straight stitches, here worked horizontally.

RIGHT The Good Shepherd, on a chalice cloth, is worked mostly in split stitch, couching and french knots and the reserves are dense laidwork.

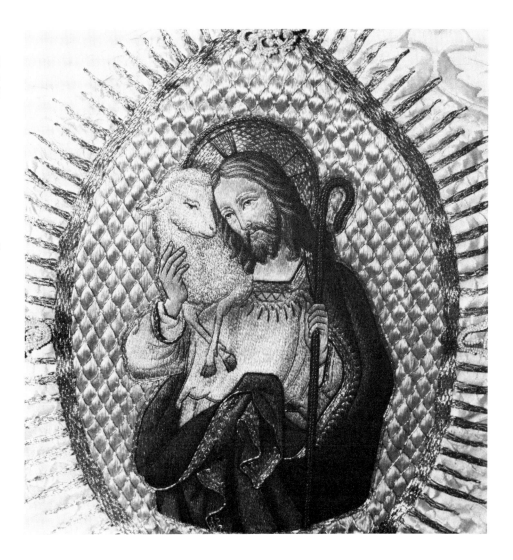

of their girls' schools, in Abingdon, then Berkshire, was dedicated to the noble and learned lady tortured because she dared to protest against the persecution of Christians by the Roman Emperor Maxentius (ruled 306–12). Catherine holds a gold-handled sword as she stands by the knife wheel. Above, a label embroidered direct to the damask reads 'Be ye faithful unto death', a reminder that she was eventually beheaded.

Miss Mackrille esteemed quality in design and execution, feeling strongly that only the best materials should be used to work patterns of classic simplicity. St Catherine's gently curving stance is echoed by her long hair flowing gracefully to her shoulders, and similar alignment is seen in a figure of the Good Shepherd on a chalice cloth: here Christ's head is to one side so that his neck is parallel to the legs of the sheep he carries on his shoulder.

Liturgical colours following those suggested by the Oxford Movement of the early 1830s have been strictly adhered to within the cathedral and

other needleworks have been commissioned for such specific occasions as the 1976 Bicentennial when a nationwide competition was organized for a commemorative high altar frontal. The winning design by artist Connie Eggers (born Cleveland, Ohio, 1932) now highlights the long length of the Cathedral's nave; from even a tenth of a mile away, it is possible to see, beneath the Cathedral's glorious rose window, a vivid spot of red and gold on the altar, truly the heart, as it were, of the building. Connie Eggers based her design on Jerusalem crosses used as a cathedral symbol (one is carved on the stone of the high altar): she planned three embroidered crosses distorted so that the sweeping horizontal lines form a large fish shape. She made up her design on five separate pieces of red fabric to be joined subsequently along design lines, and machine-stitched a central cross of padded gilt kidskin, salmon satin and peach ribbed velveteen and two unpadded darker crosses; she then couched the silk cords by hand (*see Plate 32*).

The brazen assertion of Connie Eggers' striking altar frontal is a far cry from, and yet surprisingly complementary to, the delicately coloured traditional canvaswork carpet leading up the five steps to the altar. Designed in the early 1950s by the four Misses Tebbets from South Kent, Connecticut, and worked by twenty-three women from the Diocese of Pittsburgh, the carpet is formed of twenty-two separate pieces of basket-weave canvaswork forming a set with Gospel and Epistle rugs, also designed by the Tebbets ladies and now lying either side of the high altar.

These canvasworks were among the first items worked under the auspices of the cathedral's Needlepoint Committee founded in 1954 by the Dean, the Very Rev. Francis B. Sayre Jr. The Committee compiled a list of possible sponsors and to stimulate interest in their projects they organized an exhibition of work by such canvaswork enthusiasts as Mary Martin and the Ambassador to Italy, Clare Booth Luce; in addition, professional and amateur designers were invited to submit ideas for decorating the high altar and choir and nine chapels within the cathedral. Soon, over two hundred sponsors enabled the commissioning of designs for kneelers, cushions, banners and other items subsequently stitched by enthusiastic needleworkers from all over the country and further afield. The Needlepoint Committee continues its close involvement by looking after even the earliest of the canvasworks, for after several years' hard wear many kneelers need repair and replenishing is sometimes necessary. From time to time major new commissions are undertaken to expand the range of cathedral needlework.

Each area has embroideries that are individual and beautiful. Two kneelers at the high altar, to take but one example, were specially designed to complement the Tebbets carpet with ivory, rose and blue symbols representing the cathedral's two saints, Peter and Paul. Nearby are kneelers with pentecostal emblems, and along 30 feet (9 metres) of the communion

The High Altar, dressed with the bicentennial altar frontal designed and worked in 1976 by Connie Eggers; in front can be seen the canvaswork carpet designed in 1954 by the Misses Tebbets and worked by ladies of the Diocese of Pittsburgh. *altar frontal 40 in, 101·6 cm, high, carpet 252 × 108 in, 640 × 274·3 cm*

The reverse side of
the precentor's cushion,
designed by Erica Wilson.
*basketweave tentstitch panel
15 × 25 in, 38·1 × 63·5 cm*

rail are kneelers decorated with motifs of the Holy Communion occasionally dotted with butterflies, symbols of the Resurrection. Beige cushions within the body of the choir are decorated with seals of the Dioceses of the Episcopal Church and at the west end is the precentor's cushion, its upper side bearing the head of King David playing his flute flanked by reeds, fiddle and horns, emphasizing the precentor's role in organizing services and their music. The cushion was designed by Erica Wilson (born 1929), responsible also for the communion rail and altar kneelers in St John's Chapel: here mythical beasts are taken from a design in the Victoria and Albert Museum.

As if reiterating Anglo-American unity one Englishman, Sir Winston Churchill (1874–1965), is included in the famous people represented on kneelers in St John's Chapel. Subjects chosen by three *cognoscenti* from the Smithsonian Institution include, naturally, all American presidents and also such innovators as the feminist Susan Anthony (1820–1906), represented by a mortarboard, pen and paper (reminiscences of her fifteen years' teaching), a ballot box and broken shackles. On all the kneelers, motifs are embroidered in tentstitch on a bright red ground with the person's name on the boxing at the top of the panel and birth and death dates to the left and right.

Patriotism is similarly displayed on a 12 × 9 foot (3·5 × 2·75 metre) canvaswork wall hanging in the war memorial chapel. Designed by the Needlework Studio of Bryn Mawr, Pennsylvania, and worked by eighty-nine embroiderers, the hanging is made of tentstitch medallions of the seals of States and armed forces, applied to a ground of basketweave tentstich by plunging all warp and weft threads of canvas cut close to motif edges through the surface of the worked ground. And, in gratitude for American

assistance during World War Two, kneelers in this chapel were all worked by British women: one was stitched by Her Majesty Queen Elizabeth the Queen Mother.

No area of the cathedral has been overlooked. In the children's chapel there is a delightful 'Noah's ark' scene on the altar kneeler; in the baptistry bench cushions are decorated with symbols of man's rebirth through baptism; and over two hundred communion kneelers in the Bethlehem chapel are stitched with Nativity emblems. On one side of the north transept, near to the entrance to the clergy robing room, are long cushions with delightful vignettes of staff life, suitably caricatured but not extreme, such as the choirmaster lifting his arms to direct his singers, a bellringer twirling a rope and a cleaner pushing a large broom. All the figures, outlined in black and infilled with grey, stand out in sharp relief from the bright red basketweave ground.

In the crypt an outstanding painting of the Resurrection has its colours echoed in cushions and kneelers. Another subterranean chapel that should not be overlooked is dedicated to St Joseph of Arimathea, associated also with Wells Cathedral. The designer of the embroideries, Brande Ormond, has skilfully incorporated colours used in the mural in this chapel to accentuate the boxing of the altar kneelers; the colours of their tops emulate the deep rose of Mary's robe and the gold of the Holy Grail, also echoed in the scarlet and gold edging of the painting. Behind, four fixed kneelers have similar boxing and upper facets beautifully worked in soft green, grey and beige geometric designs of trellises surrounding crowns of thorns intertwined with herbs of remembrance: rosemary, aloes, myrrh and hyssop.

Across the Atlantic, in the Quire at Wells Cathedral, another skilful designer, Lady Hylton, planned canvasworks to complement and accommodate other church decorations (adapting the shape of her stall banners, for instance, to fit surrounding stone carving). Especially in churches where needleworks are planned for a particular setting, needlework is not and should not be an isolated art form.

Ohio Historical Center, Columbus.

14

Ohio Historical Society

Local Heritage

HROUGHOUT America, State historical societies research, collect and catalogue the histories of their peoples and, on a smaller scale, local associations concentrate on an area of neighbourhood radius. It is partly due to the efforts of these groups that so much is known today about Americans of the past.

The largest State-based historical society is that of Ohio, about a fifth of the way across the northern part of America from the Atlantic seaboard. Bordered by Michigan and Lake Erie to the north and Pennsylvania and West Virginia to the east, Ohio is separated from Kentucky, to its south, by the Ohio River, and a straight longitudinal line to the west marks the border with Indiana. Because it is thus sited between the populace of the eastern seaboard and the expanding west, Ohio was from its early days ideally placed for communications. Cleveland remains its main inter-national trade and industrial centre although Columbus, at the core of the State, has been the capital since 1816.

The fertile plains that constitute much of Ohio were visited by German-speaking Moravian missionaries in the early 1760s but the first permanent settlement was not established until 1788 when some New Englanders settled at Marietta. Those who first came to live permanently in Ohio were generally travelling on from the east and, because of their heritage, they were basically anglophile. Soon, however, other groups were to arrive, in-troducing the seeds of an ethnic diversity that is today a noticeable feature of Ohio's population. Germans and Swiss came from Pennsylvania and people of Ulster Protestant lineage established bases in Ohio long before 1830. Afterwards settlers sometimes travelled direct from their homeland:

Germans, for instance, arrived to drain swampy areas in the north-west and many stayed on, as did Irish labourers employed on canals and rail-roads; Welshmen arrived to develop mineral resources, especially in Jackson County, and Scots settled throughout the State. Towards the end of the century, there were large influxes of Italians, Poles, Hungarians and Russians, many of whom came to work in heavy industry in Cleveland, Toledo and Dayton, and other immigrants arrived from Austria, China, Greece, Japan, the Netherlands and Portugal.

Ohioans are, therefore, a cosmopolitan people and, like Americans in the forty-nine other States, proud of their diverse backgrounds. They are also jubilant that they number among their famous sons, by birth or residence, over a fifth of all America's presidents (W.H.Harrison, Grant, Hayes, Garfield, B.Harrison, McKinley, Taft and Harding); in more recent times, John Glenn, astronaut and senator, was born in Cambridge, Muskingham County, in 1921.

People of Ohio are, not surprisingly, acutely aware of the factors governing their past achievement. As with similar State-based associations, the Ohio Historical Society provides a core for study into past lives and ideas. Founded in 1885, it is funded by the State, by its nearly twelve thousand members, and by sales, admission fees, grants and gifts. It has an annual budget of over five million dollars, is responsible for a seasonal payroll of over five hundred and, as well as the headquarters in Columbus, it looks after nearly sixty other museums, houses, memorials and similar sites dispersed throughout the State.

Long before reaching the Columbus headquarters, the Ohio Historical Center, the visitor is aware of a gigantic futuristic structure on the skyline. Byron Ireland's 1970 building has unrelieved vertical facets surmounting a glazed cube of smaller dimensions, like a square mushroom atop a grass-less hillock. It is sentinel too to 'Ohio village', a fifty-eight acre setting for houses, shops and other typical buildings from the 1803–50 period that bring schoolchildren's history classes vividly to life.

After entering the main door in Ireland's glazed cube, the visitor may be directed down to exhibits reflecting different aspects of Ohioan life. Perhaps there is a temporary display of clothes worn by First Ladies: here is a gown, a frothy concoction of lace over satin, worn by Mrs McKinley at the 1897 Inaugural Ball. Rumour had it that the dress had cost six hundred dollars and that did not even include the shawl. Nearby is a robe, made by Mme Dunlevy of Cincinnati and worn at the 1906 Ball by Anne Williams Pattison (1859–1959), one of the first women to graduate from Ohio Wesleyan University in 1880 and wife of John Pattison (died 1908), third Governor of Ohio.

Among items in the reserve collection, which may be seen by appointment with the curatorial department, are, as might be expected, samplers from the area such as that signed by Mary Ann Edmondson of

Dayton in 1834. The provenance of other embroideries is sometimes less well documented: Catherine Moore and seven-year-old Elizabeth Pratt, for instance, both preserved their privacy when signing their samplers, but if they were not actually worked within Ohio then at least the Moore and Pratt families later settled in the State. By contrast, fascinating documentation is available for an applied quilted coverlet signed 'PC 1872', in one corner, by Phoebe Cook (1804–91). Born in Knox County, Phoebe married a local man, Abel Cook (1802–91), with whom she had moved in 1857 to a farmhouse with eighty acres of land in Gilead Township, Morrow County, which they had purchased four years before, and where they were both to spend the rest of their lives. One of their children, Hattie Corwin, gave birth to her second daughter, Blanch, in 1872 and Phoebe worked the coverlet for her new grand-daughter who came to live with Mr and Mrs Cook at Gilead Township after her mother's death in 1877. The coverlet remained in the farmhouse where it had been worked until 1950, when it was given by Blanch Corwin Kelly to the local attorney who bought the farm from her, although in fact she (and it) retained tenancy until her death in 1962 at the age of ninety.

The main area of Phoebe Cook's beautiful present for her grand-daughter is composed of twenty-four square panels of white cotton decorated with applied calico and other cotton figures. Pieced together so that half the designs face one way, half the other, the panels are separated by bands of pink and brown cotton forming a lattice effect, and the entire area of panels with separating borders is set into an outer surround of white cotton, its periphery marked by brown, pink and brown stripes the same width as those separating the inner panels.

Each of the central panels and the outer border tell stories of the Cooks' acquaintances and their way of life (*see Plate* 29). Most of the men have bushy hair and beards formed of short lengths of unravelled thread; their women mostly wear ankle-length dresses over boots and one lady joins the men by smoking a pipe. A man and woman haggle over a broom and, in a panel above, a woman in an outsize hat plays with a small boy and a minute baby. Nearby a gentleman, reputed to be Dr Britton, father of Nan (author of *The President's Daughter*), drives a cart with two horses. Facing the other way up, a couple sit in a carriage and a large lady is approached by a lilliputian admirer bearing a flower. Stories around the outer border similarly immortalize Ohioans of the early 1870s. As if dancing around Phoebe's signature, a woman in a full-length dress tiered with miniature frills which stand away from the coverlet's surface cavorts with her escort; further along, a younger girl milks a spotted cow and a man has trouble pulling a stubborn mule. As riders progress one behind the other a black mammy stands watching. A lady wields an enormous teapot and two more visit an upright gentleman as they are approached by a pair of horses pulling a carriage with four passengers.

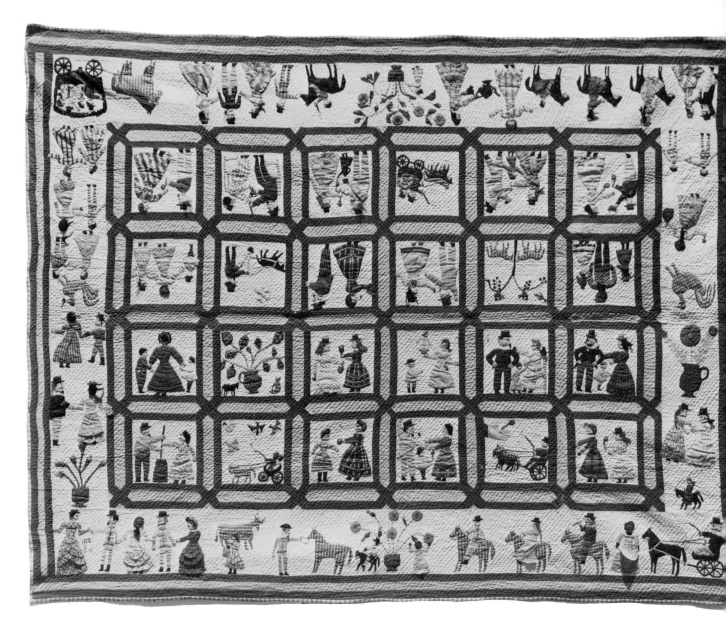

This, then, is the sample of Ohioan life recorded for posterity by Phoebe
Cook. Ninety years later, Mary Porter Borkowski of Dayton (born 1916)
had an equally fascinating story to tell on her quilted coverlet, 'The Pride
of Ohio' (*see Plate 30*), first displayed at the 1962 State Fair. Mary
Borkowski is a talented folk artist whose coverlets can be seen also in the
Smithsonian ('The White House birthday quilt') and the Lyndon Baines
Johnson Library and Museum ('The President and the world') and who
has been mentioned in such works as Hemphill and Weissman's *Twentieth
Century Folk Art and Artists*. She learnt her stitching skills as a child in
southern Ohio where 'country women did a lot of thinking and sewing
by lamplight'.

'The Pride of Ohio' took three years to make. In the centre is a map
of the State – coincidentally illustrating how similar its shape is to that
of its country. The boundary of each of its eighty-eight counties is outlined
and padded and Muskingham County has an embroidered star to denote
the birthplace of its famous son, John Glenn. (Friendship 7 was launched
from Cape Canaveral on 20 February 1962 as his fellow Ohioan was finish-

ing her coverlet.) Above the State's representation are three carnations, the State flower, symbolizing the fact that Glenn was the third American to enter space and that he orbited thrice; beneath Ohio the total of seven astronauts is represented by more carnations. A halo around Ohio is formed of eight equal-sized State seals (the number of its American presidents), each seal showing wheat sheaves in front of mountains with a full sun and surrounded by a galaxy of seventeen five-pointed stars, the number on the State flag. Buckeyes and cardinals, State flowers and birds, embellish the reserves of the design and scallops on the two vertical edges of the coverlet are each formed of twenty-five applied blue stars standing for all fifty States. The two shorter edges are worked with capital Os to symbolize the artist's loyalty to Ohio and, as if further proof could be needed, much of the coverlet is worked over with diagonal lines of stab stitch, indicative of the high rainfall in Ohio. As Mary Borkowski says with pride: 'I love every stick and stone and every hill and valley in Ohio!'

The Village Meetinghouse in Old Sturbridge Village was
once a Baptist church in nearby Fiskdale.

15

Old Sturbridge Village

New England Costume

o needlework anthology would be complete without considering embroidered clothing, here studied within the 1790–1840 period spanned by the Old Sturbridge Village complex in southern Massachusetts, where traditional costume is recreated and where there is also an important collection of older items of embroidered clothing.

Two hundred and fifty acres of woodland and pasture provide the setting for this copy of a New England village as it might have been over a hundred and fifty years ago. The project was conceived by two brothers, Albert and Joel Cheney Wells, of Southbridge, both avid collectors of tools, clocks and other items of everyday use in New England in the past. In 1936 they purchased land and brought in buildings to augment the two already *in situ* so that their treasures could be housed, and Old Sturbridge Village opened to the public ten years later.

Walks along sandy paths beside early buildings and fields dotted with sheep ignite the imagination. Here is a stark Quaker meetinghouse and, beyond, the Village Meetinghouse, a white-painted timber building with pencil-fine clock tower and an imposing portico with Doric columns; removed from its former site in nearby Fiskdale, the meetinghouse today dominates the west end of Old Sturbridge Common, facing towards General Salem Towne's House at the east end. Originally built in Charlton in 1796, this is a building of some architectural intricacy; its front door is flanked by pilasters and further decoration is provided by shuttered windows and the shingled roof rising to a monitor top with tiny windows to light the attic within.

Either side of the Common are simpler houses, shops and offices. The

Solomon Richardson House, a red and white 'saltbox', was constructed *c.* 1748 in East Brookfield by housewright Thomas Bannister who sold it the following year to Solomon Richardson, a carpenter by trade. Now the building is furnished as it might have been for Old Sturbridge's minister and his family towards the end of the first quarter of the nineteenth century, and it is easy to imagine the parson walking home from his meeting-house across the Common. Perhaps he went first to his office, converted from a parlour. His green-baize-covered desk is partly obscured under papers and surrounded by his library of bibles, theological works and contemporary periodicals. The main parlour was, to a great extent, the centre of the parson's family life; its floor was perhaps covered with a carpet 'made of old woollen cloth, cut in very narrow strips, half an inch wide … sewn together and made into long strings'. Simple turned chairs are now set around a large rectangular table covered with a cloth on which all courses of a meal would be spread at once. A tall grandfather clock almost scrapes the low plaster ceiling while, on the other side of the room, there is a corner dresser filled with the family's china. The comparative humbleness of a parson's position is illustrated by a cosy kitchen within the main house (by contrast larger houses often had separate kitchens). In the Solomon Richardson kitchen there is a high-backed wooden settle to one side of a large open fireplace in front of which children's clothing may be hanging to dry. Perhaps one of Old Sturbridge's noted interpreters enlivens the scene: wearing a frilled cap decorated with black ribbon simply held with a straight pin and carrying a tiny reticule, both items copied from paintings in the Village's study collection, she lifts the hem of her full-length dress to show the quilted petticoat she wears in winter.

The visitor continually has the feeling that life could in fact be going on. In the lawyer's office, next to the parsonage, it seems as if the meeting recently interrupted will be resumed before too long: chairs are set in haphazard fashion around a table littered with papers and books and there are quills ready in the inkwell. A regard for authenticity is paramount everywhere, as evidenced by the apprentice actually working in the shoe shop. Wearing breeches and a large protective leather apron he skilfully cuts uppers for shoes that may later be worn by interpreters or displayed in the Knight Store. The craftsmen and women as well as interpreters wear clothes designed and made by the Village's costume department to suit pre-1840 rural New England styles, although some items are in a fashion popular long before that time. There are two reasons for this: firstly, especially in country areas, costume styles lagged far behind fashion; secondly, rural garments were often worn until they fell to pieces and even then such good fabric as remained might be reused. As a result, everyday rural costume of former times can be more difficult to date accurately than high-fashion clothing.

Staff costume at Old Sturbridge therefore represents the results of long

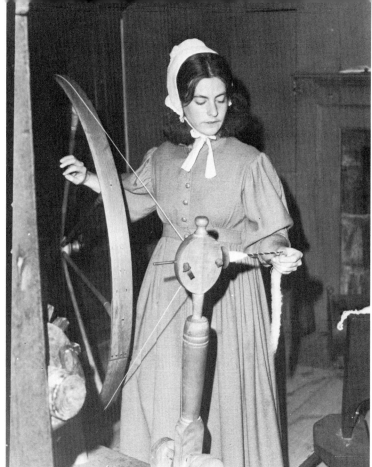

research. One girl, spinning on a tall hardwood 'great' or 'walking' wheel, describing her skill as she draws her thread, is dressed in early nineteenth-century style, her hair kept off her face by a white cap with long ties forming a bow beneath her chin. Her green homespun dress has a high rounded neckline as a reminder that country clergymen often frowned on the *décolleté* 'Empire' fashion. The front-opening bodice is without darts, full sleeves drop from slightly drooped shoulders to below-elbow cuffs and the gathered floor-length skirt falls from a high waistband.

As with the American Museum's coverlets, the cotton for the spinner's cap would probably have come, after 1776, from the south of the country. Homespun for her dress would have been locally produced, spun, wound on to a reel or 'niddy-noddy', woven and dyed at home; alternatively, ready-made fabric could have been bought from one of the manufactories in existence from about 1788. In summer, a linen dress might be preferred, formed either of fabric spun and woven from homegrown flax or of such imported fabric as that advertised by a Boston store: 'Scotch linen, striped and checked, bedticks, checked and blue-bordered handkerchiefs'. New England women would have learnt to sew when they were young girls of five or six. Copying the shape of finished garments, they carefully cut pieces of fabric which they temporarily held with straight pins while sewing new garments by hand. They subsequently embroidered clothing, mostly only for themselves and their children, although some merchants and other privileged gentlemen in Old Sturbridge might have favoured splendid professionally embroidered waistcoats and other items for special effect. Later, by the 1840s, farmers and other workmen might

LEFT Mrs Aphia Crockett, one of Old Sturbridge Village's interpreters or guides, wears a dress in early nineteenth-century style over a warm quilted petticoat. Her reticule, fichu and cap are exactly copied from historic items in the Village's collection.

RIGHT Another interpreter spins on a 'great' or 'walking' wheel.

ABOVE Women's collars, cuffs, fichus and other fine whitework items were sometimes decorated with gently curving floral sprig designs.

LEFT Patterns could be taken from such a page as this, included in a leather-bound volume, $9\frac{3}{4} \times 7\frac{3}{4}$ in (24.8×19.7 cm), inscribed 'Amelia Howard, Boston, 1818'.

BELOW Ladies' pockets were handy pocketted aprons which tied around the waist. The front of the item could be embellished with a symmetrical crewel design.

have worn smocked linen overshirts similar to English 'smocks'.

Women's clothing was embellished by a multitude of techniques. Whitework, sometimes known as 'work'd muslin', was incorporated with drawn and pulled thread to decorate caps and bonnets, fichus, collars and cuffs, full-length dresses, petticoats, sleeves, handkerchiefs and bags. The finest examples of all were often imported but New England women would embroider with patterns copied from paper templates which were available particularly from the beginning of the nineteenth century and which might be protected in leatherbound books: an area of fabric could be placed under the required page already pricked with stiletto holes through which powder would be pounced. In rural New England crewel was employed for such items as dresses, skirts, bands of about ten and a half inches (26.7 centimetres) depth which were set along lower edges of petticoats, and pockets which were pocketted aprons with waist ties popular from the middle of the seventeenth century. The most beautifully

embroidered pockets, which might also be decorated with appliqué or patchwork, were possibly worked as gifts, as illustrated by one 'embroidered dimity [cotton] pocket with the pocket-glass, comforter, and strong-waters bottle kept within it'.

Such techniques as blackwork and metal thread embroidery, both variously employed in English costume decoration, were not much used in the New World. By contrast, one skill that was especially characteristic of New England was the forming of shag mittens, with looped running stitches executed on top of knitted mittens sometimes worked by little girls as young as four. A desire for warm clothing similarly encouraged the use of quilting, for during the cold winter months heavy full-length quilted petticoats such as that worn by the interpreter in the parsonage must have provided great comfort. A rose-pink calamanco petticoat, perhaps brought from England before 1776, has the fullness of its trellis-quilted body gathered into a triangular stomach panel, and all around the bottom hem a gently curved repeating garland design resting above flowing leaves and flowers is quilted with reserves of close lines worked diagonally. More than one embroiderer may have worked such a petticoat, for Mrs Ruth Henshaw Bascomb recorded that one afternoon

LEFT Scraps of left-over calico have been used to bind the edges of this pocket.
16 in, 40·6 cm, long

RIGHT A fine pocket of printed cotton patchwork which looks as if it has never been used.
15 in, 38·1 cm, long

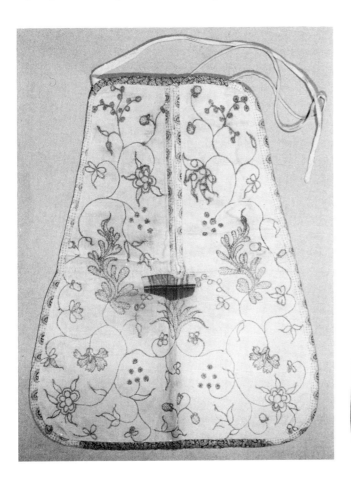

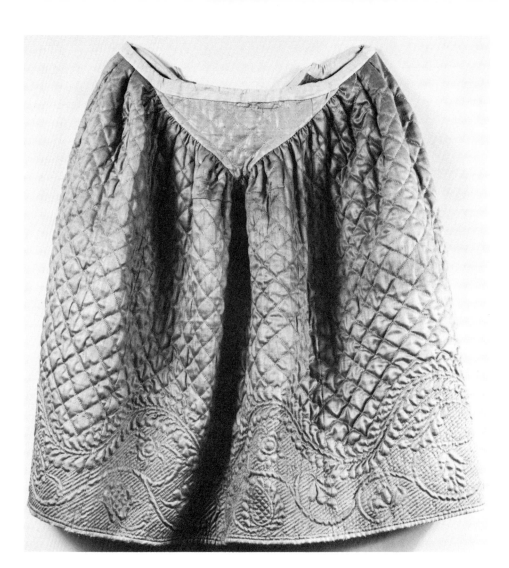

ABOVE Shag mitten: a knitted
woollen item subsequently
embroidered with close loops
in typical New England style.
11 × 7½ in, 27·9 × 19·1 cm

RIGHT Heavy quilted
petticoats such as this pink
calamanco item provided
warmth in winter.
petticoat 34 in, 86·4 cm, long

BELOW Detail of the hem of the
petticoat, its edges carefully
bound.

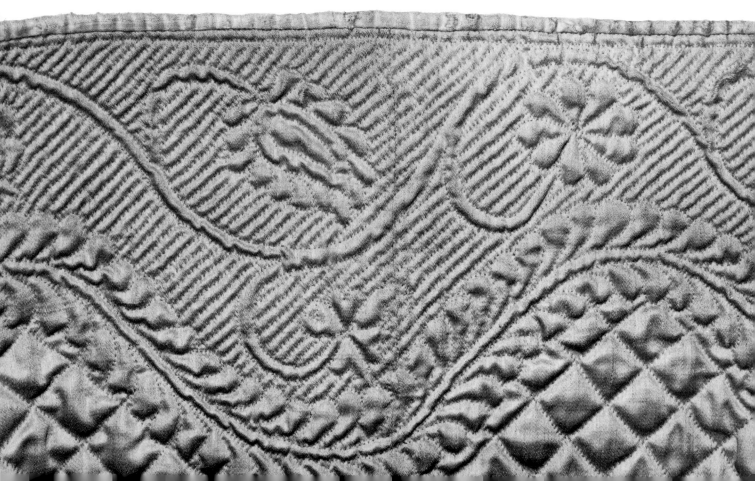

'twenty-one young ladies paid us a visit and assisted us in quilting'.

The rigid structure of that universally popular technique, canvaswork, restricted its use in costume mainly to shoes, belts, braces and such other accessories as handy portable pocketbooks. An American speciality carried by both men and women, these were gussetted pieces formed of leather or embroidered canvas stiffened with cardboard and lined with silk. A rectangular piece of canvas was sewn to two gusset panels and folded over to form a front flap, and its edges were bound with wool twill or silk ribbon about half an inch (1·3 cm) wide, two lengths of which would also be sewn on to the flap as ties. Men's pocketbooks usually had two inner compartments while those used by women had one. Canvaswork designs were often aligned in two directions so that when an item was subsequently made up, the pattern on the flap of the pocketbook faced the same way as that on its front. Flamestitch was the most popular technique employed, although tent, cross and rococo stitches were sometimes used, as illustrated by a pocketbook marked 'Mary Bliss 1811' and worked mainly in cross stitch with reserves of rococo stitch. Unless Mary had been given her pocketbook as a gift she would have worked it herself, and perhaps she carried it tucked into the slit of her waist-held pocket. She may have carried in her pocketbook 'a Pair of Stone Earrings, two Pair of Stone-Buttons which wanted mending, silver Thimble ... a large plain Stay-hook in the shape of a Heart, a silver Teaspoon broke off in the middle'.

As well as more everyday clothing, some especially sumptuous items would have been made of fine silk, perhaps produced by the Company of Silk Manufacturers formed in nearby Connecticut in 1789. Thicker silk was used for dresses and other large items while finely embroidered gauze was employed for high-necked blouses, caps and shawls like that worn by Rebecca Tufts Whittemore when she had her likeness recorded by Ethan Allen Greenwood in 1811. Another Old Sturbridge portrait, that of Mrs Elisha Noyes Sill and her two-year-old son James, also shows a lady, upright as a board, wearing embroidered or fine lace tight-frilled cap

LEFT The outer section of a pocketbook could be formed from canvas embroidered in two directions so that when the item was subsequently made up and closed the design was consistent.
linen canvas with flamestitch bordered by cross stitch, worked motif 6 × 11¼ in, 15·2 × 28·6 cm

RIGHT Mary Bliss signed her pocketbook in 1811 in cross stitch.
linen canvas mostly decorated with silk rococo stitch, green silk ribbon binding, 3½ × 5½ in, 8·9 × 14 cm

A reproduction of a baby's robe made by interpreter Jan Sargeant from an original in the Old Sturbridge Village collection. It lies on an early nineteenth-century cherry bed from New England hung with reproduction English roller-printed cotton, *c.* 1820–30, the original of which is also in the collection.

and blouse while her young son, already with a mature face, is dressed in a low horizontally necked white robe with embroidered tiny cap sleeves.

In general children's clothes have survived in greater number than those of adults, for if the owners did not succumb to the tragically high mortality rate they soon outgrew their garments. Working from a *Workwoman's Guide* published in Birmingham in 1838, Old Sturbridge Village's costume department has furnished a complete layette for the children of the parsonage. Reproductions meticulously handsewn by Village interpreters include dresses, skirts, petticoats, nightgowns, caps, aprons, bathrobes, an outdoor cloak and bonnet and underwear of pilches and diapers or napkins. As illustrated by the baby's cap at Historic Deerfield, in a rural New England village sometime before 1840 it is quite possible that any of the outer garments listed above might have been embroidered in styles imitative of adults' clothing.

Costume history is proving to be one of the most worthwhile avenues in which to explore past needleworks, especially under the aegis of the British Costume Society and the Costume Society of America. Clothing of former times illustrates not only social history, material availability and the evolution of fashion but also, in some instances, contemporary needlework styles, and it is often rewarding, as at Historic Deerfield, to study costumes which reveal our embroidery heritage.

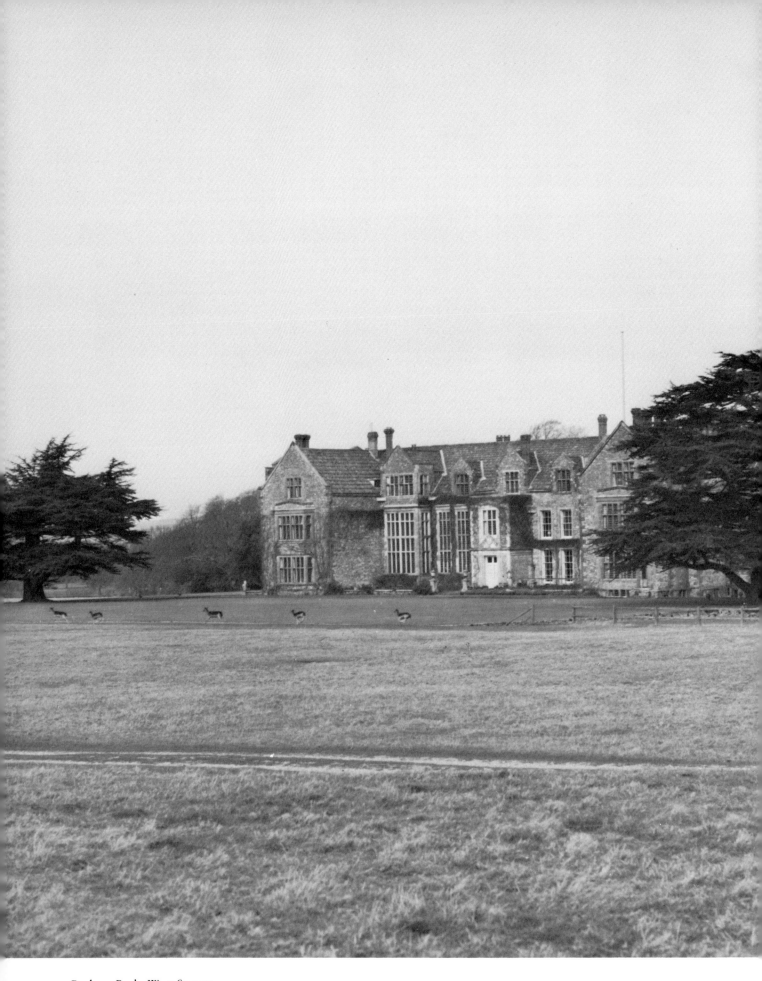

Parham Park, West Sussex.

16

Parham Park

Seventeenth-century Bible Pictures

 TORIES from Genesis are illustrated on the needlework box at Milton Manor House but to see an unsurpassed spectrum of themes from the Old Testament and the Apocrypha portrayed in seventeenth-century English needlework it is a delightful necessity to visit Parham Park, which houses the finest private collection of embroidery in the country.

Visitors to Parham, in West Sussex, are greeted by the wide, appealing eyes of fallow deer, members of a herd that has been here for three hundred years. After a mile's drive along a twisting road over Windmill Hill, trees are left behind and a grey stone house with a roof of flat Horsham stone comes into view.

A small building had been granted the Palmer family after the 1540 Dissolution but more space was required and in 1577 two-and-a-half-year-old Thomas laid the foundation stone of the house that he was to sell in 1601 to Sir Thomas Bysshopp. His descendant, ·Mary Cecil, 17th Baroness Zouche and wife of Sir Frederick Frankland, sold it in 1922 to the 1st Lord Cowdray's second son, the Hon. Clive Pearson, and it is his daughter Veronica, Mrs Tritton, who inherited the property in 1965.

Once again it will be seen that many of the treasures within the house have royal associations. Next to a portrait of Queen Elizabeth I, in this instance attributed to Zuccaro, in the Great Hall a nineteenth-century plaster coat of arms commemorates a visit three centuries before by that queen; nearby hang portraits of two of her contemporaries destined to be beheaded, Henry Howard, Earl of Surrey (1517–47), and Robert Devereux, Earl of Essex (1566–1601). Another group of paintings is

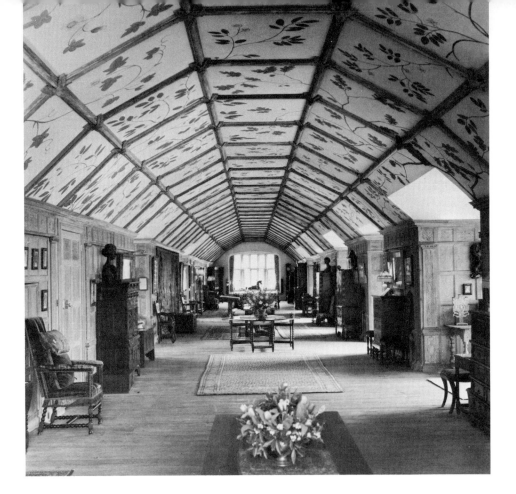

The Long Gallery, its ceiling designed by Oliver Messel in 1968.

connected with Charles I. His French queen, Henrietta Maria (1609–69), is seen, in a portrait in the Great Parlour, wearing a splendid yellow robe with deep lace collar, and there are likenesses elsewhere of her father, Henri IV (1553–1610), and other members of her family. And, continuing the association, Parham's famous bed, shown on the cover of this anthology and mentioned in the introduction, may once have belonged to Henrietta Maria's mother, Marie de Medici.

At the top of the house the Long Gallery extends, typically, the entire length of the building. Light oak panelling rises to a white arched ceiling painted in 1968 to a design by Oliver Messel (1904–78) which has a graceful twisting leaf pattern relieved by the occasional monkey, bird and butterfly and by insects appearing to climb up, as it were, from a tapestry hung on the panelling below. It is in rooms leading off and close to the gallery that the main collection of needleworks accumulated by Mrs Tritton's mother is now displayed. There are such other fascinating items as a late eighteenth-century Mexican *rebozo*, or shawl, as well as the glorious bed, but the seventeenth-century biblical pictures warrant particular study.

Although embroiderers at the end of the previous century had worked panels such as those at Hardwick it was not until about 1640 that it began to be fashionable for English ladies to embroider religious pictures for secular use. It was about this time too that amateur needleworkers began to stitch decorative pictures purely for their own edification. The appreciation of the function of art in religion which, thanks to the influence of the Puritans, had largely been lost in the hundred years since the break with Rome, was encouraged by William Laud, a Reading clothier's son

who rose to become Archbishop of Canterbury and spiritual adviser to Charles I. Laud strove, until his execution in 1645, to restore all forms of religious art and decoration; in challenging the Puritans in this way he might be said to have helped to precipitate the Civil War.

An essentially English phenomenon, panels with biblical themes worked by English women and girls from about 1640 to the end of the century were used as decorative pictures or to embellish bookbindings, cushion covers, looking-glass surrounds and boxes such as that at Milton Manor House. Panels typically show episodes from a bible story or even more than one unrelated tale, and many of the designs can ultimately be traced to works by such engravers as de Jode, Maerten van Heemskerck and Bolswert, possibly after works by Rubens (1577–1640) or Tintoretto (1518–94). Figures on all panels are usually dressed in highly detailed fashionable seventeenth-century styles and they are surrounded by birds, animals, flowers, trees, fishponds, castles with mica windows, puffy clouds and faces of sun and moon all drawn and worked with no regard whatsoever for proportionate scale. Sometimes embroiderers worked on panels already marked with designs outlined and partly shaded by itinerant pattern-drawers but in other instances they themselves possibly culled motifs from different finished panels to form 'individual' pictures. Most of the panels are canvasworks, executed on singleweave linen canvas. Tentstitch motifs are generally dark-outlined and sometimes they are embellished subsequently with buttonhole or satin stitch to highlight lace or jewels, or rococo stitch. Hair is formed of french knots or couching. Other pictures are executed in raisedwork on white satin: in these cases motifs may be scattered at random over an area perhaps subsequently embroidered in part with surface stitchery.

By far the greatest number of biblical stories told on these pictorial panels come from Genesis and elsewhere in the Old Testament and Apocrypha. Among the best known of the fewer New Testament stories are those worked by a professional male embroiderer, Edmund Harrison (1589–1666), court embroiderer to both Charles I and II, some of whose works can now be seen in the Fitzwilliam Museum, Cambridge, and in the Victoria and Albert Museum. The Parham collection includes the following recognizable stories from the Old Testament and Apocrypha, sometimes combined with more than one to a picture: Adam and Eve, Abraham, Hagar and Ishmael, and the Finding of Moses (all three times); Esther and Ahasuerus, Rebecca and Abraham's servant, and the Judgement of Solomon (all twice) and Abraham about to slay Isaac, Jezebel, Cain and Abel, Ruth and Naomi, Jael and Sisera, Susanna and the Elders, and Solomon and the Queen of Sheba (once each). These stories will be seen mostly to portray such feminine themes as maternity and fertility; less predictable perhaps is the representation by seventeenth-century English gentlewomen of violence, retribution and female supremacy.

The embroidery, 'Cain and Abel', graphically records the Genesis tale of fratricide. On the left Abel prepares the first of his flock, a sacrifice accepted by God, while Cain offers a single sheaf which is rejected. At the right, Cain brandishes a club over the brother whom he has killed in his anger.
white satin worked with silk satin and split stitches, couching and french knots and with applied spangles,
$11\frac{1}{2} \times 15\frac{1}{4}$ *in, 29·2 × 38·7 cm*

One of the Adam and Eve pictures, a square, tentstitch item, shows the pair holding fig leaves and standing either side of the serpent in the tree. Another version, embroidered by Ann Ellys, has an assortment of silver-outlined motifs of Adam, Eve and animals placed at random over white satin. By comparison, a prayer book cushion cover shows a subsequent scene: 'Therefore, the Lord God sent him forth from the garden of Eden, to till the ground from whence he was taken.' Adam is seen digging while above the couple Mary and the child, and an old man, probably the donor of the cushion, are shown. Agricultural work can also be seen on a delightful white satin panel simply labelled 'Cain and Abel'. To the left of the picture the sons of Adam and Eve are seen with offerings for God. Abel prepares a curly-haired lamb, the first of his flock, which was subsequently accepted, while Cain holds a mere sheaf of corn which was rejected. To the right of the picture, Cain brandishes his club as he stands over his brother, whom he has killed in his anger.

Different episodes from the long saga of Abraham were especially popular with English embroiderers during the seventeenth century. Three angels are sometimes shown prophesying that Sarah will bear a child, but the Parham pictures mostly recreate the later account of the banishment of Sarah's maid, Hagar, and her son, Ishmael, the story also splendidly told on the Milton Manor House box. Here, on the right side of a bible cover, a panel that would therefore cover the front of the book, the central motif of the banishment is backed by the *raison d'être*, Ishmael mocking

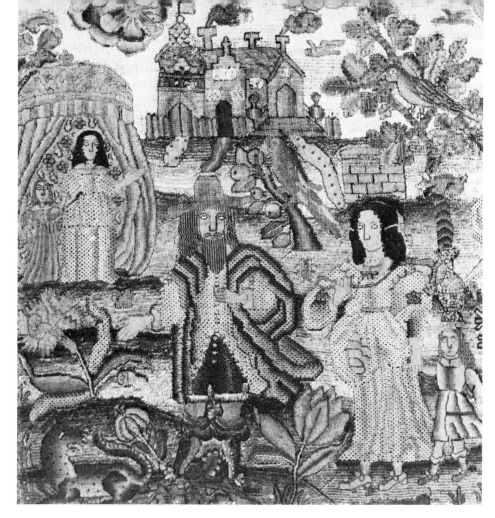

Isaac, and also by the scene in which Hagar is shown where to find water.

On another of the Parham panels, Sarah and Isaac watch from their tent as the banishment takes place while, behind, Ishmael sleeps under a large flower. And on yet another panel, set as the back of a needlework box, Ishamel has woken up and extends his hand to the angel pointing to water while, in the same design (an illustration of economizing on fabric), Abraham prepares to sacrifice Isaac.

Two pictures relate Abraham's later quest to find a bride for his son. Since Abraham wished Isaac to marry a girl from his own country, Mesopotamia, rather than from his present land of Canaan, the patriarch's servant is seen, as predicted in a dream, being offered water by a woman who will prove eligible. Sometimes said to be a prefiguration of the Annunciation, the meeting is typically portrayed by a kneeling woman offering both water and food to a man holding a staff and sometimes leading a camel.

Probably the best known of Parham's three 'Finding of Moses' pictures is a christening cushion cover, unique in that it is signed and dated (ML 1644). The baby lies in his basket as Pharaoh's daughter kneels over him, her two maidens standing behind. Here the designer has skilfully balanced motifs over all the canvas and there is further evidence of talented workmanship in the especially fine attention paid to the women's clothes. A sense of humour is also apparent in the double eyebrows signifying the women's astonishment. Indeed, many of these panels, which must have required so much patience on the part of the embroiders, show humour:

LEFT The banishment of Hagar and Ishmael, another version of the story illustrated on the Milton Manor House box. Sarah and Isaac watch as Abraham banishes Sarah's maid Hagar and her son Ishmael, who has taunted Isaac.
linen canvas embellished mostly with silk gobelin, rococo and tent stitches with details stressed with straight and satin stitches and laid and couched work. Castle windows are formed of mica held with retaining stitches, 11 × 14½ in, 27·9 × 36·8 cm

RIGHT Abraham's servant is offered water by the Mesopotamian girl, Rebecca, whom he knows to be destined as bride for Isaac, seen standing behind.
drawing from a tentstitch canvaswork at Parham Park

RIGHT A sense of humour is apparent in many of the needleworks at Parham: here Pharaoh's daughter and her maids have double eyebrows to express astonishment at finding the baby Moses in the bulrushes.
picture signed ML 1644: linen canvas worked mainly with thirty-five silk tent stitches to the inch, 11 × 14 in, 27·9 × 35·6 cm

BELOW Jephthah returns home to sacrifice whatever first comes to greet him, unfortunately his daughter.
linen canvas worked with silk tent stitch and some straight stitches, 9⅛ × 12⅜ in, 23·2 × 31·4 cm

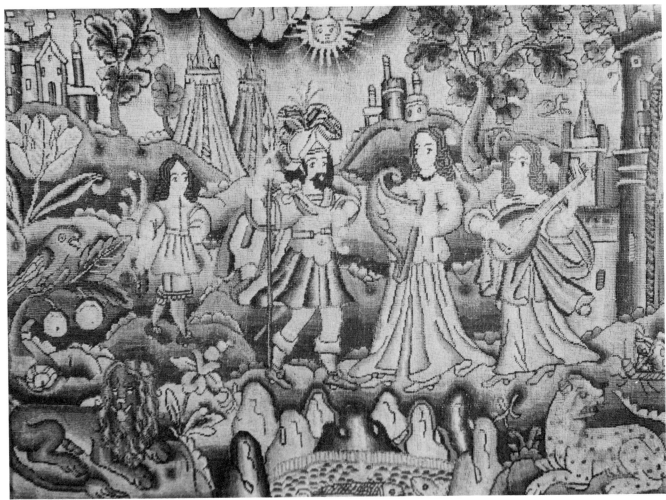

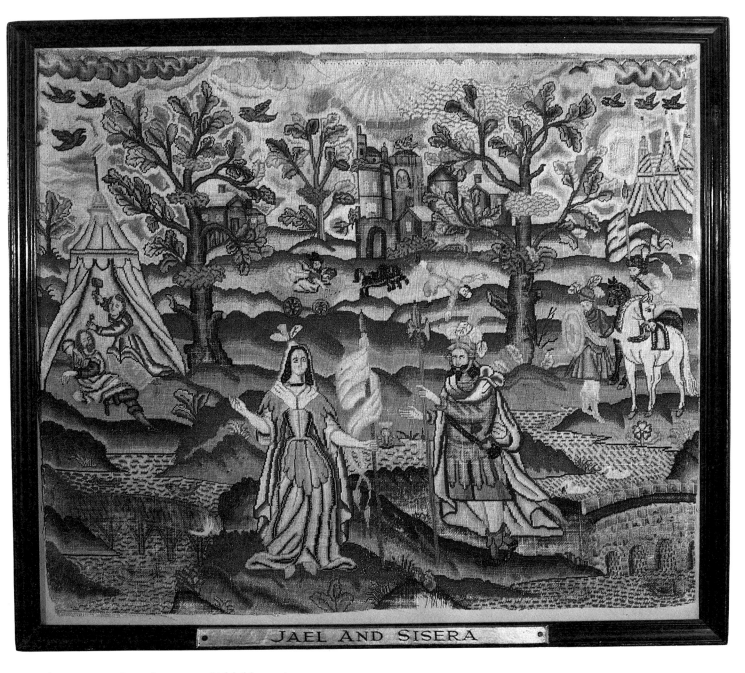

JAEL AND SISERA

Plate 33 Esoteric and even morbid bible stories were sometimes portrayed by English gentlewomen in the seventeenth century. This panel, from Parham Park, is primarily concerned with Jael tempting Sisera to her tent (she subsequently slays him with a tent peg, a macabre act portrayed on the left), but a subsidiary, unrelated tale unfolds behind as Jezebel, seen taunting Jehu, defender of Yahveh, is thrown out and hit by Jehu's chariot.

the second Parham version of the finding of Moses shows such delightful incidental motifs as a rabbit popping out of his hole to the left of the picture. The most noteworthy feature of the third version, a raisedwork panel, is the depiction of Pharaoh himself, seen driving by behind the main scene.

The stories so far mentioned are easily recognizable. One that presents more of a problem is of Jephthah's daughter, a theme popular with contemporary painters but less often worked by seventeenth-century embroiderers. Parham's tentstitch picture shows a warrior being greeted by two women making music as they come from an open doorway. Perhaps this is indeed the return of Jephthah, called from Mizpeh to lead the Israelites against the Ammonites. Having made a pact that, if he won, he would sacrifice 'whatsoever cometh forth of the doors of my house to greet me', on his return home he is confronted by his daughter 'with timbrels and dances'; in this rendering his face shows unmistakable anguish.

Another lesser-known bible story is that of Jael and Sisera, worked by an English embroiderer who was herself living at a time of constant battle and intrigue. In this morbid panel (*see Plate 33*) Jael, wife of Heber the Kenite, is seen greeting the Canaanite war-leader, Sisera, who has fled from defeat at the hands of the Israelites. While Sisera sleeps after having been given milk by his host, Jael hammers his head to the ground with a tent peg. This macabre picture has a subsidiary unrelated story portraying the death of Jezebel, daughter of Ethbaal, King of Sidon, and wife of Ahab, King of Israel, who was a worshipper of Baal. Jezebel, whose name is now synonymous with female depravity, is seen at the window of her husband's palace at Jezreel: she has painted her face and dressed her hair to taunt Jehu, who leads an uprising of the defenders of Yahveh. In a subsequent scene, Jehu's chariot drives fiercely at the falling body of the queen, thrown from the castle by two eunuchs. (Perhaps it is fortunate that lack of space prevented the embroiderer from portraying the finale, for after Jezebel was trampled by the horses her body was eaten by dogs so that only her skull, her feet and the palms of her hands remained.)

A happier note is provided by Ruth, Moabite widow of a Hebrew immigrant, Chilion. Ruth, in a splendid royal blue dress, is shown in a circular panel with her mother-in-law Naomi as she gleans corn in Bethlehem: 'And she went, and came, and gleaned in the field after the reapers: and her hap was to light on a part of the field belonging unto Boaz' (a distant cousin, whom she later married).

Ruth's great-grandson, David, provided themes for many seventeenth-century embroiderers. Sometimes his meeting with Bathsheba is shown; at Parham, their child Solomon (*c.* 970–931 BC) is portrayed in two versions of his Judgement, a story already seen on one of the professionally embroidered panels at Hardwick Hall, and perhaps taken indirectly from a Rubens. Called upon to adjudicate between two prostitutes who had given birth in the same house at the same time and who both now claimed

A detail of Rubens' Judgement of Solomon, a painting credited with having inspired seventeenth-century English needleworkers.

maternity of the one living baby, Solomon decrees, 'divide the living child in two and give half to the one and half to the other'; and it is this poignant moment rather than the reassuring sequel when the true mother is revealed that is generally shown on embroideries. One of the Parham versions of the Judgement is a random motif raisedwork picture initialled E.B. Solomon, the two mothers, the dead baby and the executioner holding the living child aloft are all delightfully portrayed, as they are too on the other panel (*see Plates 34 and 35*) a tentstitch canvaswork with minute lengths of fine needlepoint braid for the men's garters and buttons and tiny pieces of mica for castle windows. In this latter work Solomon is seen as Charles I, a representation continued by embroiderers long after the king was beheaded in 1649. As has been shown at Dearborn, the moustache, pointed beard and long hair aid recognition of figures supposed to be Charles I or a Solomon–Charles amalgam, for Solomon is the biblical king most often portrayed on seventeenth-century embroideries. He is sometimes shown with the Queen of Sheba, a visit said to be prefiguration of the coming of the magi. One of Parham's canvaswork cushion covers shows the two sovereigns standing either side of a double-headed palm tree: the queen wears contemporary court costume and Solomon in this instance is primarily noticeable for his feathered turban.

Two Parham pictures show another powerful ruler, Ahasuerus, King Xerxes of Persia (*c.* 519–465 BC), and Esther, now annually remembered during the Jewish festival of Purim. Seeking a wife to replace his queen, Vashti, Ahasuerus, from a choice of hundreds, picked Esther, an orphan and (unknown to him) a Jew brought up by her cousin Mordecai. After Esther was requisitioned to spend twelve months preparing, 'For so were the days of their purifications accomplished, to wit, six months with oil of myrrh, and six months with sweet odours, and with other things for the purification,' she was finally acclaimed queen. Both pictures show a

LEFT Raisedwork version of the Judgement: Solomon is called on to adjudicate between two women claiming maternity of a living child.
white satin worked with silk and metal threads, chenille and mica: tree leaves are formed separately around wire frames and then lightly attached to the ground, 13⅛ × 17½ in, 33·3 × 44·5 cm

RIGHT The executioner about to divide the baby shows little interest in his gruesome task.

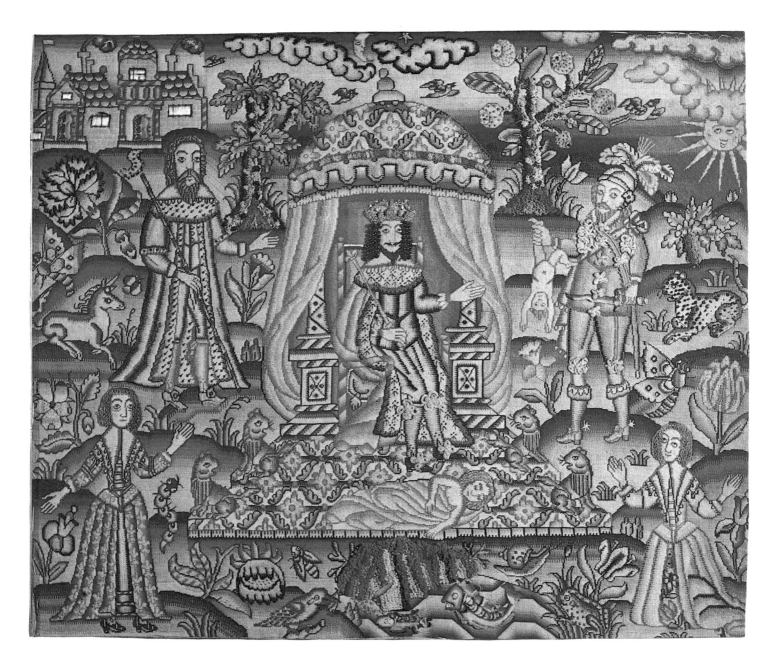

Plates 34 and 35 Another biblical panel from Parham Park. English embroiderers in the seventeenth century sometimes asserted patriotism by featuring oak trees, admittedly somewhat stylized, and, for many years after his execution, Charles I. Here the king is seen in the guise of Solomon, about to adjudicate between the two women who have claimed maternity of one living child (seen held aloft by the executioner ready to be cut in two). True to the story of the judgement, the other – dead – baby lies at Solomon's feet.

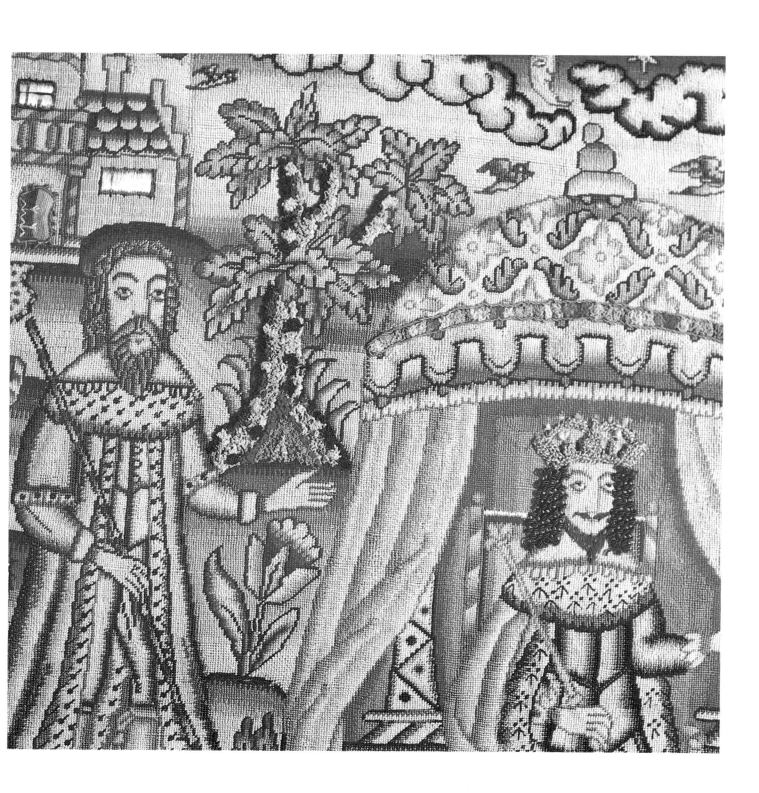

ABOVE The story of Susanna, from the Apocrypha, is clearly told on this panel. Symbol of purity, Susanna is seen accosted by two elders who subsequently accuse her of adultery.
satin worked with silk, chenille, metal thread and applied coral,
19⅛ × 21¾ in, 48·6 × 54 cm

OPPOSITE A detail of Susanna shows how her body is formed of raisedwork.

later episode (*see Plate 36*), that of her intercession when Haman, the King's minister, plots against the Jews in general and Mordecai in particular. Esther is seen coming before her husband, who holds out his sceptre as a sign that he will receive her invitation to a banquet; the feast scene, with Esther entertaining Haman and her husband, is portrayed and so is the further vignette of Haman hanging on the gallows 'fifty cubits high' that he and his wife, Zeresh, had prepared for Mordecai.

Another picture relates the story of Susanna, daughter of Hilkiah and wife of Joachim, as told in the Apocrypha. Seen naked but for a strategically placed shawl, Susanna, 'a very fair woman and one that feared the Lord', is accosted by two old men who later accuse her of adultery with 'a young man, who there was hid'. Once again further episodes from the story are included: Daniel is seen coming forward successfully to defend her life. As with all other stories mentioned, this panel of Susanna and

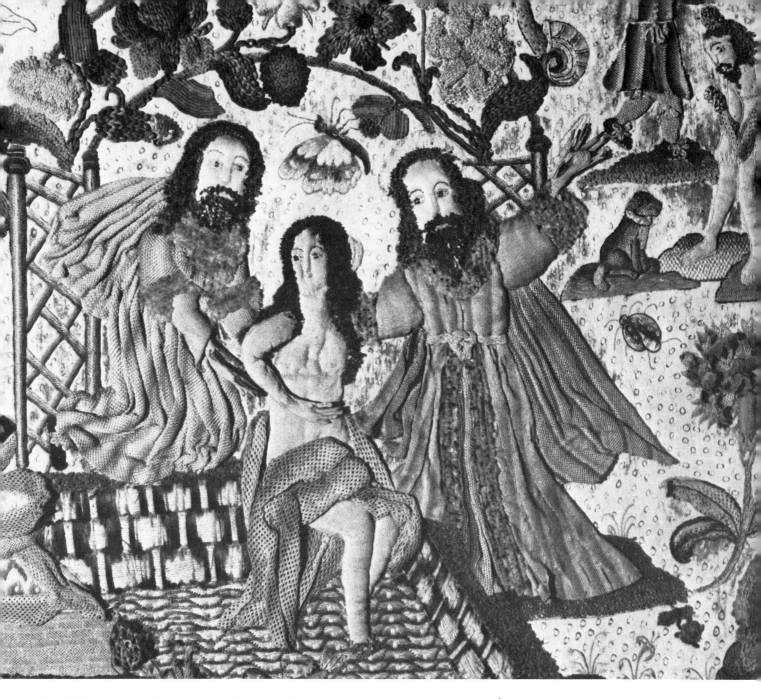

the Elders provides an insight into the religious preoccupations of
seventeenth-century English gentlewomen concerned with purity, family
life, royalty and the dominant role of women. It is appropriate, therefore,
that the only one of Parham Park's needlework pictures to show a New
Testament story includes Mary presenting the Child to the Magi, an
episode which combines all these themes.

ESTHER AND AHAS

Plate 36 The themes of female determination and bravery recur in the needleworks at Parham Park. Here, Esther comes unbidden before her husband, King Ahasuerus (Xerxes) of Persia, to plead successfully for her people, the Jews. (This story can always be identified by a gallows from which the traitor Haman hangs.)

Traquair House, Peeblesshire.

17

Traquair House

Flowers in Profusion

LOVERS of beauty are seldom blinkered and it is not surprising therefore that flowers appear again and again on outstanding needleworks. Within this anthology, indeed, a veritable bouquet could be gleaned from, for example, Lady Evelyn Stewart-Murray's whiteworks, from nineteenth-century items in Helen Allen's collection and from canvasworks two hundred years older at Parham Park. Flowers also appear as applied motifs on coverlets at the American Museum, on beds at Hardwick, Glamis and Parham and as oversized random motifs on the Mellerstain panel, to name but a few more examples.

Particularly remarkable among floral needleworks are the colifichets (double-faced silk and metal thread embroideries on paper) and outstanding early seventeenth-century canvaswork panels at Traquair House, an imposing storybook castle in wooded parkland in Peeblesshire. Home of the 20th Laird of Traquair, Mr Peter Maxwell Stuart, it has been continually enlarged and fortified in the typical Borders style of thick walls and tiny windows, designed to keep out the Scottish weather and, in past times, English marauders. For a time, the house was approached through outer wrought-iron gates, erected in 1737 by two workmen for a total cost of £22 19s and two gallons of ale, and flanked by two stone bears, reminders of animals that in earlier times were hunted in surrounding forests. But now the gates are closed, as they have been since 1745 when Bonnie Prince Charlie passed through them, at which time the 5th Earl of Traquair swore they would never be completely re-opened until a Stuart king once more sat on the throne in London.

Inside the house there are always marvellous flower displays and bowls

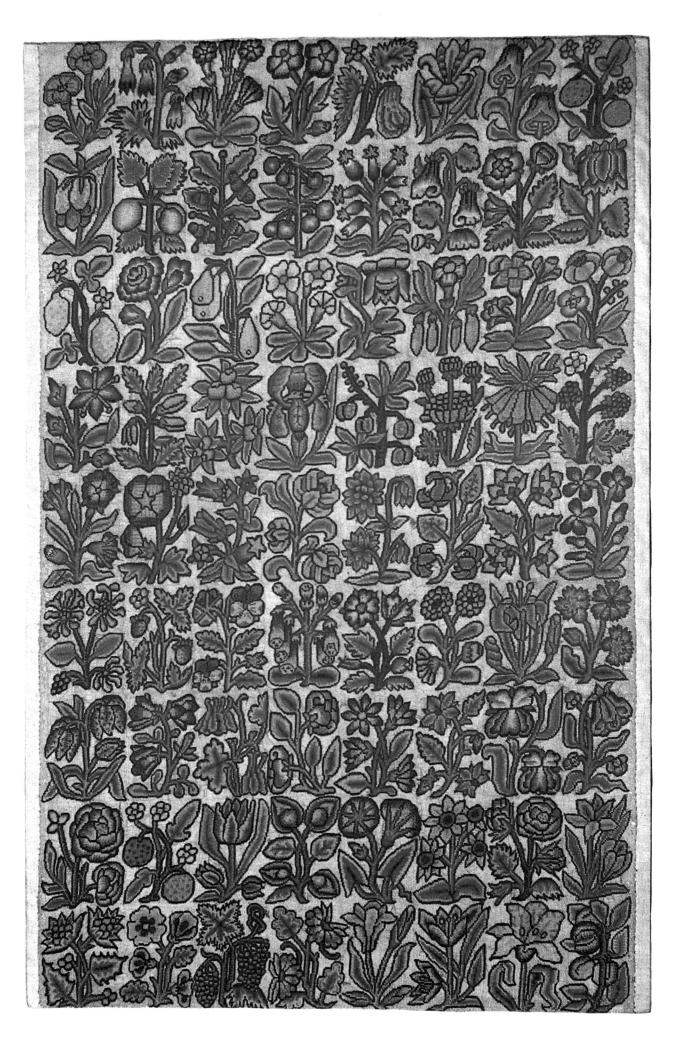

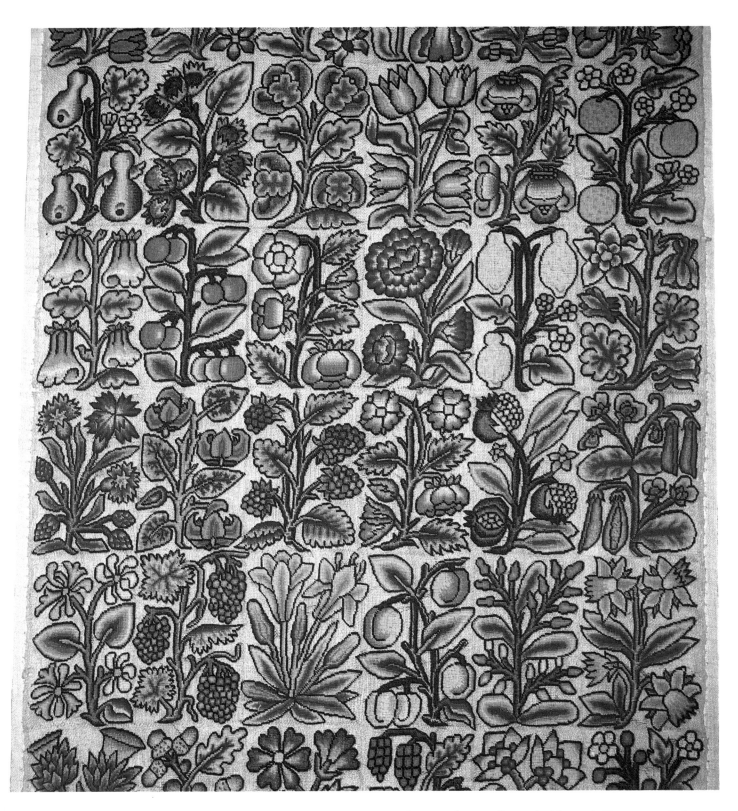

Plate 37 (left) One of Traquair House's outstanding floral canvasworks portrays no less than seventy-two different flowers. Dated *c.* 1610, the panels have carefully aligned black-outlined motifs; reserves are unworked and the motifs may have been intended for subsequent individual application to such hangings as those now at Glamis Castle.

Plate 38 (above) Silks on the Traquair House tentstitch panels have kept their bright colours for over three hundred and fifty years.

of pot-pourri, appetizers for the needlework flowers to come. Family portraits gaze down from the walls, including a full-length oil of John Stuart (1600–59), 7th Laird and later 1st Earl of Traquair. One of his four grandsons, Charles, the 4th Earl and 10th Laird (1659–1741) and his wife, Lady Mary Maxwell (1672–1759) had seventeen children, of whom the fifth and sixth, Lady Lucy (1695–1768) and Lady Anne Maxwell Stuart (1696–1755) are of special interest to needlework historians. In 1713 the two young ladies were sent to the Ursuline Convent of St Jacques, Paris, to 'finish' their education with such accomplishments as dancing, spelling, French and fine needlework under the instruction of sisters who included among their number Sister Arabella Waldegrave, grand-daughter of James II (1633–1701) and his common-law wife, (another) Arabella Stuart. The girls spent six months at the convent, after which they were among students asked to leave when tuition was restricted to younger pupils, but during their time there they obviously worked hard at their needlework, for four paper colifichets survive.

Colifichets were worked with silk and metal thread satin stitches through holes already needle-pricked on paper, perhaps letter paper, to produce patterns identical on both sides of the sheet. To prevent such a fragile 'ground' tearing during embroidery it might have been placed between a protective sandwich of two sheets of card with holes, say 2 in (5 cm) across, cut in them so that the inner paper could be rotated, with only one area visible at one time. The delicacy required in embroidering on paper, an art probably introduced from China at the end of the seventeenth century, restricted its following and it is not surprising that the few items still extant were worked within the fastidious surroundings of

LEFT One of the colifichets, double-sided paper embroideries, worked by Lady Lucy and Lady Anne Maxwell Stuart who were sent to an Ursuline convent in Paris in 1713.
paper worked in silk and metal threads, mostly in satin stitch, 13 × 9½ in, 33 × 24.1 cm

RIGHT Individual floral motifs typically had stumpy terminals and drooping flower heads: these two tentstitch panels are from a set of thirteen now in the Royal Ontario Museum.
average size 8¾ × 7¾ in, 22.2 × 19.7 cm

convent life. As would be expected, most examples (including two of the Traquair House quartet) show religious subjects. Glorious floral bouquets occupy the other two colifichets. Full-blown peonies, small lilies and other flowers are arranged in exaggeratedly convex pots standing on tables covered with fringed cloths hanging to striped scrolled legs. There is a sophisticated finesse to these designs, indicative of the controlled patience needed for their planning and execution.

Equally well-known are Traquair's brilliantly coloured canvaswork flowers, breathtaking panels executed about a hundred years before, *c.* 1610, probably by adult needlewomen within the household of young John Stuart, who had become 7th Laird at the age of seven. Because of the sheer scale of these canvasworks, it is unlikely that one embroiderer was responsible: perhaps several hands worked together on designs which may already have had their black outlines worked in a manner similar to those panels on which Mary Queen of Scots had been working at Lochleven Castle some fifty years earlier. The panels, all with silk and wool tent and crossstitch flowers, sometimes with accompanying birds and animals, and carefully aligned with unworked reserves on singlethread linen canvas with twenty-six threads to the inch, are supreme in their design, colouring and ambitious scale. Contemporary examples of slips, individual flower motifs, may be found in such museum collections as the Valentine and the St Louis and Royal Ontario Museums, and the Victoria and Albert Museum has a panel with eleven flowers on it, but at Traquair House one needlework panel alone has seventy-two *different* flowers.

One of the panels, displayed warp threads horizontal, selvedges thus at top and bottom, is embellished with twelve tentstitch bands worked along its length in a repeating design of scrolled flowers and oak leaves as if suggesting the close proximity to England. Pencilled marks bordering separation between bands indicate that the panel might be cut into strips which could later be joined and twisted decoratively around a pole similar to that now standing nearby. The uncut panel was obviously not worked on a frame for it is considerably distorted. Six other uncut panels were, however, probably held taut while embroidery was worked sideways on (tentstitches are set diagonally up to the left). These exactly rectangular canvases are all decorated with individual motifs, not spotted at random but carefully stylized to fit into a required area, generally an upright portrait rectangle, with the minimum space between motifs. Although some flowers at first appear similar they are in detail unique. Many, with stumpy foliage typical of the early seventeenth century, are directly recognizable as having been taken from folios of the *Miscellany* or *Commonplace Book* published in 1608 by Thomas Trevelyon, possibly a Cornishman of whom there is no other record.

The purpose of these panels is uncertain, although probably worked motifs would have been carefully cut out and applied to hangings of silk,

ABOVE Drawing of a cornflower embroidered in the seventeenth century. *taken from a floral slip in the Victoria and Albert Museum*

Later in the century flower patterns became more curvilinear: this honeysuckle was produced by John Overton, who published at the White Horse, City of London, 1667–1707. (The drawing can be compared with the engraving on page 17 of the Mellerstain pattern book.)

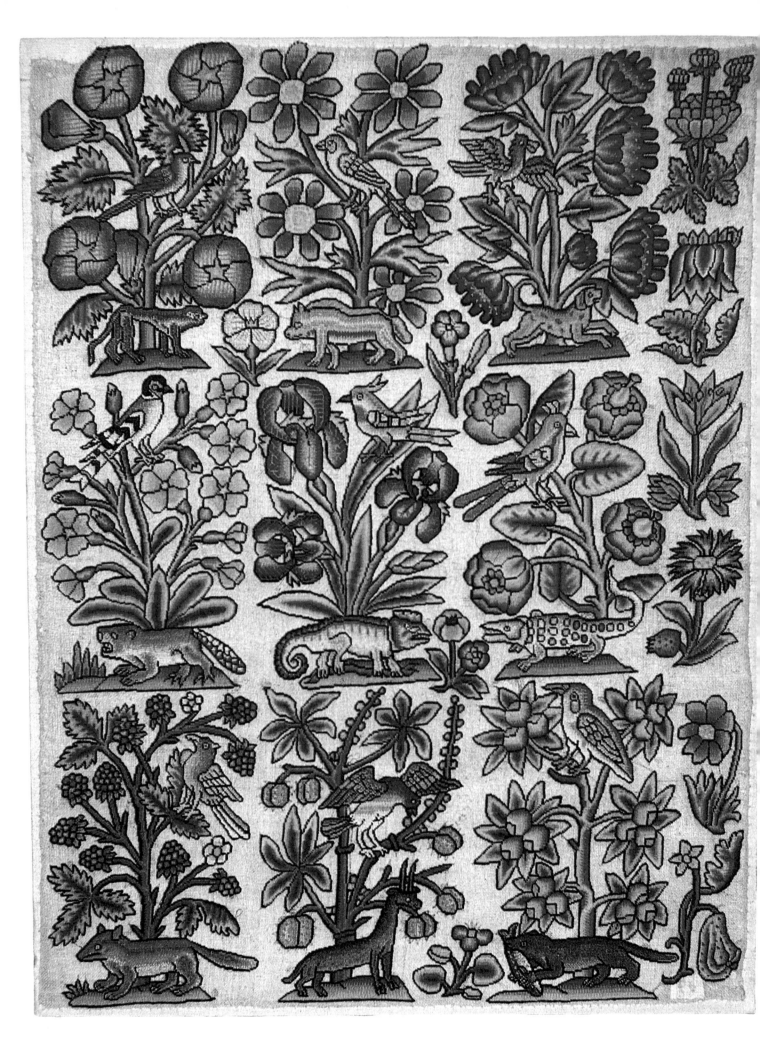

velvet or linen such as those now in King Malcolm's Room at Glamis. The close alignment of motifs on the canvas indicates that if this was the eventual intent the minute area of surplus canvas around each cut motif would have been carefully turned under before it was hemmed to its final ground. In other cases where there is more surplus available, motifs could be held to new grounds by individual surplus canvas threads separately plunged (taken through the surface of the new ground).

Fortunately, however, none of the Traquair floral canvasworks has been cut and they remain floral bouquets *per se*. Perhaps the most beautiful of them all is the panel with seventy-two different flowers in nine horizontal rows (*see Plate 37*). Here are daisies, pansies and a strawberry; in the sixth row, a pink rose with twisting stem can be compared to a similar individual

RIGHT Detail of one of the Traquair House tentstitch canvasworks, *c.* 1610: twelve bands of embroidery are placed parallel with the selvedges, displayed horizontally, and each band may have been intended for subsequent embellishment of hangings. *bands 1½ in, 3·8 cm, wide*

BELOW Detail of a panel: surplus canvas between motifs is economically filled with individual spot motifs. *detail of panel 29½ × 22⅞ in, 74·9 × 58·1 cm*

Plate 39 (left) Other panels at Traquair have flowers, so beloved of embroiderers of all eras, delightfully set with exotic birds and animals, some imaginary. The surplus areas of canvas are economically filled with individual random motifs.

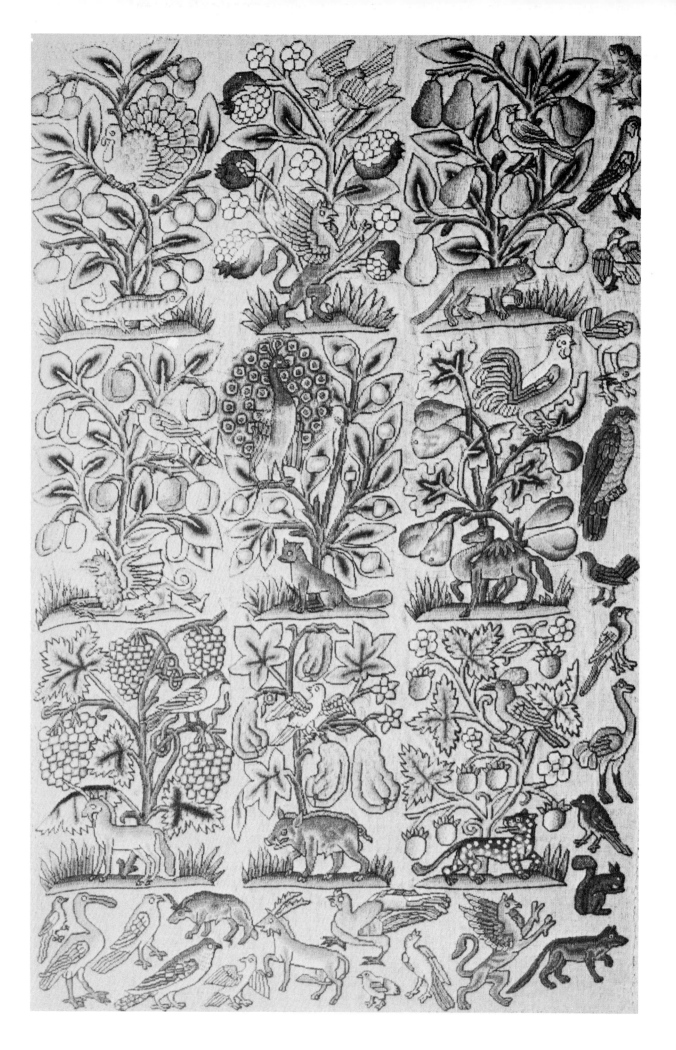

OPPOSITE A panel with motifs of birds, flowers and animals, some highly imaginary.
linen canvas worked with silk tent stitch, 35⅜ × 22¾ in, 89·9 × 57·8 cm

RIGHT Detail of the panel with forty-two flowers: motifs show typical early seventeenth-century stumpy terminals.

slip in the Royal Ontario Museum; and a cornflower to the right of this row is more simple than another piece in that same museum. At first sight it might seem that some of the flowers have been repeated on another panel which has only forty-two flowers, but closer inspection reveals that even the cornflower, a possible facsimile, is in fact slightly different (this version has four florets).

The variety of design is endless (*see Plates 38 and 39*). Some of the other panels have tripartite motifs of birds harmonizing with animals and fruit: a peacock, fox and berries; a turkey with a lizard and cherries; or an un-identified bird with a dragon and a pomegranate and surplus canvas to the edges of the panel filled with random motifs of a dragon, a squirrel, birds, etc. Another fantasy panel has an armadillo and a chameleon among its motifs, and here again surplus canvas is economically filled with indivi-dual devices, in this case flower sprigs.

A fresh look at any one of the Traquair House canvasworks can only provide renewed excitement, for although initially their colours dominate, providing a brilliant palette of bright yellows, turquoises, reds and greens, with increasing familiarity the beauty, intricacy and sheer ingenuity of the designs become apparent.

18

The Valentine Museum

Beautiful Needleworks amid Elegance

TUDYING embroidery in an elegant atmosphere exquisitely appointed with many other fine collections must, without doubt, encourage the acceptance of decorative needlework as a major art form. Few places provide a more favourable ambience than the Valentine Museum, and its subsidiary Textile Resource and Research Center in the Wickham-Valentine House and three neighbouring buildings in Richmond, Virginia.

After a circuitous route through downtown Richmond, East Clay Street seems like an oasis. The complex known colloquially as 'the Valentine' rises imposingly on one side of the narrow brick-pavemented tree-lined road. The main building, the Wickham-Valentine House itself, was designed in 1812 by the Charleston architect Robert Mills (1781–1855) for John Wickham (1763–1839) who had purchased land in Richmond seventeen years before. Wickham, described as the 'eloquent, witty and graceful' lawyer most famous for having assisted in the successful defence of Aaron Burr during his trial for treason in 1807, later made extensive alterations to Mills's three-storey symmetrical building. He stuccoed the exterior, changed much of the interior and in the garden he built a *garçonnière*, a boys' house, in which some of his seventeen children (by two marriages, first to Mary Fanning and then to Elizabeth Selden McClurg) could live with their tutor.

Wickham left the main house to his son William and it thence passed through two more owners before it was bought in 1882 by Mann Satterwhite Valentine II (1824–92), a local philanthropist and proprietor of the Valentine Meat Juice Company, and father of Granville Gray, Edward

The Victorian Parlor in the Wickham-Valentine House, Richmond, Virginia. Gesso and gilded cornices and mirror surround were placed here 1853–8 and drapes in contemporary style are held back with unusual green glass and brass tiebacks. A seated cherub figure of French bisque stands flanked by two French porcelain vases on a low marble-topped console table. The central table, on a Meshad-Korrishan carpet c. 1830, supports a small marble figure by Hiram Power.

P. and Benjamin Valentine. Following the example of his own parents, Mann Satterwhite and Elizabeth Mosby Valentine, he was a gregarious patron of the arts, and as well as avidly collecting and commissioning special works he opened the door of his East Clay Street home to other enthusiasts. On his death ten years later Valentine's will stated:

I desire to establish in the City of Richmond, Virginia, an institute to be called the Valentine Museum, for the purpose of preserving and accumulating objects of Archaeology, Anthropology and other kindred arts, and ... for publishing literary, historical and scientific papers compatible with the ability and amount of endowment of the said institute.

This instruction was to be implemented, according to a codicil, by his trustees, who were his sons and brother, the sculptor, Edward Virginius Valentine (1838–1930).

Although the Valentine Museum was in existence by 1898, the house was not fully ready until some thirty years later. In 1928 major renovations were undertaken, for instance, to undo mid-nineteenth-century elaborations which had been made before the Valentine family took possession, and a neighbouring row of three houses which had been built in the 1870s was incorporated into the new museum complex. Today the Valentine, officially opened in 1930 as a museum of Richmond architecture and social life in the late eighteenth and early nineteenth centuries, has four major symbiotic divisions. As well as the Museum of the Life and History of Richmond there is a Junior Center, a Research Library and the Textile Resource and Research Center conceived in 1970.

In 1971 a spring assembly established an annual gathering of participants from many fields to study all aspects of embroidery and to learn new techniques. Later other assemblies were held, in England under Mildred Davis's guidance and, in Richmond in the fall, to concentrate specifically on conservation, identification and the history of needlework. During these invaluable assemblies it is possible to concentrate on embroidery in the ideal setting of the Wickham-Valentine treasure-house. The novice sampler collector may, for example, learn much from a museum specialist from far afield as they talk during a break from a busy work schedule. It runs an authoritative teachers' certification programme (with teacher preparation, teacher certifications one and two and honour programme levels) as well as offering correspondence courses in crewel and other techniques.

Outside the confines of an assembly, however, the individual visitor will still be able to appreciate the gracious setting of the museum. Perhaps he or she will especially savour the furnishings of the Victorian Parlor, used by the Wickham family for formal entertaining and after-dinner family gatherings and converted by Mann S. Valentine II into a storehouse for some of his treasures. Now it is restored to its former beauty. Between

a pair of tall, richly draped windows crested with wood, gesso and gilt cornices, a pier glass reaches almost ceiling-high. A seated bisque cherub and a pair of French porcelain vases adorn a marble-topped console table beneath. The carpet is Meshad-Korrishan, *c.* 1830, and on a rosewood centre table a small marble figure by Hiram Power (1805–73) faces visitors entering the room. In all the rooms there are furniture, ceramics, paintings and metalwork to savour; these include nearly a hundred mid-nineteenth-century Staffordshire dogs from the Ellen Glasgow collection and a magnificent tea service crafted by the noted Alexandria silversmith Charles A. Burnett (1785–1849). Horologists will admire the tall-case mahogany and brass item worked by William McCabe of Richmond *c.* 1810 and others will especially delight in the many beautiful portraits by such artists as Peale and Angelica Kauffmann (1741–1807).

The textile collection includes the exquisite laces donated by Mabel Foster Bainbridge and over ten thousand costume items which include a brocade dress worn by Mary Ball Washington, mother of the first President, and a tamboured white muslin dress that belonged to Dolley Payne Madison (1768–1849), wife of the White House's fourth occupant. Not surprisingly a great number of the Valentine's costume holdings come from the south, for readily available labour and the local climate meant that many privileged people had large wardrobes. Similarly, many of the museum's 'flat textiles' can also be identified with southern workmanship, for many women had time in which to sew.

Perhaps the best known of all the lovely needleworks in the collection is the 'Westover-Berkeley' coverlet, worked in the 1770s by ladies of the families of William Byrd II of Westover Plantation and Benjamin Harrison IV of the neighbouring Berkeley Plantation in Charles County, Virginia. As has already been shown at the American Museum, coverlet making and quilting were often communal affairs, and the Byrd and Harrison ladies met regularly every other week underneath a tree on the boundary of their properties, spending much time carefully planning before making up their coverlet.

Following local tradition they planned a top of unbleached calico with only partial filling. Applied thin strips of printed cotton divide the calico into geometric shapes infilled with *broderie perse*, applied motifs of printed chintz probably brought from England pre-1776. Intricate sprigs of flowers and, in contrast, larger bouquets have been carefully cut out, their edges turned under and held to the coverlet with buttonhole and chain stitches. A little chipmunk greedily chews a nut; a pineapple, an exotic reminder of the fruit then being imported from the West Indies, indicates the interest the ladies must have had in stitching motifs of objects around them. The patience they had for such fine work was typical of southern life, as illustrated too by another *broderie perse* coverlet worked on the Hillsborough Plantation in King and Queen County. In this instance

Pineapple motif from the Westover-Berkeley coverlet worked in *broderie perse* techniques by the ladies of the Byrd and Harrison families of Westover and Berkeley Plantations in Charles County, Virginia.
drawing of section of unbleached cotton coverlet, $105\frac{1}{2} \times 97\frac{3}{4}$ *in, 267·8 × 248·3 cm*

Another coverlet in the
Valentine collection has an
applied motif of Robinson
Crusoe. The hybrid in front of
which he stands can be
compared to one on the Strong
coverlet at Historic Deerfield.

Embroiderers may have copied
designs from such a treasured
item as this early seventeenth-
century English panel, similar
to some seen at Traquair
House.
*linen panel worked with silk
and metal tent stitch, 10 × 9¾ in,
25·4 × 24·8 cm, overall*

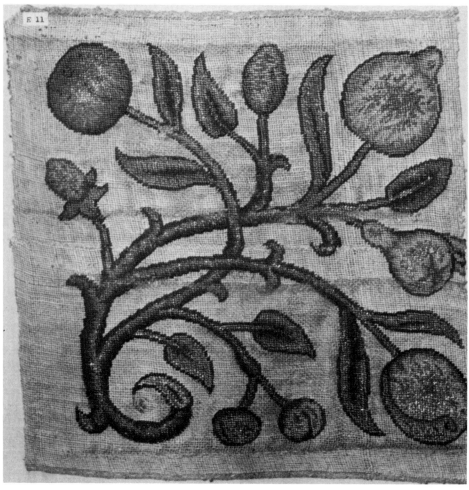

two outer borders, one partly decorated with a repeating ziggurat pattern of applied printed calico, surround a motif of Robinson Crusoe, bearded, barefoot and holding a stick, in front of an enormous hybrid blooming with a floral miscellany of carnation, iris and rose. By stitching a motif taken from the 1719 book by Daniel Defoe (1660–1731), the Hillsborough Plantation ladies indicated that they were familiar with various publications. And, despite the fact that in this case they worked three different blooms on one tree, their botanical knowledge was generally accurate if stylized. They copied flowers and fruits from what they saw around them, or from books or finished needleworks perhaps brought from England.

While their elders may have been involved in executing intricate designs on coverlets and other large projects, young girls practised alphabets and numbers on samplers. Once again patience was required, as evidenced by two items, one worked by TT in 1735 and the other by TL nine years later, decorated respectively with eleven and ten different alphabet renderings. In both cases letters increase in elaboration and size towards the

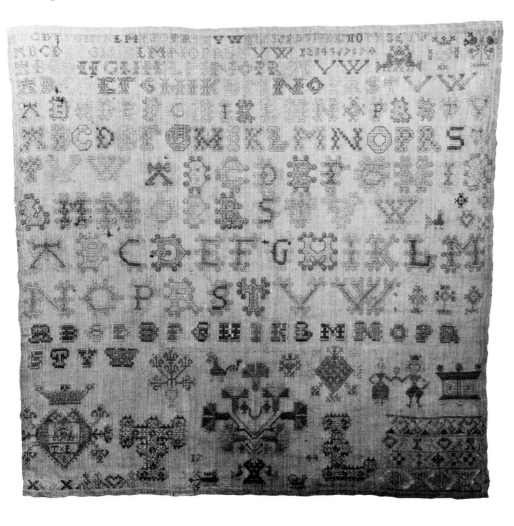

Linen sampler worked by TL in 1744: ten different alphabet renderings are shown, all with the letters JQUXY and Z missing.
linen canvas worked in a variety of silk stitches, 20 in, 55.9 cm, square

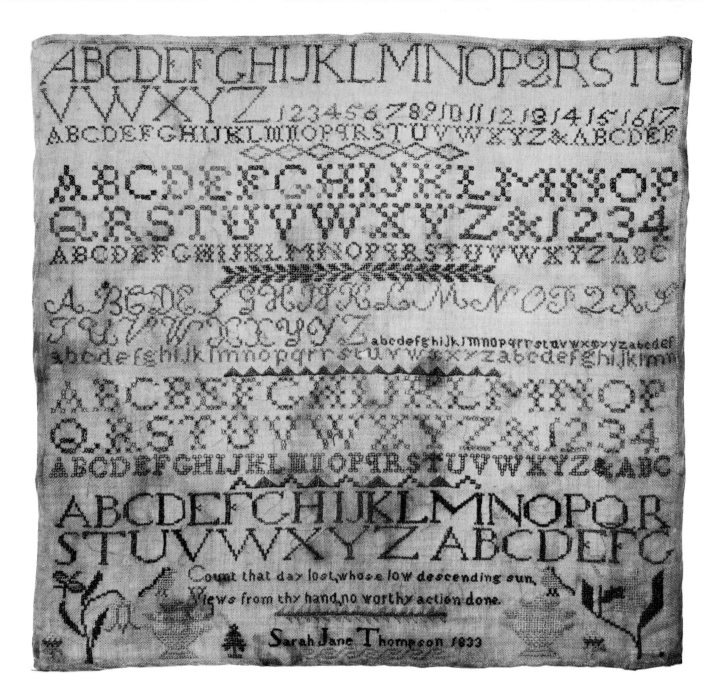

ABOVE Sarah Jane Thompson of Amelia County worked all letters in her ten renderings and digits one to seventeen, repeating 1 2 3 and 4 to fill space.
linen canvas worked in different silk stitches,
$16\frac{3}{4} \times 18\frac{1}{8}$ *in, 42·5 × 46 cm*

OPPOSITE Sampler wrought by nine-year-old Mary Victor in 1764: crowns and initials stand for dukes, earls, viscounts and barons.
linen canvas worked in wools,
$12\frac{1}{8} \times 12\frac{5}{8}$ *in, 30·8 × 32·1 cm*

bottom of the panels as if proficiency advanced but patience decreased as the embroidery progressed. Both samplers have the letters JQUXYZ omitted throughout. By contrast, Sarah Jane Thompson, who finished her testpiece in 1833, included all letters in her ten different renderings. Obviously a fastidious needlewoman, she inscribed her sampler: 'Count the day lost whose low descending sun / Views from thy hand no worthy action done.'

Many of the Valentine's samplers are sophisticated in design and execution. In 1764, for instance, nine-year-old Mary Victor worked a piece that shows a distinguished brick house with three dormer windows in its steeply-sloping roof. Either side are four different crowns neatly labelled DEV and B, thus identifying the symbols of Dukes, Earls, Viscounts and Barons, an exhibition of the young embroiderer's grasp of the kind of general knowledge required of a well-brought-up lady.

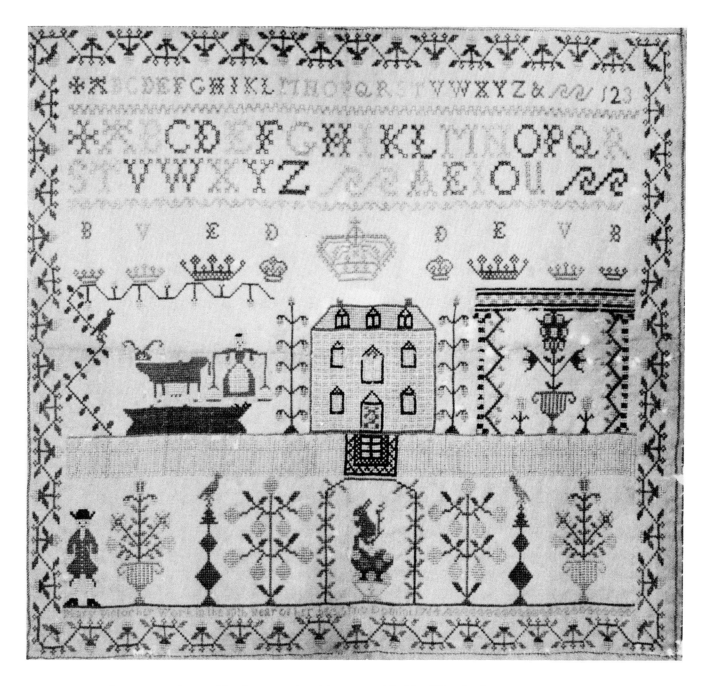

Some sampler inscriptions offer the moral guidance typified by Elizabeth Ellett, who stitched:

> *Virtue's the chiefest Beauty of the Mind*
> *The noblest Ornament of human Kind*
> *Virtue's our Safeguard and our guiding Star*
> *That stirs up Reason when our Senses err.*

This statement acts, indeed, as a reminder that beauty pervades the needle-works of 'the Valentine'. Here, as well as admiring historic works, students and others can also perfect their own prowess through assemblies and other teaching.

19

The Washington Family

Patriotic Embroideries

EFERENCE has already been made to the family associations of embroidered records and mourning pictures. This chapter reflects on needleworks connected with the most famous of America's first families. At least two members of Washington's immediate family embroidered and examples of their work can be seen at Mount Vernon and the Woodlawn and Kenmore Plantations, all in Virginia. Of related interest too is the fact that the president's death was to inspire memorial or mourning pictures worked by patriotic needlewomen all over the country.

Mount Vernon, the Washington family estate, was acquired by the future president in 1761 after the death of his half-brother, Lawrence. George Washington described his land, said to be the best in Virginia, in glowing terms: 'No estate in United America is more pleasantly situated than this.' His father, Augustine, had sensibly built in the best possible position, with commanding views over the Potomac to the low Maryland hills beyond. Washington increased the height of the house from one-and-a-half to two-and-a-half storeys and he undertook extensive interior renovations partly necessitated by family demands. After his marriage in 1759 to Martha Dandridge (1731–1802), widow of Daniel Parke Custis, Washington accepted responsibility for her two children, John (1753–81), known as Jacky, and Martha Parke Custis (born 1755), called Patsy. Washington was extremely fond of them, and when Jacky died of camp fever caught at the Siege of Yorktown Jacky's two children, Eleanor (1779–1852), known as Nelly, and George Washington Parke Custis became his wards.

Managed by the Mount Vernon Ladies Association since 1860,

View from the colonnaded east porch at Mount Vernon, Washington's home in Virginia, beside the Potomac.

Washington's home is a shrine at which thousands of visitors pay homage every year. After a walk around the edge of a large lawn, they enter the house and slowly progress through the Dining Room; painted in 1785, it was garnished a year later with carved mantel and Worcester porcelain given by Samuel Vaughan, an English admirer to whom Washington wrote in thanks: 'I have the honour to inform you that the chimney-piece is arrived and, by the number of cases (ten) too elegant and costly by far, I fear for my own room and the republic style of living.' The Dining Room opens behind to the east – river – side on to a white-columned portico set with a line of high-backed chairs that, in the early evening light, cast a ballet of shadows against the beautiful backcloth of the Potomac. Back inside the house, the Little Parlor has five Windsor chairs made by Robert Gaw of Philadelphia and now furnished with canvaswork seat covers in a facsimile of 'Martha Washington's shell pattern', adapted from at least a dozen panels worked by that lady between October 1765 (when her husband ordered canvas, yellow worsted and silk floss from England) and her death thirty-seven years later.

This shell pattern must surely be one of the most famous and popular embroidery designs of all time. As can be seen on an original now in the museum outside the house, Martha Washington's work comprises repeating fluted shells worked mostly in orange and gold silk and wool cross stitch. Perhaps Mrs Washington was inspired by shells found on nearby beaches; and perhaps she worked with the canvas held taut in the rectangular mahogany table-standing frame now to be seen in an upstairs bedroom. It is fascinating to imagine what she may have overheard when sitting at her work. After Washington's death in 1799 she probably embroidered as she talked with her daughter and son-in-law, Lawrence Lewis, Washington's nephew, who kept her company at Mount Vernon. Martha Washington is said to have taught Mrs John Hancock, who worked the sections of shoe tongues now to be seen in the museum. She may, too, have instructed her own daughter, although Nelly is known also to have taken needlework lessons in Philadelphia during the presidency.

When Nelly married (*see Plate* 40) Washington put aside two thousand acres for the couple but he urged them to build straightaway. William Thornton, architect of the Capitol, was accordingly commissioned to design what is now known as Woodlawn. It was not completed before Washington's death, however, which meant a three-year sojourn at Mount Vernon, during which time Nelly's first children, Frances Parke and Martha Betty Lewis, were born. After Martha Washington died in 1802, Nelly and her family removed to their own home ten miles west. Woodlawn is an imposing two-storey mansion of warm red brick with wings reached by corridors to either side. The house was to see much unhappiness during Nelly's lifetime, for seven of her eight children predeceased her; and in 1848 the entire estate was offered for public sale so

Diagram taken from Martha Washington's famous crossstitch 'shell pattern'.

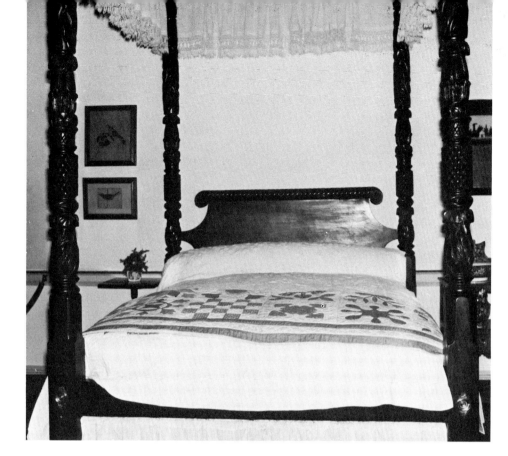

that during her last four years she would have been aware that new owners were cutting down trees and dividing her precious land into small farms. Woodlawn subsequently had four more owners before being sold in 1948 to the Woodlawn Public Foundation, a member of the National Trust for Historic Preservation which now officially administers the house and its grounds.

Several examples of Nelly Custis Lewis's embroidery can be seen in her house. A crossstitch panel of flowers in a vase embellishes a fire screen in the music room, and in the master bedroom, conveniently and typically also on the ground floor, there can be seen a canvaswork footstool and another floral picture. The Lewis children all slept upstairs, and in son Lorenzo's room there is a small cross and tentstitch picture of a Spanish boy on a donkey worked by Nelly. A woman of many talents, other pieces by her exhibited throughout the house include little bookmarks with patterns worked in silk and chenille cross stitch through the widely spaced large holes of perforated paper, and a delicate hand-coloured drawing, now in the girls' bedroom, of a cedar waxwing probably copied from Alexander Wilson's *American Ornithology: or The Natural History of Birds of the United States.* Like Martha, Nelly may have executed canvasworks with her ground canvas held taut on a rectangular frame. The frame now standing in the master bedroom, however, is a sturdy floor-standing piece, which sensibly incorporates two thread containers on the vertical supports.

Nelly's husband Lawrence was the son of Fielding Lewis and his second wife Betty Washington (born 1733, the year after the birth of her famous brother George). Lawrence was brought up on Kenmore Plantation, Fredericksburg, in another red brick bulding, built 1752–6, in Georgian style

LEFT The girls' bedroom is furnished as it could have been in 1815 when three of Nelly's children were sixteen, ten and two. The quilt on the empire four-poster was a present; on the wall behind can be seen Nelly's watercolour of the cedar waxwing, probably copied from Alexander Wilson's *American Ornithology: or The Natural History of Birds of the United States.*

RIGHT Drawing of Nelly's painting.

An embroidery frame at Woodlawn, now set with two Portuguese samplers, has handy containers for holding threads.

and, true to the briefings of Grand Tour devotees of that time, furnished with carpets from the Levant, Chinese porcelain, English furniture and silver and Dutch Delftware. Now organized by the Kenmore Association, the house is still furnished with many family treasures. In the ground floor library, for example, best known for its plaster ceiling carefully moulded with reliefs of the four seasons, there is a gaming table illuminated by four crested silver candlesticks and, behind, another floor-standing embroidery frame set with a piece of crewel.

Plate 40 Many members of America's first First Family are associated with fine needleworks. This engraving (right), now hanging at Woodlawn Plantation, records the wedding of Nelly Custis, Martha Washington's granddaughter, to Washington's nephew, Lawrence Lewis. The President escorts the bride as her grandmother follows behind.

Plate 41 (below) This embroidered picture was worked by Martha Washington and Betty Lewis Carter from Savage's 1796 painting: the President and his lady are shown with Nelly and her brother George Washington Custis.

House owners in the Fredericksburg area, fifty miles south of Mount Vernon and Woodlawn Plantation, would have enjoyed much of the air of southern elegance referred to in the chapter on the Valentine. Sometimes boys were sent away, perhaps as far as England, to be educated, and their mothers and sisters would undoubtedly have been dressed in the finest robes, perhaps brought from Paris. Even their fathers wore such elegant garments as the French satin waistcoat exquisitely embroidered in silks and now sometimes publicly displayed in a ground floor office. Upstairs

The office at the Lewis family home at Kenmore, Fredericksburg, is furnished with a maple chaise longue probably made in Philadelphia, 1740–60. The flamestitch cushion is worked in simulation of knitting and in front is displayed a silk taffeta waistcoat decorated with silk chain and satin stitches and bullion knots. On the English reading stand behind is an open copy of William Duane's *First Principles of Military Discipline.*
cushion 12 × 21 in, 30.5 × 53.3 cm, and waistcoat 26 in, 66 cm, long

can be seen a needle painting (*see Plate 41*) by Martha Washington and Betty Lewis Carter, Lawrence Lewis's sister, who together worked a silk copy of Savage's 1796 painting of the Washington family. The president himself is known to have purchased at least four of the engravings which the artist made from the painting in 1798. George and Martha Washington are shown with her two grandchildren and a servant around a cloth-covered table on which a map of the Washington area is being studied. To the left the president leans back, his right hand resting on his young namesake's shoulder. Opposite him, Martha, her face characteristically firmly set, points to the 'Capital City' then being developed on the banks of the Potomac. Nelly helps to keep the map unrolled.

During his lifetime Washington therefore stimulated members of his own family and perhaps others besides to embroider patriotic pictures. After his death, however, came a whole flood of tearful embroideries worked in honour of the great president. Sometimes marked 'sacred to Washington' or the like, Washington mourning pictures typically have likenesses of the dead hero surrounded by other memorabilia. A great number of 'Washington memorials' resemble another engraving, 'In memory of General Washington and his lady' (first published in 1804 and reissued ten years later), and others took inspiration from such contemporary funereal accessories as Ebenezer Clough's special Washington wallpaper, printed in Boston in 1800. Washington memorials continued to be embroidered by patriotic Americans for many years, and examples are to be seen today in many museum and private collections. One particularly fine piece, inscribed either side of the hero's likeness, 'Born / 1732 / First / in / war / first / in / peace' and 'Died 1799 / first / in / fame / first / in / virtue' is now suitably displayed at another National Trust house, the Shadows in Iberia, Louisiana, which was built by David Weeks, husband of Nelly's daughter Angela's sister-in-law, Mary Conrad.

Even today indeed the image of the Washington family is close to the heart of many patriotic embroiderers. As well as Martha's shell pattern, her grand-daughter Nelly's cedar waxwing is only one of many family artefacts that have now been copied on canvas, and Woodlawn Plantation is the home of an annual spring exhibition which has helped pave the way for artistic recognition of embroideries displayed in historic surroundings.

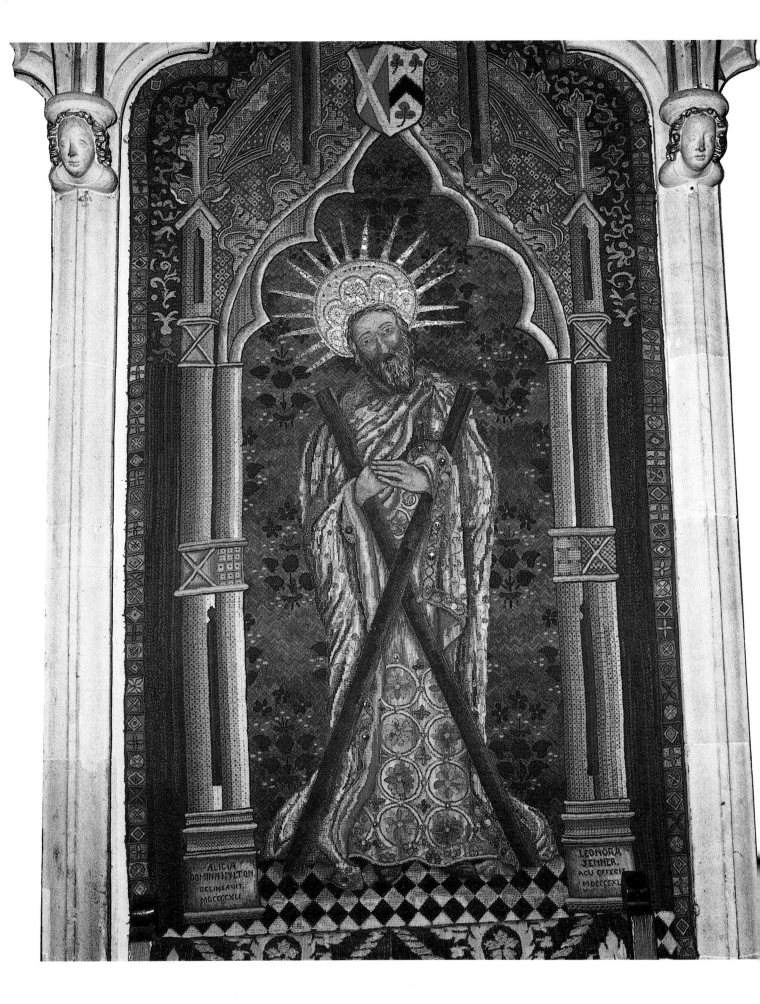

Plates 42 and 43 Among the nearly two hundred unique
panels in the main quire of Wells Cathedral is the centre of
the triptych hanging above the bishop's throne, showing
St Andrew, patron of the cathedral, his robes richly
embellished with metals and semi-precious stones.

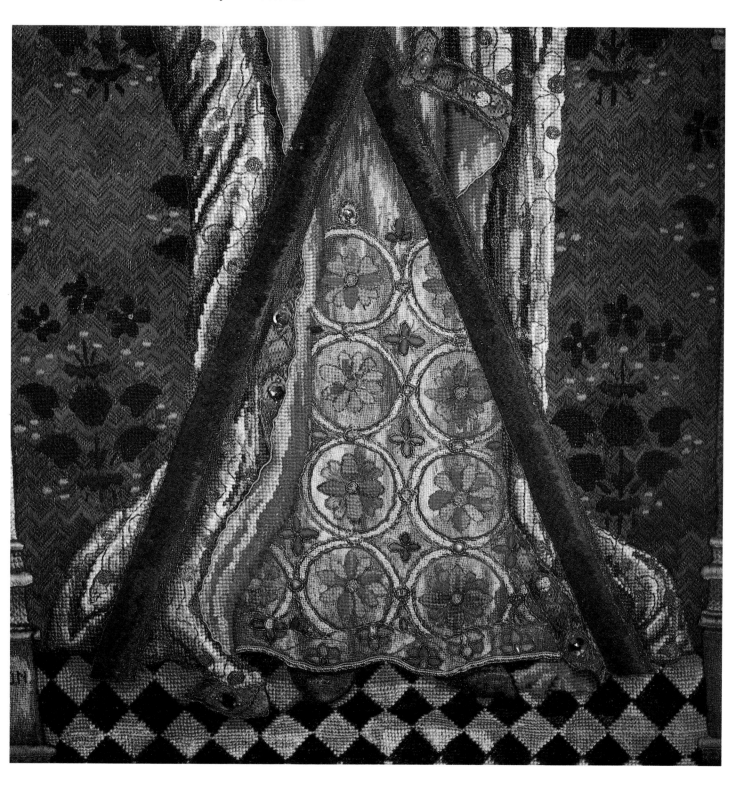

20

Wells Cathedral

The Quire Canvasworks

OR many years, even centuries, churches have benefited from offerings of needleworks, and congregations all over Britain and America continue to work specific projects such as those seen in the National Cathedral. One of the most ambitious and fascinating single collections of canvasworks is that specially worked for the quire of Wells Cathedral. What makes these items so extraordinary is that over two hundred intricate panels were designed by one lady, and were executed in an especially large number of different canvaswork stitches.

The bishopric of Wells, named after a group of springs which flow into a moat surrounding the Bishop's Palace, was established in 909 when Athelm made his cathedral within a Saxon church built *c*. 705 by King Ina of Wessex (688–726). For a short time the see was transferred to Bath but in 1245 the combined title 'Bath and Wells' was adopted. From a marketplace outside the cathedral limits, a covered gatehouse (the 'Penniless Porch' where beggars once sat) leads to the wide expanse of the green around which the cathedral houses are grouped. At the far end the main building's two magnificent west towers, consecrated in 1239 by Bishop Jocelin, surmount a façade where almost lifesize limestone statues of kings, saints, bishops and biblical figures stand.

The oldest parts of the present structure within are the quire and transept, raised in the penultimate decade of the twelfth century, and in general little has been changed for the last five hundred years. Here are pointed arches in association with compound pillars of grey oolite piers masked by twenty-four slender shafts rising to stiff-leafed capitals. The eastern end of the cathedral was extended during the first years of the fourteenth

The famous west front of Wells Cathedral, Somerset, built *c*. 1230.

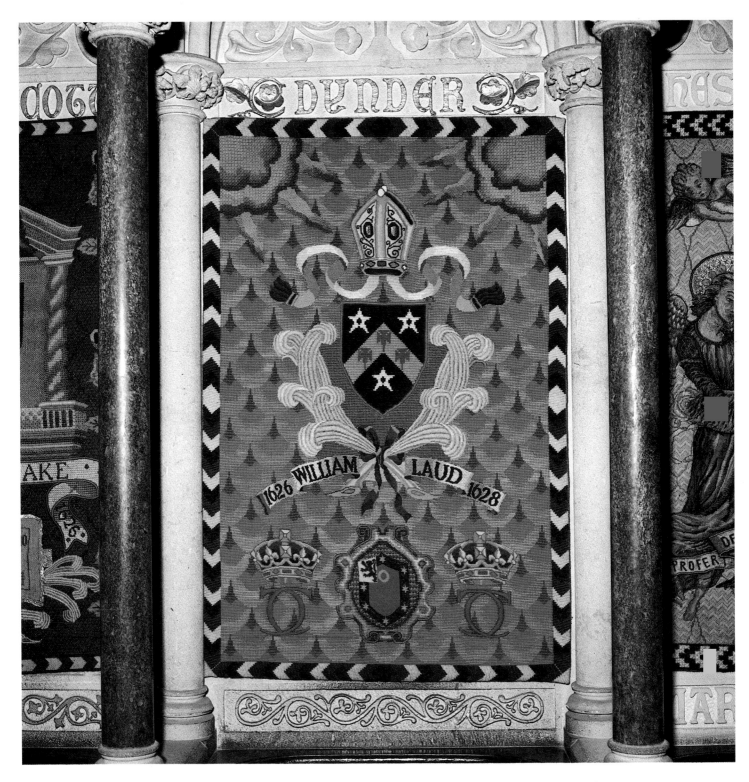

Plate 44 Thirty-nine stalls in the Wells Cathedral quire
have banners remembering bishops of the see. William
Laud was Bishop of Bath and Wells from 1626 to 1628. His
memorial banner is embellished with his own arms above
those of St John's College, Oxford, and to either side are
crowned interleaved Cs denoting loyalty to Charles I.
Laud's banner is flanked by that of his successor, Arthur
Lake, and by a classic panel for the treasurer of the
cathedral, who is represented by the symbols of his office.

Plate 45 One of the symbols of wind aptly placed at the corners of Richard Kidder's panel; Bishop from 1691 to 1703, he was killed by the fall, during a storm, of the palace chimneys.

King Ina of Wessex, who built a Saxon church at Wells in 705, is commemorated on a substall canvaswork panel in the quire.

century to provide a large enclosed quire with retrochoir and lady chapel behind. In 1933 the Friends of Wells Cathedral were set up to help furnish and look after the cathedral's fabric. As well as financing repairs to stone-work in other parts of the building they turned their attention to the chilly appearance of the quire, with its stone canopies and backs to prebendal stalls and dark fourteenth-century oak substalls. The quire had at one time been equipped with embroideries donated by Polydore Vergil, an Italian historian who in 1525 published a list of historical sources in England; as Archdeacon of Wells from 1508–24, he had donated hangings in the quire. These are thought, however, to have been destroyed by zealous Puritans in the seventeenth century.

The Friends therefore decided to undertake new canvaswork hangings, a mammoth project that resulted in the three unlined panels hanging above the bishop's throne, thirty-nine stall banners lined with dark blue and boxed cushions, thirty-six back and thirty-five seat cushions for the higher row of substalls and thirty-one back and seat panels for the lower substalls, as well as eight bench covers in the main body of the quire and numerous other bench covers in the presbytery immediately before the high altar, and runners and kneelers in the lady and other chapels.

All the canvasworks were designed by Lady Hylton (1874–1962), daughter of the 3rd Marquis of Bristol. In 1896 she had married the Hon. George Jollife, who was to succeed to the barony in 1899. Described as 'having great charm and ... unusually cultivated, for she knows something of Italian history and literature', she had studied art under the great impressionist Sickert (1860–1942) and her own style was compared later to that of E.H.Shepard (1879–1976), best known for his illustration of *Winnie the Pooh* and *The Wind in the Willows*.

Lady Hylton was helped considerably in the design of the Wells quire

canvasworks by the then Dean, Richard Henry Malden, by A. Vivyan-Neal and by the Surveyor of the Fabric, Sir Charles Nicholson. They felt it important that the dominant colours should not conflict with the glorious east window, still with early fourteenth-century glass; the main fields of the stall banners were accordingly planned alternately red and blue, with the occasional gold reserved for stalls of the *quinque personae* (the dean, precentor, archdeacon, chancellor and treasurer). Apart from the central panel above the bishop's throne, worked on single canvas with twenty-six threads to the inch, all items are single canvas with twenty threads to the inch. A whole gamut of canvaswork stitches has mostly been worked in wools, sometimes hand-dyed with the result that varying

Lady Hylton, designer of the Wells canvasworks, was a methodical organizer: she made work plans for each section of the quire and later, when embroidery commenced, she supervised much of the work from her own home, Ammerdown House, one room of which was 'constantly full of patterns, half-worked canvases and wools'.

Plates 46 and 47 Canvasworks by Edgar Graham Lister
(died 1956) can be seen in the beautiful surroundings of his
home, Westwood Manor. Lister stitched chair and stool
coverings and even full-length wall hangings. (above) One
of the chairs in the Great Parlour, in flamestitch highlighted
with silver thread. (right) A wing chair in the King's Room,
worked in cross stitch, stands in front of a flamestitch-
covered chaise longue.

shades of colour can be seen, particularly on front bench covers, and designs are highlighted with extensive use of silks and some metal threads and semi-precious stones. The bishop's throne panels and the banner above the dean's stall have unique patterns while those of the other *personae* are decorated with devices symbolic of the office concerned. Other stall banners represent all but nine of the bishops who held the see from 1309 to the time of Bishop Wynne-Willson (incumbent 1921–37). Each banner has a central shield displaying the respective bishop's coat of arms surrounded by symbols of his career and other suitable motifs. By contrast, the furnishings of the two rows of substalls are embellished with an intriguing spectrum which alludes to real and imaginary associations with the cathedral, its locality, natural flora and many other subjects. Motifs were copied from a variety of sources including such diverse works as a ninth-century Rheims manuscript, now in the Pierpont Morgan Library, New York, and *Queen Mary's Psalter*, a fourteenth-century work, perhaps from East Anglia and now permanently exhibited in the British Library Department of Manuscripts.

Stitching began in 1937 and later men and women from many parts of the country worked under the difficulties imposed by wartime blackout regulations. As items were finished they were hung or set in place, thus providing continual stimulus for those still at work. Lady Hylton wrote to a friend on 21 July 1941:

You may be astonished to hear the Wells Cathedral work still carries on … doctors say they [the oldest needleworkers] must give up such strenuous pursuits but seven hangings have been hung. I don't assert that it helps to win the war but I don't think it does any real harm.

The last banner was hung in 1948 and the rest of the items finished a few years later, since which time they have become an integral part of the cathedral and in particular the quire.

Countless visitors have admired their design and workmanship, for they are permanently displayed except during recordings, when they are removed to improve the acoustics. Facing west from the high altar, visitors see the bishop's throne immediately to the left and thereafter the stall banners commemorating incumbents, panels hung more or less in chronological order in a clockwise direction. The central panel above the throne (*see Plates 42 and 43*) is inscribed '*Alicia Domina Hylton delineavit MCMXLI*' (Alice Lady Hylton designed this 1941) and '*Leonora Jenner acu effecit MCMXLII*' (Leonora Jenner [Mrs Leopold Jenner of 9 The Circus, Bath] embroidered this 1942). St Andrew, patron of the cathedral, is seen in a pose taken from the fourteenth-century screen at Ranworth, Norfolk. Sumptuously embellished with rich stones and metal threads, the saint stands beneath the see's coat of arms, with his cross impaling that of Francis Underhill, bishop when the panel was worked.

Heraldry plays an important role in the design of this triptych as well

St Ealdhelm, first Bishop of Sherborne, shown on a substall panel playing his harp on a bridge over the river Yeo.

as elsewhere in the quire. Both side panels, worked by Miss Mildred Alice Carr, of 30 The Royal Crescent, Bath, are decorated with a vertical series of coats of arms. The left-hand panel displays, from top to bottom, another St Andrew's cross, the arms of the see of Canterbury held by two flying angels not unlike the gilded ones atop the organ case at the west of the quire, a dragon of Wessex and a raven typical of standards carried by Danish invaders in the ninth century. Beneath, a square panel illustrates the elaborate enamel plaque known as 'King Alfred's jewel'; also ninth century, the plaque itself, now in the Ashmolean Museum, Oxford, is inscribed '*Aelfred mec hecht gewyran*' (Alfred ordered me to be made), denoting its possible association with Alfred the Great (849–99), who succeeded to the throne of Wessex in 871. Continuing down the panel, a motif of the dragon rampant of Somerset is above the cross of Alfred's son Edward, responsible for founding the bishopric, a Wessex dragon and the arms of the abbey of nearby Glastonbury, the only Christian sanctuary to have passed intact from British to Saxon hands in the seventh century.

The right-hand panel is similarly heraldic. Again, from top to bottom, St Andrew's cross and the arms of Canterbury are set above the Wessex dragon. Then, in descending order, come King Alfred's arms and a cross inscribed '*In hoc signes vinces*' (In this cross thou shalt conquer), commemorating the vision of the Emperor Constantine (274–338), who is supposed to have seen the words written in the sky. Next come the arms of Glastonbury, a dragon of Somerset and the arms of the see of Sherborne, Dorset, also founded by King Ina in 705. Beneath, suitably, is the harp of St Ealdhelm (died 709), first Bishop of that see, remembered here, as on one of the substall panels, by the harp that he used to play as he sat

singing on a bridge over the river Yeo. At the base of the panel is the slim cross used by later Saxon kings.

Many hours could be spent studying each of the quire canvasworks but the framework of this anthology allows concentration on only a few sample items worked by many different hands. Lady Hylton asked several friends to help with the stitching: Miss Symonds, of Wigmore Street, London, for instance, worked the banner commemorating Lady Hylton's uncle, Lord Arthur Charles Hervey, Bishop from 1869 to 1894, who founded Wells Cottage Hospital. A doctor, a music master and two clergymen were also among the needleworkers. The dean's stall, typically at the west end of the decanal (south) side of the quire, was worked by Miss Wigram of Green Acres. In the centre of the golden banner, its corners cut to accommodate the stone carving, are the arms of office impaling those of Dean Malden, and his family motto 'Miseris auxilium fero' (I bring help to the wretched). Nearby are arms of two other deans, John Gunthorpe (incumbent 1472–98), who considerably enlarged the deanery, and Ralph Bathurst (incumbent 1669–1704), who installed its fine panelling. Around are roses-en-soleil, reminders that Dean Gunthorpe had served Edward IV (1442–83), whose impresa these were, and daisies, badges of Margaret Beaufort, mother of Henry VII (1457–1509), who used to stay at the deanery. At the bottom of the banner are the arms of Eton College and King's College, Cambridge, Dean Malden's seats of learning.

White lilies of the Eton arms are also seen on a panel worked by Mrs Shaw-Mellor of Box, commemorating Bishop Oliver King (incumbent 1495–1503), admitted to Eton as scholar in about 1445. Another educational reference appears on the panel worked by Mrs Bates Harbin of Newton Surmaville, Yeovil, as reminder of Bishop Wynne-Willson, in this instance, the shield of Marlborough College where he was master from 1911 to 1916. And the panel for the chancellor, responsible for all books and supervision of learning within the cathedral, shows an illuminated bible, copied from the Rheims manuscript, inscribed 'In principio erat verbum' (In the Beginning was the Word), 'Cancellarii ecclie sedes' (The seat of the chancellor of the church) and 'Docebo vobis timorem Domini' (I will teach you the fear of the Lord). Among other equally fascinating banners is one commemorating William Laud, Bishop from 1626 to 1628 (see Plate 44). This panel, worked by Miss Child, is embellished with his arms set above those of St John's College, Oxford, of which he had at one time been president, and to either side are crowned pairs of interleaved Cs symbolizing his devotion to Charles I.

The banner to its left, worked by Miss Carr, is a remembrance of Laud's predecessor, Arthur Lake (1568–1626), who held the see from 1616 to 1626. A scholar and Warden of New College, Oxford, from 1613, Lake is commemorated by a banner inscribed 'Omnis sapienta a Domino Deo est' (All wisdom cometh from the Lord God) and nearby are six crowned English

Plate 48 (opposite) Gigs Stevens' explosive free-form bargello is an example of the exciting designs created by modern embroiderers.

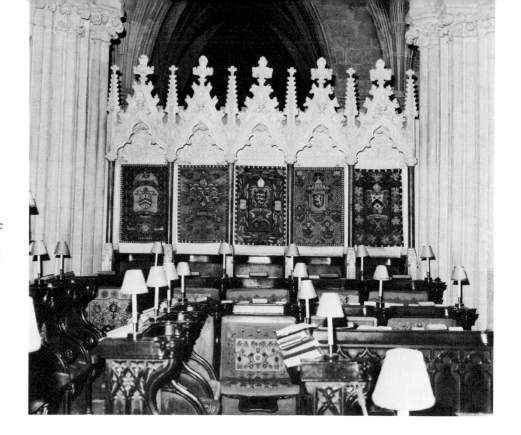

The thirty-nine stalls each have banners hanging behind them and substalls in front have seat backs and cushions: all these items are worked on single-thread canvas with twenty threads to the inch.
mean size of stall banners 36 × 23 in, 91·4 × 58·4 cm, substall back cushions 20 × 24 in, 50·8 × 61 cm, and substall seat cushions 14 × 24 in, 35·6 × 61 cm

roses and Scottish thistles dimidiated (halved), hybrids found on several of the quire banners and continuing a symbolism used by Stuart kings to denote the union of the two nations. The treasurer's banner, to the right of Laud's panel, indicates the office of the *persona* traditionally responsible for the hangings, vestments, sacred vessels and cathedral chattels. The golden field of the panel, worked by Mrs Jenner, shows two angels holding a paten and chalice with the text '*Profert de thesauro suo nova et vetera*' (He bringeth out of his treasure things new and old). Its neighbour, the Archdeacon of Bath's panel, also worked by Mrs Jenner, was one of the first to be finished and hung in place. Because this office is not armigerous the centre of the panel is filled with the arms of the Priory or Abbey Church in Bath, flanked by tiny olive trees formed of tent stitch and french knots and with miniature round raisedwork olives of intricate buttonhole stitch over padding. The trees illustrate a circumferential inscription, 'Let a king restore the church, let an olive establish the crown', a reference to the dream that supposedly stimulated Oliver King to rebuild the ruined priory at the beginning of the sixteenth century.

The panels show great ingenuity. Symbols of winds (*see Plate 45*) at the corners of Mrs Jenner's panel commemorating Richard Kidder (bishop 1691–1703) are reminders that he was killed when palace chimneys collapsed during a storm, and the crossed pens on that of Edward Willes, bishop for the three decades until 1773, indicate that he was decypherer to the king. The Willes panel was worked by Dr F. J. Child, medical officer of Winchester College from 1904 to 1929. Another keen participant of the quire project was the Reverend Jocelyn James Antrobus (1876–1953), who worked the chancellor's and three other stall banners. Former rector of Hatfield, he removed to Ston Easton, near Wells, in 1936; he was related by marriage to that other well-known embroiderer, Mary Symonds (Mrs

LEFT A device at the bottom of the stall banner remembering George Hooper, bishop 1704–27, is the dimidiated English rose and Scottish thistle used by Stuart kings to denote the union of the two countries.

BELOW The treasurer's panel includes two angels holding paten and chalice, symbols of office of the *persona* traditionally in charge of hangings, vestments, sacred vessels and other removable items in the cathedral.

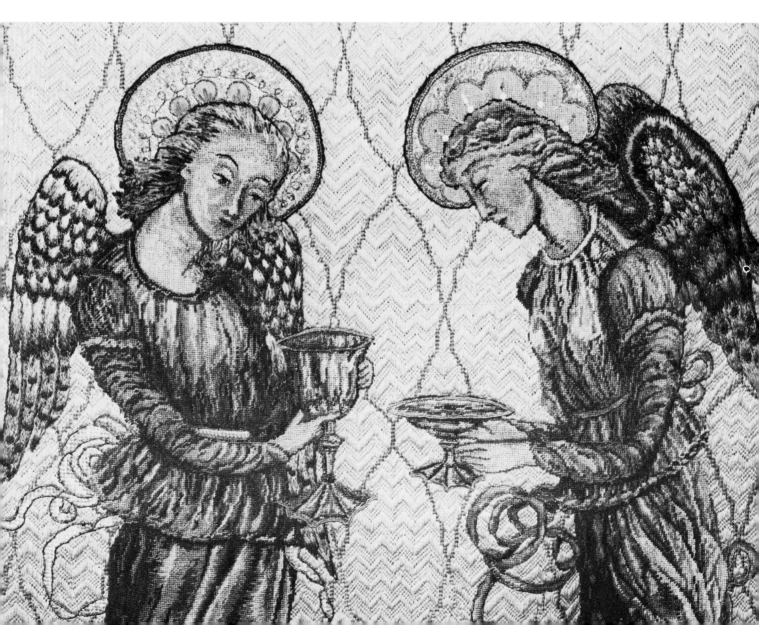

RIGHT Cardinal Wolsey was titular bishop 1518–23 although it is not certain if he ever visited his see: behind his shield are a pastoral staff, an archiepiscopal and a legatine cross and a cardinal's hat as a reminder that he was papal legate, the direct representative of the Pope, in 1518.

OPPOSITE TOP Swans now once again on the palace moat are shown on a substall back panel.

Guy Antrobus). Mr Antrobus must have enjoyed working his panels. That which commemorates Bishop Gilbert Berkeley (1498–1581), for instance, shows two scrolls copied from his tomb and reading 'VIXI' and 'LVXI', meaning 'I have lived' and 'I have shone'. There is also a numerical significance in the inscriptions: the value of VIXI is 17 (5 + 1 + 10 + 1) and that of LVXI 66 (50 + 5 + 10 + 1) which, added together, make eighty-three, his total age. Equally fascinating, too, is the panel for Richard Beadon (bishop 1802–24). Here, typically, are college arms, for Beadon was Master of Jesus College, Cambridge, 1781–9, but above is a mitre formed of applied satin cut from a gown worn by Mrs Beadon when she was presented to George III.

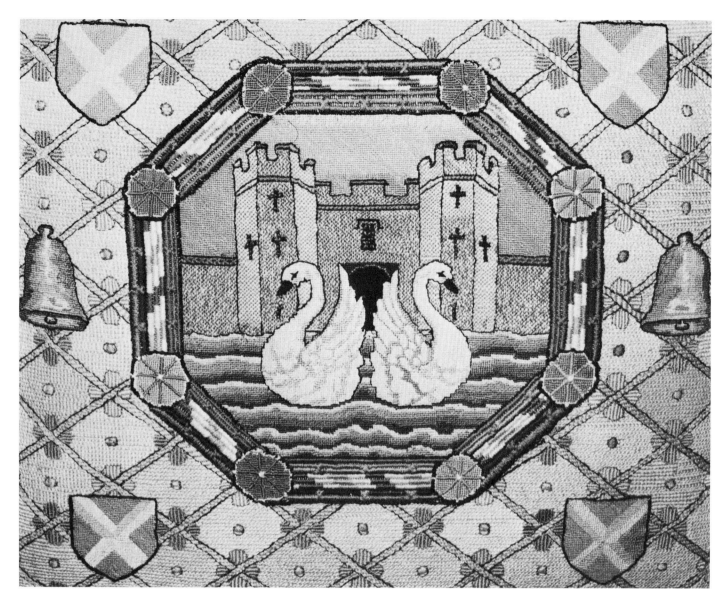

Another needleworker was Kenneth Stubbs of Rugby School. He stitched the panel commemorating Thomas Wolsey (1475–1530), the Suffolk butcher's son who rose to become Lord Chancellor and here remembered because from 1518 to 1523, while Archbishop of York, he was titular holder of the Bath and Wells see, although it is not certain whether he ever visited his incumbency.

There are also some intriguing, more immediate associations. Swans, for example, represent the birds now once again to be seen on the moat. (They were scared away during television filming in the early 1970s but a new pair presented to the bishop at Christmas in 1975 has since bred successfully.) A back cushion in the lower substalls bears a picture of the cathedral's famous mechanical clock, fashioned c. 1390 and the second-oldest working model in existence. Glastonbury is mentioned again on several substall panels. The town's coat of arms are shown and there are panels remembering a local son, St Dunstan (924–88). St Indract, an Irishman who established a cell in Glastonbury during Ina's reign, is also remembered, particularly because he and his brethren were attacked by the king's men who reputedly mistook for hoarded gold the stock of wild

Other swans decorate the corners of a stall banner remembering John Drokensford, who held the see 1309–29.

Another substall back panel shows the cathedral's famous mechanical clock, made *c.* 1390 and now the second-oldest working model in England.

Sphericus·Archetypum·globus
hic·monstrat·microcosmum

NEQUID PEREAT

A drawing of another flower design illustrates the wide variety of floribunda portrayed on the quire panels.

celery that Indract wished to introduce to his native land.

Other substalls tell part of the story of Joseph of Arimathea (born in what is now called Ramallah), the rich disciple who, according to Robert de Borron's *Joseph d'Arimathie* (*c.* 1200), was entrusted with the Holy Grail at the Last Supper. According to thirteenth-century interpolation, St Philip sent Joseph as head of a team of a dozen missionaries dispatched to England: a panel copied from fifteenth-century glass in Langport church shows Joseph's arrival in Glastonbury, the Tor clearly visible in the distance, and another cushion is decorated with his arms, two cruets supposedly containing Christ's blood and sweat and the thorn Joseph planted.

Plants appear again and again on the Wells panels. Pomegranates, *impresa* of Catherine of Aragon (1485–1536) and her daughter, Mary Tudor, and used by the anonymous embroiderer who worked the seventeenth-century slip now at the Valentine, appear here on the banner of Gilbert Bourne, who was appointed by Mary to be President of Wales. (This panel was worked by Mrs Leyborne Popham of Hunstrete House, Pensford.) Lilies and honeysuckle on substall and bench cushions are among designs in styles found in the notebooks of Louisa Pesel (1870–1947), who had herself been actively concerned with canvasworks at

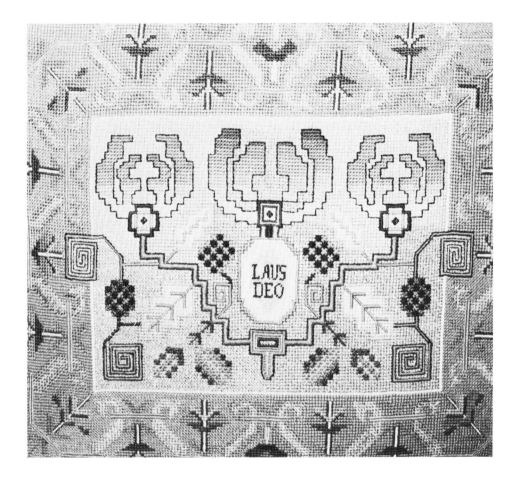

Fruit and flowers adorn many panels: this design is in the style of Louisa Pesel, who was herself actively concerned with a canvaswork project at Winchester Cathedral.

Winchester Cathedral a few years before, and yet more items show stylized plants and flower springs whose precise inspiration remains unknown.

There is in any study of the Wells quire canvasworks a reminder of other dioceses, an indication of the communal aspect of this project. The wide range of talents which contributed to the execution of Lady Hylton's designs can now be contrasted, during a visit to nearby Westwood Manor, with the needlework skill of just one pair of hands.

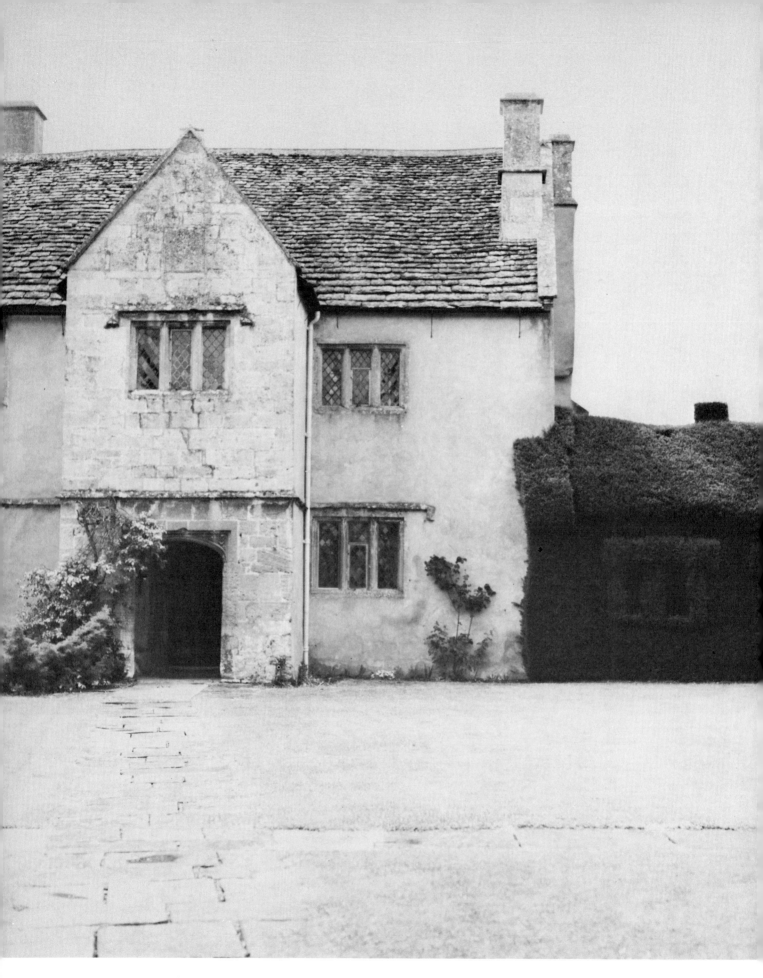

Westwood Manor, Wiltshire.

21

Westwood Manor

A Gentleman's Needleworks

N the past, men embroidered professionally and for their own purposes and today many still enjoy canvaswork and other techniques. Few, however, achieve the prolific output of Edgar Graham Lister (1873–1956), who stitched many of the furnishings for his country house, Westwood Manor, eight miles from Bath.

The two-storey manor house, accepted by the Treasury in part payment of estate duty and passed in 1960 to the National Trust through the National Land Fund procedures, remains the perfect specimen of a smaller English country house. Its origins can be traced to 983 when King Ethelred granted land to a servant. By the time of the Norman Conquest in 1066 it had passed to the Priory of St Swithin at Winchester who were to own it for over eight centuries; from 1317 they leased it to various tenant farmers at an annual rent of five pounds.

By the early sixteenth century the west of England was flourishing, owing to the prosperity of the undyed broadcloth trade, and clothier Thomas Horton (died 1530), who acquired the lease *c.* 1518, took advantage of his good fortune to expand the house and build other property nearby. Westwood continued in his family for nearly a hundred years until a descendant, one Toby Horton, was forced to sell to his brother-in-law John Farewell (died 1642) for £1,050; for this, Farewell received a twenty-one-year lease on nearly two hundred acres, still at five pounds per annum, and 'a hall, a parlour wainscotted, a kitchen, a buttery, a dairy-house, a brew house, six lodging chambers, two garretts, a stable, a barn, an ox-stall, a cow-stall, a wain-house, a sheep-house, a hay house, a garden, an orchard, a dovehouse reasonably well stored and a yard'. Inherited by

Edgar Graham Lister (1873–1956), English needleworker extraordinary.

234 *Westwood Manor*

Farewell's daughter and grand-daughter in turn, the lease was later held by various other tenants before the priory granted it to the Tugwell family in 1775; in 1861 Westwood was finally sold to the Ecclesiastical Commissioners from whom the Tugwells bought the house and they themselves sold it to Mr Lister in 1911.

Educated at Uppingham and Magdalen College, Oxford, Lister was a delightful all-rounder about whom James Lees-Milne wrote:

> To his friends he seemed ageless. Was it because of his complete disregard of age in human beings and assumption that all his friends were so youthful in spirit as himself? Was it because of his chortling sense of fun and inexhaustible stories at their and his expense? ... He had a fund of intellectual resources to fall back upon. He was a master of, literally, more than a score of European languages acquired during early travels – many of an adventuresome kind – and his Foreign Office career. He had a passion for music written for early keyboard instruments and the harp, which he played proficiently. He was an expert needleworker with an expert's fine understanding of old needlework. [Westwood remains] wonderfully expressive of Ted Lister's own character in its flawless good manners and its total avoidance of the pretentious or second-rate.

After serving in Constantinople, Sofia and Paris, Lister retired from the Foreign Office in 1919 and spent much of his time beautifying his house. He undid philistine 'restorations' undertaken by earlier occupants and filled rooms restored to their original beauty with fine furniture and other antiques. He bought late seventeenth-century crewel bed hangings and a contemporary silk picture of a shepherdess and, ever a connoisseur of historic needlework, he resolved himself to cover some of his walls and furniture with canvaswork executed in designs contemporary with the antique item concerned.

Mr Lister numbered among his many friends such needleworkers as Lady Cecilie Goff (1874–1960) and her son Thomas, and both stayed from time to time at Westwood. During long winter evenings their host might tell stories as he played on one of his twenty-odd harps. Perhaps a string would break, at which point he would 'look over his spectacles and say "Damnation!" but nothing else and go on with his stories'. His household was run by an old Bulgarian servant, Christo, married to a local girl who produced excellent simple English food. Although there was minimal heating, bedrooms were always warmed in winter with fires whose light flickered through the drawn curtains of four-poster beds; as late as the 1940s there was no electricity and oil lamps and candles in hurricane globes with silver handles and stands had to be carried from room to room.

Working with wools perhaps purchased from Evans and Owen Ltd, then of Alfred Street, Bath, and hand-held canvas already marked with drawn outlines, Mr Lister embroidered by lamplight far into the night. As he stitched he told yet more stories 'about old houses, ghosts, eccentric families and local lore' and he would occasionally throw his work to one

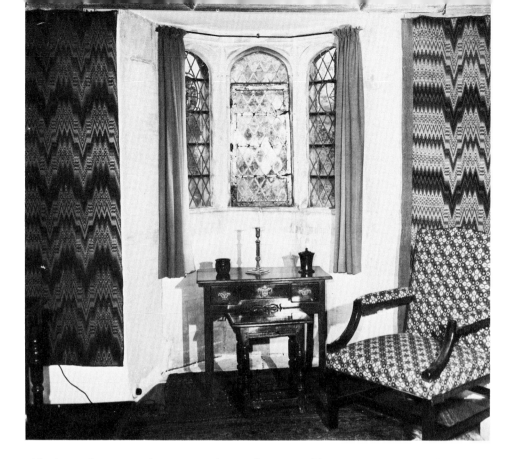

The Oriel Room is called after the projecting window: one of its leaded panes is set with stained glass showing the letters HOR and a barrel or tun, commemorative of the Horton family, tenants of Westwood from the late fifteenth to the seventeenth century. Mr Lister, who lived at the Manor 1911–56, worked the wall hangings and the chair cover.

side in order to embrace passionately one of his enormous smelly long-haired sheepdogs.

When finished, his panels were made up locally before being placed in the rooms for which they were worked. Mr Lister looked after all his needleworks with great care: chairs and stools were covered and only revealed if that other needlework enthusiast, Queen Mary, or another important visitor was coming to tea.

Visitors today may be tempted before going into the manor to linger awhile in the delightful topiary house, cut from living yew and extending the entire depth of the main building. Inside, after being greeted in the panelled Great Hall, remodelled by Farewell, visitors progress upstairs to the Great Parlour, set with such treasures as a late seventeenth- or early eighteenth-century spinet by Keene of London, and a 1537 virginal fashioned by Mutinensis of Modena. Then, after admiring the Panelled, Corner and Gothic Rooms, and the Oriel Room, a descent is made to the King's Room, called after the portraits of British rulers which decorate its panelling.

There are flamestitch bed hangings, wall and window furnishings in no less than five rooms, and one sofa, six chairs and one stool variously displayed are all evidence of Mr Lister's industry. Curtains for the Great Hall and hangings in the Gothic, Panelled and Oriel Rooms are formed of strips of singleweave linen canvas twenty-five inches (63.5 cm) wide with fourteen threads to the inch, worked with two- or four-ply softly shaded wools in flamestitches over six or seven threads, each stitch emerging in horizontal alignment but one thread across from the finish of its predecessor. Strips of worked canvas have been carefully joined, patterns matching, to form larger curtains suspended from the walls, and some other curtains

ABOVE LEFT Flamestitch hangings are worked in two- or four-ply wools on single canvas twenty-five inches (63·5 cm) wide, with fourteen threads to the inch.

ABOVE Oak leaf and acorn pattern on a stool top worked by Mr Lister.
dark brown outlined motifs in rice stitch and reserves in tent stitch in various shades of blue and green

LEFT High-backed late eighteenth-century chair in the Great Parlour covered with a canvaswork design of brown-outlined pink, orange and brown ricestitch octagons.
overall height 45 in, 114·3 cm

Drawing of the acorn pattern.

have now been utilized as base valances for magnificent four-posters in the Panelled and Oriel Rooms. Mr Lister had some help with the execution of these larger flamestitch items but the two chairs in the Oriel Room are probably all his own work. One has a delicate pink, purple and brown silk and wool crossstitch design on the back, seat and arm panels and the other, a wing chair with squab and matching throw cushions, is furnished with a wool and silk black-outlined carnation design infilled with shades of greens and browns; once again, all the upper diagonals of his cross stitches methodically face the same direction.

Another favourite technique was obviously rice stitch, as illustrated by a sofa in the Panelled Room covered with a pink, brown and beige candle design with five stitches to the inch, and also for a Great Parlour stool worked, perhaps as a reminder of the embroiderer's heritage, with a rice-stitch oak leaf pattern surrounded by tentstitch reserves in various shades of green and blue as if leftover threads were being economically used up. One of the three chairs in the Great Parlour is also covered with rice stitch, worked in a brown-outlined blue, pink and orange octagonal design. The other chairs are flamestitch, worked in predominantly red, green and white exaggerated zigzags (*see Plate* 46), and crossstitch in a pink rose within castellated diamonds on a mustard ground design.

Downstairs in the King's Room more superb canvasworks can be seen. Here is a chaise longue covered with more of Mr Lister's zigzag flamestitch and a library chair, its seat embellished with a candle ricestitch pattern; a wing chair nearby (*see Plate* 47) has squab and throw cushions similarly worked in yellow, blue and brown cross stitch and a tall upright chair is embellished with cross and tent stitches in an eighteenth-century stylized shell design.

This, then, is the public display of the needlework talent of a man gifted in many fields: proof, should any be needed, that embroidery can be an extremely gentlemanly pursuit.

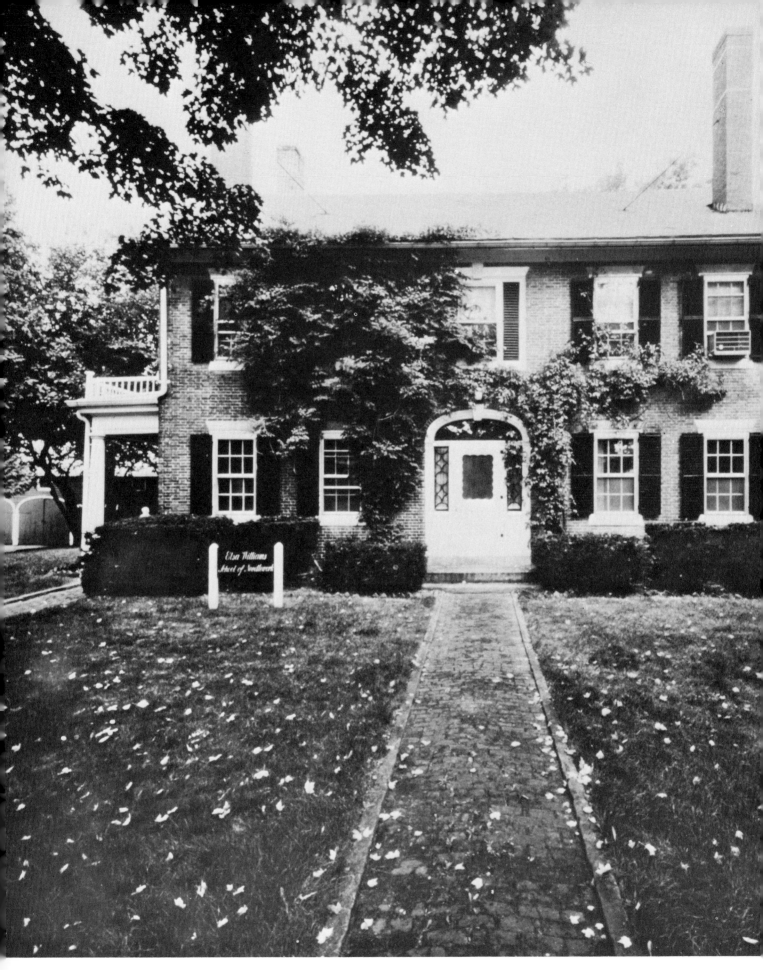

Beautiful surroundings for present-day embroiderers:
Homer House, the Elsa Williams School of Needleart in
Massachusetts.

22

The Continuing Heritage

A FTER what can only be an introductory tour of historic needleworks in stately homes and other beautiful sites on both sides of the Atlantic, it is now time to reflect whether or not this artistic heritage is being continued.

Decorative needlework has been seen embellishing houses and churches, clothing and furniture and as an art form *per se*. Through representations of flowers, animals, family trees, biblical and classical stories and through portrayals of royal and other heroes, the lives of embroiderers and their knowledge, loyalties and interests have become apparent. Many different techniques have been explored and although none is supreme it may be fair to say that today canvaswork enjoys the greatest following. Not only are pictures and furnishings treasured items in many beautiful homes not covered in this anthology but on a practical front too the delights of canvaswork provide enjoyment for twentieth-century needleworkers of whom Mr Lister provides an – admittedly extreme – example. Partly because it is a geometric form which can be worked on canvas with large holes, canvaswork continues to be practised by many busy men and women to decorate items for their own homes. The Earl of Haddington (born 1894), to give one example, is an enthusiastic and patient artist who still works continental tentstitch pictures on hand-held single canvas with twenty-four threads to the inch. He forms charming flower and bird pictures for his East Lothian home, Tyninghame, and often takes his themes from engravings in his own collection. By adapting other treasures around him to provide designs for his needleworks he is, indeed, continuing the tradition of his ancestor Rachel Binning, who all those years ago joined with her older sister and

RIGHT Tentstitch picture
worked in 1976 by the Earl of
Haddington (born 1894): he
works with hand-held canvas.
*single canvas with twenty-four
threads to the inch worked
with three strands of stranded
cotton tent stitch, $13\frac{1}{8} \times 9\frac{5}{8}$ in,
33·3 × 24·4 cm*

FAR RIGHT Lord Haddington
took his design from a Redouté
plate.
$14 \times 9\frac{1}{2}$ in, 35·6 × 24·1 cm

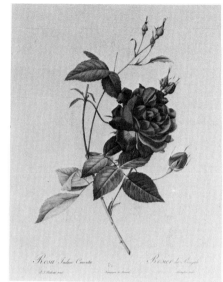

RIGHT Detail of a handy roll-
carrier worked by Chottie
Alderson using her special
plaid stitch.
*canvas worked with wool and
metal thread, $7 \times 11\frac{3}{4}$ in,
17·8 × 29·8 cm overall*

BELOW Chottie's plaid consists
of tent stitch worked over
alternate threads in the manner
illustrated. Here the plaid is
formed with rows of white
followed by two rows of
shaded stitches.

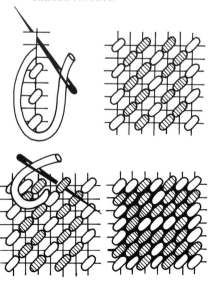

their governess, May Menzies, to use pages of a pattern book to provide inspiration for their 'Mellerstain panel'.

Most of the needleworks covered in this tour are similarly the results of careful planning. Without patient trial pieces the time put into a finished item may have been worthless. Lady Evelyn's whitework could not possibly have occupied its pinnacle of excellence had she not painstakingly practised the minutiae of her design and execution and devoted forethought to colour and composite symbolism. Similarly, Lady Hylton's ideas for the Wells quire canvasworks would not have combined to produce such a satisfying result.

Skilled professional designs have been visited particularly at Hardwick Hall, the National Cathedral and the Valentine Museum. By contrast, the humorous appliqué caricaturing a marital quarrel which embellishes one of the American Museum's fascinating coverlet tops illustrates that a creative amateur need not be excluded from artistic needlework. Suitability of design for intended technique and subsequent purpose is overall more important than the status of the artist. Some needleworkers concentrate on more traditional techniques and patterns; Mr Lister, for example, executed such well-established designs as flamestitch zigzags and repeating English oaks. Other embroiderers continue to work classic motifs but it is essential too that they should at least respect and accept innovation and possibly adapt their outlooks to accommodate changes around them. Embroiderers in the mid-nineteenth century, for example, quickly accepted the brightly coloured threads made possible by the chemical dyes of young William Perkin (1838–1907) and similar note should be taken today of such innovations. 'Chottie's plaid' and 'free-form bargello', credited to American artists Chottie Alderson and Gigs Stevens, are canvaswork

Free-form bargello can be worked in this manner: (left) a small motif has been executed in tent stitch (here black) and curvilinear free-form lines marking the eventual periphery of each colour of stitching are drawn on the canvas. Vertical straight stitches over three threads are then worked following as closely as possible the inside of each marked line. Where necessary, stitches over two threads should be worked in preference to a stitch over four threads. Following the lines and colours of these initial stitches, reserves are filled with straight stitches as illustrated in the second drawing (right).

LEFT 'Lenham Landscape' by Diana Springall.
various techniques, 36 × 48 in, 91·4 × 121·9 cm

RIGHT A collection of cushion designs by Anna Pearson.

BELOW Erica Wilson, a needlecrafter who has been responsible for encouraging embroidery throughout America, where she now lives, and in her native Britain.

techniques remarkable for their colour, the plaid in controlled form and the bargello without restraint (*see Plate 48*). Both techniques are addictive to work and they illustrate the continual novelty of needlework.

Admittedly in the past much embroidery must have been an enforced task, but even the young girls working samplers now to be seen at the Daughters of the American Revolution Museum and at the Valentine Museum must have felt pleasure in accomplishing lines of alphabet renderings. While some were taught in schools, Grisell and Rachel Baillie developed their finesse at home; Lady Lucy and Lady Anne Maxwell Stuart and, nearly two centuries later, possibly Lady Evelyn Stewart-Murray were taught by nuns. Today the teaching of embroidery is rarely part of the standard curriculum. Instead, assemblies, correspondence courses and exhibitions such as those of the Valentine and Woodlawn inspire and instruct and, throughout Britain and America, guilds, organizations and needlework shops similarly excite and explain. The modern deluge of needlework books and programmes on television also helps to widen the awareness of what embroidery can entail.

Personal association and attribution has always given embroidery a particular interest. The fact that so much is known about Lady Evelyn, Mary Queen of Scots, Bess of Hardwick, Ellen Miller and Margaret Whiting, the Baillie sisters, Phoebe Cooke, Mary Borkowski, the two young Maxwell Stuarts, the Washington ladies and Mr Lister makes a study of their work especially worthwhile (and encourages research into identification of the anonymous hands who worked such treasures as the Milton Manor House box and the Parham Park pictures). So today it is important to recognize the talents of individual artists, many working in their own studios and homes throughout Britain and America: for it is they who will be remembered in the future, either for their own embroideries or for designs they prepare for other people.

Embroidery is a friendly and open enjoyment, a point repeatedly brought home to me by the continual kindness and help offered during compilation of this anthology. Embroiderers and those who study their works share their enthusiasm and knowledge. Friendship coverlets at the

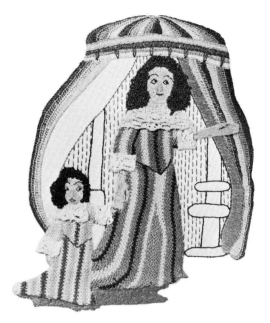

Part of the enjoyment of
studying historic pieces can be
working one's own
copy. This copy was taken
from the front of the Milton
Manor House needlework box
and shows Sarah and Isaac.

American Museum and canvasworks in the National and Wells Cathedrals illustrate how embroiderers have often worked together, a tradition continued by such projects as the Peace Rug now hanging in the United Nations building in New York City as a reaffirmation of beliefs and hopes for the future. Many enthusiasts enjoy travelling to a national or local gathering or a luxurious 'stately home' to stitch, and beautiful embroidery is often produced in agreeable surroundings. But embroidery can also be a calming companion for momentary solitude, an apt example of which is provided by a Minneapolis mother of thirteen who says she enjoys canvaswork for relaxation and as a 'creative outlet'.

As a needlework historian, I am constantly asked whether I too actually embroider. The answer is a categorical 'Yes' (on planes, in trains and cars, at home and away . . .). Photographs illustrate finer points of an historic needlework but I find I learn even more by copying or re-creating an earlier technique. The personal satisfaction of completing something does not necessarily entail pretentious assumptions of having created a future heirloom but it does, on a more modest level, indicate a certain accomplishment. I hope that this anthology will inspire others similarly to emulate the past and, by combining it with current materials and ideas, to prepare a heritage for our descendants. I also hope that this journey to some popular and other less-known areas of Britain and America will illustrate that decorative needlework, perhaps one of the most widely practised of all creative pursuits, can truly be called the art of embroidery.

Stitch diagrams

These diagrams show some of the embroidery techniques most frequently referred to in *Art of Embroidery* (see this page), and some other popular stitches (see facing page).

Chain stitch

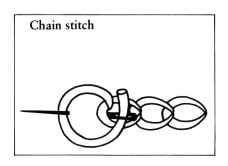

Couching
One thread is held to the ground by another

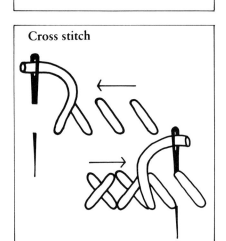

Cross stitch

Flamestitch
Consists of parallel rows of differently coloured stitches often worked in zigzag formation

Tent stitch
The usual form is sometimes known as continental tent stitch, diagrammed here (alternatively half a cross stitch can also produce a tent stitch)

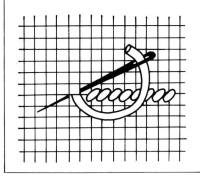

Basket weave stitch
Another form of tent stitch, alternate diagonal rows worked up and down (1 and 2) produce a solid block of stitching which does not distort: the stitch is named after the basketweave effect on the reverse (3)

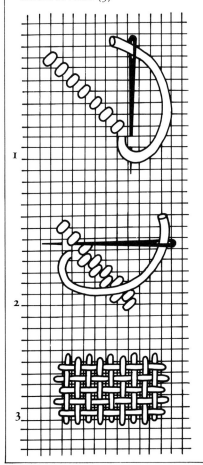

Back stitch

Gobelin

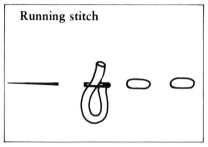

Rice stitch

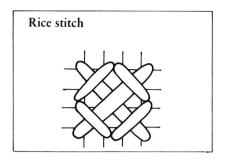

Bullion knot

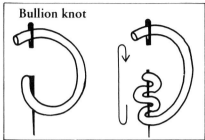

Long-and-short stitch

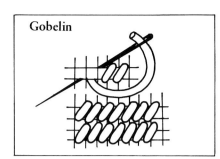
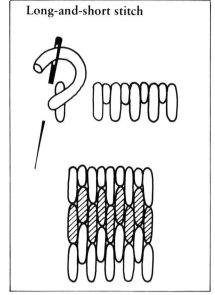
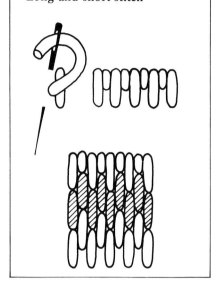

Running stitch

Buttonhole stitch

Satin stitch

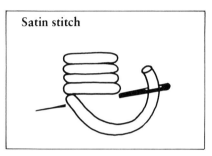

Double-running stitch

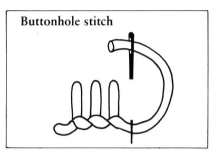

Rococo stitch

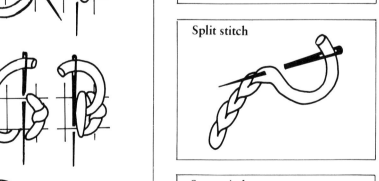

Seeding

French knot

Split stitch

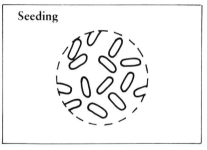

Stem stitch

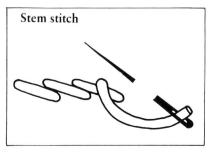

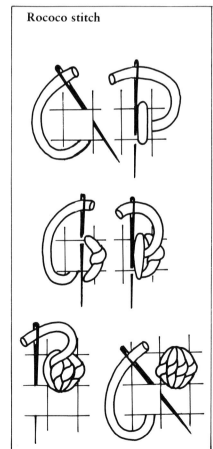

Notes to the text

Introduction
p.13 line 21 Blackwork is, as its name implies, characterized by black embroidery on white, usually silk thread on linen fabric. Although known in England before that time, it became especially popular after the arrival of Catherine of Aragon in 1501. Blackwork is sometimes called 'spanish work', a phrase best reserved for other monochrome embroidery worked with a coloured thread (see John L. Nevinson's *Catalogue of English Domestic Embroidery*, p.18).

1 The American Museum in Britain
p.18 line 27 The American Museum in Britain's two relevant publications, *American Textiles and Needlework* and *Quilts and Coverlets from the American Museum in Britain*, both by Shiela Betterton, have both provided invaluable information, as has the same author's *The American Quilt Tradition*, the illustrated catalogue published by the Museum of an exhibition arranged by the Museum and the Commonwealth Institute, at the Commonwealth Art Gallery, London, 23 July–2 September 1976.
p.19 line 10 The colouring and geometric designs of Amish coverlets can also be compared with those of the Mennonites (see two relevant examples, colour illustrations nos. 5 and 53, in Cyril I. Nelson's *The Quilt Engagement Calendar*).
p.20 line 36 See Grace Rogers Cooper's article, 'United States', in *Needlework: An Illustrated History*, Harriet Bridgeman & Elizabeth Drury (eds), p.12.

2 Blair Castle
p.28 line 9 Needleworks by earlier Atholl ladies can also be seen in the Small and Large Drawing Rooms.
p.28 line 22 Letter from Lady Evelyn Stewart-Murray to a newly married friend, 26 September 1937.
p.29 line 8 Letter as above.
p.29 line 22 The SS *Crichtoum* sailed on 29 October 1936.
p.29 line 27 Letter from Lady Evelyn, 10 October 1936.
p.30 line 14 In embroidery terms, 'pricking' is the method of outlining a paper pattern by piercing it with a needle. A 'pounce', perhaps powdered charcoal or cuttlefish, is then rubbed through the perforations to the fabric beneath (see *Mary Gostelow's Embroidery Book*, p.106).
p.33 line 12 See Margaret Swain's 'Needlework at Blair Castle' in *Embroidery*, Summer 1971, p.42, and *Historical*

Needlework: A Study of the Influences in Scotland and Northern England, p.113.

3 Colonial Williamsburg
p.35 line 26 A newly married Scottish merchant from Yorktown, rebuffed at the tavern in 1783, wrote this description of Mrs Campbell (see Colonial Williamsburg's *Official Guidebook*, 1976, p.96).
p.36 line 11 Allied textile interest is provided by Colonial Williamsburg's superb collection of needlework tools (see Sandra C. Shaffer's article, 'Sewing Tools in the Collection of Colonial Williamsburg', in *Antiques*, August 1973, p.233).
p.38 line 3 Information on bed rugs can be found in William Warren's *Bed Ruggs 1722–1833* and also in Joel and Kate Kopp's *American Hooked and Sewn Rugs: Folk Art Underfoot*.
p.40 line 10 This carpet is now known generally as the Caswell carpet. It was worked *c.* 1832–5 and at least two of the eighty motifs carefully aligned over an area 160 × 147 in, 400 × 370 cm, may have been worked by Potawatami Indians studying at the Castle Medical College in Vermont. (Metropolitan Museum of Art, accession no. 38.157.)
p.40 line 13 Colonial Williamsburg's carpet came from the collection of the Countess Mountbatten of Burma and it was sold at Parke-Bernet in New York on 19 November 1959. It is illustrated in M. J. Mayorcas's *English Needlework Carpets, Sixteenth to Nineteenth Centuries* (plate 45) and Mildred B. Lanier's *English and Oriental Carpets at Williamsburg*, pp.18–19.

4 Daughters of the American Revolution Museum
p.45 line 12 A sampler is a collection of patterns worked in one or more techniques on a piece of fabric, usually linen, which can later be used for reference. Long worked by professionals to show different needlework patterns, samplers became useful test-pieces in girls' schools and pupils learnt how to master cross stitch and other techniques as well as practising alphabets and numbers. Details of fabrics and threads and their dyes used in American schools from the end of the eighteenth century are given in Glee Krueger's *A Gallery of American Samplers: The Theodore H. Kapnek Collection*, pp.14ff.
p.45 line 16 Invaluable information on needlework pictures and samplers in the Daughters of the American Revolution Museum is given in Elisabeth Donaghy Garrett's two articles, 'American Samplers

and Needlework Pictures in the DAR Museum, Part I: 1739–1806' and 'Part II: 1806–1840' in *Antiques*, February 1974 and April 1975. See also Betty Ring's article, 'Memorial Embroideries by American Schoolgirls', in the October 1971 issue of the same magazine.
p.48 line 1 Linen worked in silk cross stitch and stem stitches, $37\frac{1}{4} \times 27\frac{5}{8}$ in, 94.6 × 70.2 cm, framed.
p.48 line 4 For arches on earlier pieces, see Krueger's *A Gallery of American Samplers*, plates 37 and 37a, p.33 and, for an arch with columns, p.50; see also Betty Ring's 'The Balch School in Providence, Rhode Island' in *Antiques*, April 1975, p.663.
p.48 line 24 George Eisenbrey's sampler (accession no.323a) is $7\frac{7}{8} \times 8\frac{1}{8}$ in, 20 × 20.6 cm, and is worked in cotton and silk cross stitch on coarse linen.
p.48 line 26 Some schools were called after their owners, as exemplified by academies run by Susanna Rowson, Catherine Fisk, Mary (sometimes called Polly) Balch and so on (see Krueger's *A Gallery of American Samplers*, p.13, and also Ring's 'The Balch School in Providence, Rhode Island', 'Mrs Saunders' and Miss Beach's Academy, Dorchester', and 'Saint Joseph's Academy in Needlework Pictures', all in *Antiques*, April 1975, p.660, August 1976, p.302, and March 1978, p.592, respectively.). Others were organized by such religious groups as the Quakers and Moravians. Sometimes embroidery instruction was charged separately (see Margaret B. Schiffer's *Historical Needlework of Pennsylvania*, p.53).
p.48 line 32 At least four other examples of similar trees, all worked in the Lexington–Concord area, are known (see Susan Burrows Swan's *Plain and Fancy: American Women and Their Needlework*, 1700–1850, colour plate 8, for Lorenza Fisk's sampler).
p.48 line 44 Swan, *Plain and Fancy*, p.180
p.49 line 1 Swan, *Plain and Fancy*, p.175
p.49 line 22 Silk painted in watercolour, and then partly embroidered *en grisaille*, mostly with chain, satin and stem stitches, seeding and french knots, $25\frac{5}{8} \times 31\frac{3}{4}$ in, 65.7 × 80.6 cm, framed.
p.52 line 6 Silk embellished with ink and watercolour and embroidered, mostly in silk straight stitch, $14\frac{1}{4} \times 12\frac{7}{8}$ in, 36.2 × 32.7 cm, framed.
p.56 line 5 Green linen canvas embroidered with silks and chenille in cross, satin and stem stitches and french knots, $23\frac{1}{2} \times 23$ in, 59.7 × 55.9 cm, framed.
p.57 line 3 Linen embroidered mostly with floss silk cross stitch, $20\frac{3}{8} \times 22\frac{1}{4}$ in, 51.8 × 56.5 cm, framed.

p.57 line 5 Garrett's 'American Samplers and Needlework Pictures in the DAR Museum: Part II', pp.698–700.
p.57 line 12 10¼ × 16¼ in, 26 × 41·3 cm.
p.57 line 13 Silk decorated with watercolour and silk and chenille embroidery, 16 × 26½ in, 40·6 × 67·3 cm.
p.57 line 23 Garrett's 'American Samplers, Part I', pp.363–4. Another version of this design can be seen at Winterthur (accession no.69.1790); this can be compared with another picture of Liberty in the same collection (no.67.893).

5 Glamis Castle
p.64 line 9 See Margaret Swain's *Needlework of Mary Queen of Scots*, p.34.
p.64 line 22 Swain, *Needlework of Mary Queen of Scots*, p.43.
p.64 line 35 Partly quoted in David Durant's *Bess of Hardwick: Portrait of an Elizabethan Dynast*, p.63.
p.64 line 41 John L. Nevinson's article, 'Embroidered by Queen and Countess', in *Country Life*, London, 22 January 1976, p.196.
p.67 line 2 Nevinson's investigation, 'English Domestic Embroidery Patterns of the Sixteenth and Seventeenth Centuries' in the *Walpole Society*, 28, 1934–40, refers both to the 1573 Antwerp edition of *Aesop's Fables* and also to the later, Leipzig, edition; the latter is most similar to the embroideries.
p.67 line 5 Nevinson, 'English Domestic Embroidery Patterns', p.6; Faerno's *Fables*, 37.
p.67 line 11 Nevinson, 'English Domestic Embroidery Patterns', p.3; Faerno's *Fables*, 42.
p.67 line 15 Nevinson, 'English Domestic Embroidery Patterns', p.3; Faerno's *Fables*, 24.
p.67 line 29 Bed worked with crewel wools, mostly long-and-short, satin, and stem stitches and french knots, headboard 45½ in, 116 cm, above pillow, tester valance 10¼ in, 26 cm, deep.
p.69 line 30 Bodleian Library, Oxford, MS Cherry 36. Other book bindings supposed to have been embroidered by the Princess can be seen in the British Library (Royal MSS 7.D.X.) and the Scottish Record Office, Edinburgh (MS RH.13/78). See Margaret Swain's 'A Year's Gift from the Princess Elizabeth' in *The Connoisseur*, London, August 1973, pp.258–66.
p. 70 line 6 Account in the *Northampton Mercury*, 21 June 1879.
p.70 line 7 Agnes Strickland's *Lives of the Queens of England*, IV (Colburn & Company, London, 1851), p.414.

p.70 line 12 David Durant's *Bess of Hardwick*, p.92.
p.71 line 11 Oil on three boards, 31 × 24½ in, 78·7 × 62·2 cm.
p.71 line 23 See David Durant's *Arbella Stuart: A Rival to the Queen* (Weidenfeld & Nicolson, London, 1978).

6 Hardwick Hall
p.73 line 10 Described by Edmund Lodge in *Illustrations of British History*, published in 1780.
p.74 line 42 For reports of Bess's behaviour, see J. Hunter, *History of Hallamshire*, published in 1869 (letter from Gilbert Talbot to Bess dated 1 August 1577), and Durant's *Bess of Hardwick*, p. 99.
p.75 line 16 *Hardwick* MS 8, f.108, now at Chatsworth, Derbyshire.
p.75 line 20 See John L. Nevinson's 'Stitched for Bess of Hardwick: Embroideries at Hardwick Hall, Derbyshire' in *Country Life*, London, 29 November 1973, p.1756.
p.75 line 25 Lindsay Boynton (ed), *The Hardwick Hall Inventories of 1601* (The Furniture History Society, London, 1971), p.31.
p.75 line 27 Hardwick MS 9, f.24v.
p.75 line 30 Hardwick MS 9, ff.79–80.
p.75 line 35 A. D. Edward's *John Petre* (Regency Press, London, 1975), p. 85.
p.76 line 1 Boynton (ed), *Hardwick Hall Inventories of 1601*, p.28.
p.76 line 4 Nevinson, 'English Domestic Embroidery Patterns', p.8.
p.77 line 6 Nevinson in 'Stitched for Bess of Hardwick', p.1757, says that the designs are 'almost certainly' taken from this; a copy 'does not appear in the lists of books in the seventeenth-century library, but must have been available for the designer'.
p.77 line 25 Other versions of this story, directly copied from the page 'Europe ravie' in Salomon's version, can be seen in the Metropolitan Museum of Art, and the Musée Historique des Tissus, Lyons (accession no.29.055). This latter example is a detail of a bed valance (see E. A. Standen's 'A Picture For Every Story', Metropolitan Museum of Art *Bulletin*, XV, 1957, p.165).

7 The Helen Allen Collection
p.84 line 2 Personal statement by Miss Allen, a written copy of which is in the author's possession (n.d.).
p.84 line 23 Statement by the Related Art Department, School of Family Resources and Consumer Sciences at the University of Wisconsin, 1968–9, entitled 'The Allen–

Related Art Textile Collection – Purpose and Organization' (copy in author's possession).
p.85 line 15 Embroidered in wools and silks, mostly in satin stitch, french knots and couching, 40 × 10¼ in. 101·6 × 26 cm.
p.85 line 22 Nineteenth-century embroiderers were imaginative and resourceful: some other materials used at this time included fish head bones and beetles' wings (otolith embroidery – see *Mary Gostelow's Embroidery Book*, p.169) and flower shapes of different fabrics sewn to a ground fabric with widely spaced buttonhole stitch (sabrina work – see Erica Wilson's *Ask Erica*, Newspaper Books and Charles Scribner's Sons, 1977, p.7).
p.85 line 32 For berlin woolwork, see S. A. Levey's *Discovering Embroidery of the Nineteenth Century* (Shire Publications, Tring, 1971) and Barbara Morris's *Victorian Needlework* (Herbert Jenkins, London, 1962).
p.88 line 10 Some berlin woolwork samplers reached barely credible proportions: a well-known one in the Victoria and Albert Museum (accession no.T.333-1910) is 131¾ × 4 in, 334·6 × 10·2 cm. For one measuring a record 41 feet, 12·2 m, in length, see Mildred J. Davis (ed), *The Dowell–Simpson Sampler* (Textile Resource and Research Center, Valentine Museum, Richmond, 1975).
p.89 line 11 44¾ × 26 in, 113·7 × 66 cm.
p.93 line 20 Dr Donald A. Shelley's Foreword to *Selected Treasures of Greenfield Village and Henry Ford Museum* (The Edison Institute, Dearborn, 1969).
p.98 line 5 See John L. Nevinson's article, 'The Embroidered Miniature Portraits of Charles I' in *Apollo*, LXXXII, 1966, p.310.
p.99 line 14 Metropolitan Museum of Art (accession no. 64.101.1353), illustrated in Preston Remington's *English Domestic Needlework of the XVI, XVII and XVIII Centuries* (Metropolitan Museum of Art, New York, 1945), plate 54.

9 The Henry Francis du Pont Winterthur Museum
p.102 line 27 Helen Bowen, in 'Tent-stitch Work', first published in *Antiques* in December 1922 and included in Betty Ring (ed), *Needlework: An Historical Survey*, p.37, gives other alternatives, namely 'needle-tapestry' and 'cushion work'.
p.102 line 32 'The Calthorpe purse', in the Victoria and Albert Museum (accession no.T.246-1927), is thought to be one of the earliest examples of western canvaswork, worked c. 1540.
p.102 line 37 Susan Burrows Swan's

Winterthur Guide to American Needlework, p.26.

p.102 line 43 Swan's *Plain and Fancy: American Women and Their Needlework 1700–1850*, p.91.

p.103 line 3 Rococo stitch was especially popular in America from about 1780 to 1810 (Swan, *Winterthur Guide*, p.49).

p.103 line 21 See Florence M. Montgomery's 'A Pattern-woven "Flamestitch" Fabric', *Antiques*, New York, November 1961, pp.453–55.

p.103 line 24 Making the reverse as well as the front of a needlework tidy and neat was not a normal ambition until the nineteenth century. See Swan, *Winterthur Guide*, p.37.

p.103 line 30 Quoted in Swan, *Winterthur Guide*, p.31.

p.105 line 10 Nancy Graves Cabot, in 'The Fishing Lady and Boston Common' in *Antiques*, New York, July 1941, pp.28–31, said there were then fifty-eight known examples, in all but twelve of which the 'fishing lady' appears.

p.107 line 17 See C. Stella's engraving, *Le Soir*, in the Museum of Fine Arts, Boston. Nancy Graves Cabot ('Engravings and Embroideries: The Sources of Some Designs in the Fishing Lady Pictures', *Antiques*, New York, December 1941, pp. 367–9) suggests that other engravings in the Stellas' *Pastorales* set similarly provided design inspiration for these canvaswork panels.

p.107 line 28 A. Hyatt Mayor has found an early eighteenth-century playing card that shows a lady fishing in a pose similar to, but reversed from, some of the needleworks; see 'The Hunt for the Fishing Lady', *Antiques*, New York, July 1977, p.113).

p.107 line 36 Quoted in Gertrude Townsend's 'A Set of Eighteenth-century Embroidered Bed Curtains' in *Bulletin of the Museum of Fine Arts, Boston*, XI, no. 242, December 1942, XLI 15.

10 Historic Deerfield

p.112 line 30 See Robert Bishop and Carleton L. Safford's *America's Quilts and Coverlets*, pp. 52–5.

p.112 line 38 Unlike other types of needlework which were more generally popular, crewel embroidery (that is to say, embroidery with plied worsted thread rather than with any particular stitches, for 'crewel' as a technique was not generally thus named until the end of the nineteenth century) was associated particularly with New England, although rare examples from New York or Pennsylvania are found. Within New England those pieces worked near the coast not surprisingly show more English

influence: some of these articles may have been worked by middle- and lower-class women who had been warned by colonizing companies before they left their English homeland to bring with them supplies, including embroidery designs. See Catherine A. Hedlund's *A Primer of New England Crewel Embroidery* (Old Sturbridge Village, 1963), p.9.

p.114 line 20 See a similar dress, worked in Connecticut 1730–80, at Winterthur (accession no.67.225).

p.116 line 14 Margery Burnham Howe's *Deerfield Embroidery: Traditional Patterns from Colonial Massachusetts*, p. 25.

p.116 line 18 Howe, *Deerfield Embroidery*, p.23.

p.117 line 14 It is thought that the grey paper, 70 × 77 in, 177·8 × 195·6 cm, was drawn by Olive Curtiss Baker, born in Durham, Connecticut, c. 1776 (see Howe, *Deerfield Embroidery*, pp.121–2).

p.117 line 20 *Chicago Daily News*, 10 June 1897.

11 Mellerstain

p.119 line 3 Linen canvas with twenty-four wool and silk tent stitches to the inch, 13 × 19½ in, 33 × 54·6 cm.

p.120 line 18 Margaret Swain's 'The Mellerstain Panel', *Apollo*, July 1966, p.62.

p.121 line 9 The smudging indicates that possibly the two little girls themselves had a hand in colouring the engravings.

p.121 line 25 Hand-coloured, 7½ × 5½ in, 19·1 × 14·0 cm.

p.121 line 37 See John L. Nevinson's comparison of Johnson with Peter Stent, who published 1643–1707, in 'Peter Stent and John Overton, Publishers of Embroidery Designs', *Apollo* 24, 1936, p.279.

p.125 line 21 *Memoirs of the Lives and Characters of the Rt Hon. George Baillie of Jerviswood and of Lady Grisell Baillie by Their Daughter, Lady Murray of Stanhope* (Edinburgh, 1822), p.146.

p.125 line 31 Lady Murray, *Memoirs*, p.162.

12 Milton Manor House

p.129 line 4 There are, however, one or two records of earlier boxes with needlework panels, though none survive – see George Wingfield Digby's *Elizabethan Embroidery* (Faber, London, 1963), p.127.

p.132 line 11 *Archaeologia*, XLII, 2 (1867), p.361 (quoted in Nevinson's *Catalogue of English Domestic Embroidery*, p.49).

p.133 line 13 See Muriel Baker's *Stumpwork: The Art of Raised Embroidery*, p.84.

p.136 line 3 Nicholas Ferrar's community operated at Little Gidding, Huntingdonshire, from about 1626 until 1647 (see Kendrick's *English Needlework*, p.105).

p.137 line 26 St Louis Art Museum, accession no.3.1972.

p.141 line 2 Lynn E. Springer's 'Biblical Scenes in Embroideries', p.374.

13 The National Cathedral

p.145 line 13 The British architect G. F. Bodley (1827–1907) was himself keenly interested in embroidery, not only as furnishings for the churches he designed but also *per se*; some of his work can still be seen at St Paul's, Knightsbridge. See Christa Mayer-Thurman's *Raiment for the Lord's Service: A Thousand Years of Western Vestments* (Art Institute of Chicago, 1975), pp.316–7.

p.146 line 13 Lucy Vaughan Hayden Mackrille's *Church Embroidery and Church Vestments*, p.9.

p.148 line 17 Mackrille, *Church Embroidery and Church Vestments*, p.69.

p.149 line 14 For an explanation of liturgical colours, see Marion P. Ireland's *Textile Art in the Church*, pp.71ff.

14 Ohio Historical Society

p.156 line 44 Glee Krueger (*A Gallery of American Samplers*, pl.103) illustrates another of the few Ohioan samplers. Now in the Theodore H. Kapnek collection, this 21½ × 22½ in, 53·9 × 56·5 cm, silk on linen sampler picture was worked, in many different stitches, by Achsah Carter, of Smithfield, Ohio, in 1830.

p.157 line 7 Information from Walter D. Moore, Attorney at Law, Marion, Ohio, 5 December 1962.

p.157 line 27 Central panels 8¾ in, 21 cm, square.

p.158 line 4 White cotton embellished mostly with appliqué, quilted in various formations, 74 × 92 in, 188 × 233·7 cm, overall.

p.158 line 9 E. P. Dutton, New York, 1974.

p.158 line 11 *Dayton Daily News*, 30 July 1975.

15 Old Sturbridge Village

p.162 line 13 Quote from *Floor Coverings in New England Before 1850* mentioned in the *Rural Visitor*, XV, 3, Summer 1975 (Sturbridge), p.11.

p.163 line 18 Catherine Fennelly's *Textiles in New England 1790–1840*, p.5.

p.165 line 3 Dimity was a stout cotton fabric, woven with raised stripes or fancy

patterns, used mainly for bed hangings but also for some garments (see Hazel E. Cummin's 'What Was Dimity In 1790?' in *Antiques*, July 1940, pp.23–5).
p.165 line 4 Alice Morse Earle's *Two Centuries of Costume in America, 1620–1820*, II, p.589.
p.167 line 1 Fennelly's *Textiles in New England 1790–1840*, p.10.
p.167 line 10 Swan's 'Worked Pocketbooks' in *Antiques*, New York, February 1975, p.299.
p.167 line 19 Swan, 'Worked Pocket-books', p.298.
p.167 line 22 *Boston Weekly News-letter*, 9 August 1753, quoted in Swan, 'Worked Pocketbooks', p.303.

16 Parham Park
p.172 line 5 Silk coverings and linen canvas flamestitch ground all lined with cream silk, embroidery worked variously in wools and silks embellished with pearls, height of bed overall 108½ in, 287 cm (*Plates 1 & 2*).
p.172 line 21 Marion P. Bolles, in 'Bible Pictures in English Needlework' (*Antiques*, New York, March 1946), pp.164–6, suggests that the growing popularity of small easel paintings, often of the Dutch or Flemish school, also played a part in popularizing the working of small embroideries simply for decorative purposes.
p.173 line 6 Some other outstanding collections of seventeenth-century needleworks with biblical themes can be seen in the Victoria and Albert Museum, City of Glasgow Art Gallery and Museum (Burrell Collection), St Louis Art Museum, Missouri (McDonnell Collection) and the Metropolitan Museum of Art (Untermyer Collection).
p.173 line 31 Edmund Harrison was embroiderer to three British kings (James I, Charles I and Charles II). He is best known for his large pictorial embroideries, some of which can be seen today in the Victoria and Albert Museum (Bequest of Captain H. B. Murray – the *Adoration of the Magi* and *Adoration of the Shepherds*), the Fitzwilliam Museum, Cambridge and the Royal Scottish Museum, Edinburgh (see Kendrick's *English Needlework*, pp.110–12).
p.178 line 21 This same morbid detail of the peg-hammering can be seen on a box in the Whitworth Art Gallery, Manchester (accession no.8237), worked by Hannah Smith (born 1643) from 1654–6 in Oxford (see A. F. Kendrick's 'Embroideries at the Whitworth Art Gallery, Manchester' in *The Connoisseur*, 86, 1930, pp.288–91).
p.179 line 8 Embellished with satin stitch

and bullion and french knots, 15¾ × 19¼ in, 40 × 48·9 cm.
p.182 line 1 (*Plate 36*) Linen canvas worked mostly in rococo and tent stitches, 10 × 15½ in, 25·4 × 39·4 cm.
p.182 line 8 History of Susanna.

17 Traquair House
p.187 line 11 The word 'colifichet' (convent slang for a trifle) was first documented by Monseigneur X. Barbier de Montault in 1879: he had found the name written with a box of such pictures belonging to a former nun (see Margaret Swain's 'Colifichets – Embroideries on Paper' in *The Connoisseur*, 159, no.642, London, 1965, p.271).
p.190 line 19 See also Margaret Swain's 'Colifichets, Double-face Embroideries on Paper' (*Antiques*, New York, September 1973), pp.441–4.
p.191 line 1 Other colifichets can be seen in the Detroit Institute of Arts, the Metropolitan Museum of Art and the Museum of Fine Arts, Boston (Elizabeth Day McCormick collection).
p.191 line 16 As can be seen from an unworked individual flower in the Art Institute of Chicago (accession no.1966.149D), the outline design was first inked on the canvas and then shading was indicated with paint.
p.191 line 40 See John L. Nevinson's *Embroidery Patterns of Thomas Trevelyon* (Walpole Society, London, 1968).
p.193 line 11 35¾ × 22¾ in, 90·8 × 57·8 cm, overall.
p.195 line 4 Linen canvas worked in silk tent stitch, 37¾ × 22¾ in, 95·9 × 57·8 cm.

18 The Valentine Museum
p.198 line 10 Quoted in Molly Holt's 'History of the Valentine Museum' (*Antiques*, January 1973), p.145.
p.199 line 14 See Mildred J. Davis's article, 'Textiles in the Valentine Museum' (*Antiques*, New York, January 1973), pp.175–83.
p.199 line 27 See also Bishop and Safford's *Quilts and Coverlets*, pp.145–8.
p.201 line 14 Glee Krueger (in *A Gallery of American Samplers*, p.16) makes the point that girls may have worked together on their samplers: the Valentine has two examples, signed Mildred Malone and Flora Virginia Homes *c.* 1817, both with woollen embroidery on the borders.
p.202 line 9 It is not known whether Mary Victor was American or British.

19 The Washington Family
p.205 line 15 Preface to *Mount Vernon: An*

Illustrated Handbook, published by the Mount Vernon Ladies' Association of the Union, Mount Vernon, 1974.
p.206 line 8 George Washington to Samuel Vaughan, 15 February 1785, quoted in *Mount Vernon*, p.46.
p.206 line 33 Engraving of wedding (*Plate 40*) by Jean Boussod, Manxi, Joyant and Company of Berlin, 20 × 16 in, 50·8 × 40·6 cm.
p.211 line 3 Oil on canvas 84⅜ × 111⅛ in, 214·3 × 284·2 cm.
p.211 line 5 One of these copies can be seen in the Mansion Dining Room at Mount Vernon.
p.211 line 17 See Enoch G. Gridley's etching, '*Pater Patriae*', after the painting by John Coles Jr, and an embroidered copy, both researched and reproduced in Swan's *Plain and Fancy*, pp.186–7.
p.211 line 19 A version of this, worked by Elizabeth Lane in 1817 after Samuel Seymour's engraving published by Savage, can be seen at the Winterthur (accession no.57.784).
p.211 line 22 See a design perhaps taken from the paper, printed at the Boston Paper-Staining Manufactory, in Ring's 'Memorial Embroideries by American Schoolgirls', *Antiques* (New York, October 1971).

20 Wells Cathedral
p.218 line 24 Diary of Walburga, Lady Paget, 26 November 1896.
p.222 line 17 British Library, Royal MS.2. B.vii.
p.222 line 26 Letter from Lady Hylton to Miss Cicely Stanhope, 21 July 1941.
p.222 line 36 Three panels worked on single-weave canvas with twenty-six threads to the inch, embroidered in silks and wools with many different techniques and embellished with spangles and semi-precious stones, height of side panels 98 in, 248·9 cm, widths 18½, 33 and 18 in, 47, 83·8 and.45·7 cm.
p.222 line 39 *Quire Embroideries*, p.4. Lady Hylton wrote to Miss Stanhope on 23 March 1943: 'Mrs Jenner working at Wells Cathedral works more divinely than ever – she has finished her great St Andrew 8 ft. long.'
p.226 line 28 Information from the Cathedral Secretary, Mr L. S. Colchester, and Miss M. E. Antrobus, July and August 1978.
p.230 line 18 Louisa Pesel, formerly Director of the Royal Hellenic Schools of Needlework and Laces in Athens and President of the Embroiderers Guild, was in 1938 appointed 'Mistress of Broderers of Winchester Cathedral'. As well as

needleworks in the cathedral, some of her sample pieces can be seen in the Brotherton Library of the University of Leeds (see also Laura Pesel's 'Louisa Frances Pesel, 1870–1947' in *Embroidery*, XIII, No. 1, London, Spring 1962, pp. 18–20).

21 Westwood Manor

p.233 line 26 1649 survey of Commonwealth Commissioners quoted in Denys Sutton's *Westwood Manor*, p.19.

p.234 line 18 *The Times*, 13 July 1956.

p.234 line 29 See Mary Gostelow's *World of Embroidery* (Mills & Boon, London, and Scribner's, New York, 1975), p.363.

p.234 line 33 Reminiscence by James Lees-Milne, July 1978.

p.234 line 39 Lees-Milne, *Ancestral Voices* (Chatto & Windus, London, 1975), p.45.

p.234 line 40 Letter from Lady Seymour, Westbury, Wiltshire, July 1978.

p.234 line 44 Lees-Milne, July 1978.

p.235 line 7 Lees-Milne, July 1978.

22 A Continuing Heritage

p.239 line 19 12th Earl of Haddington KT: his great-grandfather George Baillie-Hamilton (great-grandson of Rachel Binning) succeeded his second cousin as Earl of Haddington in 1858, since which time the Earldom of Haddington and the estate of Mellerstain have been combined. Lord Haddington's heir is Lord Binning, who today lives at Mellerstain.

p.241 line 27 See Chottie Alderson's *Stitchin' with Chottie* (Ladybug Series, Running Springs, California), I, 1975, and Gigs Stevens' *Free-form Bargello* (Scribner's, New York, 1977).

p.242 line 2 (Plate 48) Canvas worked with persian wools, $37 \times 49\frac{1}{2}$ in, 94×125.7 cm.

p.243 line 5 See Catherine and Charles Lawrence Crenshaw's *The United Nations Peace Rug* (Crenshaw, Inman, South Carolina, 1975).

Specific technical instruction can be found in Mary Gostelow's *Coats Book of Embroidery* (David & Charles, 1978; published in America under the title *Mary Gostelow's Embroidery Book*, E. P. Dutton, 1979) or Pamela Clabburn's *Needleworker's Dictionary* (Macmillan, 1977/William Morrow, 1976).

Classical and biblical symbolism has been interpreted throughout according to James Hall's *Dictionary of Subjects and Symbols in Art* (Murray, London, 1974).

Listed below are publications of use to students of the aspects of needlework and related interests mentioned in *Art of Embroidery*. Sources more specifically related to the text are mentioned in the chapter notes.

Baker, Muriel, *The ABCs of Canvas Embroidery* (Old Sturbridge Village, 1971)
– *Stumpwork: The Art of Raised Embroidery* (Scribner's, New York, 1978).
– *The XYZs of Canvas Embroidery* (Old Sturbridge Village, 1971)
Betterton, Shiela, *American Textiles and Needlework* (American Museum)
– *Quilts and Coverlets from the American Museum in Britain* (American Museum, 1978)
Bishop, Robert (with Carleton L. Safford), *America's Quilts and Coverlets* (E. P. Dutton, New York, 1972)
– *New Discoveries in American Quilts* (Phaidon, Oxford, 1977)
Boynton, Lindsay (ed), *The Hardwick Hall Inventories of 1601* (Furniture History Society, London, 1961)
Brett, K. B., 'English Crewelwork Curtains in the Royal Ontario Museum', *Embroidery* (London, Spring 1965)
– *English Embroidery in the Royal Ontario Museum* (Royal Ontario Museum, Toronto, 1972)
Clabburn, Pamela, *Samplers* (Shire Publications, Aylesbury, 1977)
Cooper, Grace Rogers, 'United States', *Needlework, An Illustrated History*, Harriet Bridgeman and Elizabeth Drury (eds) (Paddington Press, London/ Grosset & Dunlap, New York, 1978)
Davis, Mildred J., *The Art of Crewel Embroidery* (Crown, New York, 1962)
– *Early American Embroidery Designs* (Crown, New York, 1969)
Duke, Jane Taylor, *Kenmore and the Lewises* (Kenmore Association, 1975)
Durant, David N., *Bess of Hardwick: Portrait of an Elizabethan Dynast*

(Weidenfeld & Nicolson, London, 1977)
Earle, Alice Morse, *Home Life in Colonial Days* (Berkshire Traveller Press, Stockbridge, Mass., 1974)
– *Two Centuries of Costume in America 1620–1820* (Dover, New York, 1970)
Edwards, Joan, *Crewel Embroidery in England* (Batsford, London, 1975)
Emmison, F. G., *Elizabethan Life: Home Work and Land* (Essex Record Office, Chelmsford, 1976)
Fennely, Catherine, *The Garb of Country New Englanders 1790–1840* (Old Sturbridge Village, 1966)
– *Textiles in New England 1790–1840* (Old Sturbridge Village, 1961)
Fraser, Antonia, *Mary Queen of Scots*, 2nd edition (Weidenfeld & Nicolson, London, 1978)
Gesner, Conrad, *Curious Woodcuts of Fanciful and Real Beasts* (Dover, New York, 1971)
Harbeson, Georgiana Brown, *American Needlework* (Coward, McCann & Geoghegan, New York, 1938)
Howe, Margery B., 'Deerfield Blue and White Needlework', *Needle and Bobbin Bulletin*, 47, Nos. 1 & 2, New York, 1963)
– *Deerfield Embroidery: Traditional Patterns from Colonial Massachusetts* (Scribner's, New York, 1976)
Hughes, Therle, *English Domestic Needlework 1660–1860* (Macmillan, London, 1961)
Ireland, Marion, *Textile Art in the Church: Vestments, Paraments and Hangings in Contemporary Worship, Art and Architecture* (Abingdon, New York, 1966)
Kendrick, A. F., *English Needlework* (A & C Black, London, 1933)
Kopp, Joel and Kate, *American Hooked and Sewn Rugs: Folk Art Underfoot* (E. P. Dutton, New York, 1975)
Krueger, Glee, *A Gallery of American Samplers: the Theodore H. Kapnek Collection* (E. P. Dutton, New York, 1978)
– *New England Samplers to 1840* (Old Sturbridge Village, 1978)
Lanier, Mildred B., *English and Oriental Carpets at Williamsburg* (Colonial Williamsburg, 1975)
Little, Nina Fletcher, *Country Art in New England 1790–1840* (Old Sturbridge Village, 1960)
Mackrille, Lucy Vaughan Hayden, *Church Embroidery and Church Vestments* (Cathedral Studios, Maryland, 1939)

Malden, R. H., *The Hangings in the Quire of Wells Cathedral* (Butler & Tanner, Frome, 1962)
Mayorcas, M. J., *English Needlework Carpets, Sixteenth to Nineteenth Centuries* (Lewis, Leigh-on-Sea, 1963)
Nelson, Cyril I., *The Quilt Engagement Calendar* (E. P. Dutton, New York, 1978)
Nevinson, J. L., *Catalogue of English Domestic Embroidery of the Sixteenth and Seventeenth Centuries* (Victoria & Albert Museum, London, 1938)
Parry, Linda, 'Great Britain', *Needlework, An Illustrated History*, Harriet Bridgeman and Elizabeth Drury (eds) (Paddington Press, London/Grosset & Dunlap, New York, 1978)
Ring, Betty, (ed) *Needlework: An Historical Survey* (*Antiques* Magazine Library, New York, 1975)
Schiffer, Margaret B., *Historical Needlework of Pennsylvania* (Scribner's, New York, 1968)
Smith, James Morton, 'The Henry Francis du Pont Winterthur Museum', *Antiques* (New York, June 1978)
Snook, Barbara, 'Needlework at Parham Park', *Embroidery* (London, Winter 1974 and Spring 1975)
Springer, Lynn E., 'Biblical Scenes in Embroidery', *Antiques* (New York, February 1972)
Standen, Edith, 'Needlework Carpets in New York', *Embroidery* (London, Spring 1964)
Sutton, Denys, *Westwood Manor: The History of the House and Its Inhabitants* (*Country Life* for the National Trust, 1962)
Swain, Margaret, 'Colifichets: The Story of a Search', *Embroidery* (London, Summer 1967)
– *Historical Needlework: A Study of Influences in Scotland and Northern England* (Barrie & Jenkins, London, 1970)
– 'Letters from School', *Scotland's Magazine* (Edinburgh, May 1965)
– *The Needlework of Mary Queen of Scots* (Van Nostrand Reinhold, New York, 1973)
– 'A Wild Kind of Imagination: Embroidery Pattern-drawers 1760–1839', *Country Life* (London, 26 January 1978)
Swan, Susan Burrows, *Plain and Fancy: American Women and Their Needlework 1700–1850* (Rutledge/Holt, Rinehart and Winston, New York, 1977)

– *A Winterthur Guide to American Needlework* (Winterthur/Rutledge, 1976)

Tillett, Leslie, *American Needlework 1776–1976* (New York Graphic Society, 1975)

Warren, William L., *Bed Ruggs 1722–1833* (Wadsworth Atheneum, Hartford, Conn., 1972)

Acknowledgments

Without the continued gracious co-operation of the owners of houses and their colleagues *Art of Embroidery* would never have been possible. Mary Gostelow would like especially to thank, for their help in so many ways:

Miss Mary Antrobus, for information on her father; The Duke of Atholl; Air Commodore Clive Baker OBE for patient discussion of Hardwick; Francesca Barran and the National Trust; Pace Barnes; Linda Baumgarten for help at the Valentine and now at Colonial Williamsburg; Shiela Betterton and the American Museum; Lord and Lady Binning; J. M. Cobban CBE for explanation of classical allusions; L. S. Colchester, who has made Wells so fascinating; Margaret Davis at Woodlawn; Louise Downing, a friend at the Valentine; Pamela Dubreil of Parham; David Durant, for opening his files on Bess of Hardwick; Julie Fallowfield; Jean Taylor Federico and the interest of the Daughters of the American Revolution; the Foreign Office Library and Records Department; Wendell Garrett and Alison M. Eckardt of *Antiques*; A. V. Griffiths and the Print Room of the British Museum; The Earl of Haddington KT; Anne Harrel; Pamela Hodgkins for help at Deerfield; Mrs Sheldon Howe, who inspires study of the Blue and White needleworks; the Dowager Lady Hylton and Lady Hylton for extensive and fascinating reminiscences; Susan Ford Johnson and Kenmore; V. J. Kite, Area Librarian of Bath, for information on Mr Lister's needlework supplies; James Lees-Milne, for such lively recollections of Mr Lister; Christine Meadows of Mount Vernon; Surgeon Captain and Mrs Mockler; Nancy Montgomery at the National Cathedral; Ruth Morrissey, curator of the Helen Allen Collection; Mr A. E. Moulton, for lending a photograph of Mr Lister; Kathleen Musa at the Helen Allen Collection; Jane Nylander, who made our visits to Old Sturbridge a delight; Nancy Richards and the National Trust for Historic Preservation; Mrs Philip Rollings, for detailed explanation at the National Cathedral; Ellice Ronsheim of the Ohio Historical Society; Lady Seymour, for information on Mr Lister; the Somerset Herald of Arms, Mr Rodney Dennys, for elucidation of the Royal arms; Peter Spang III, for his time and interest at Deerfield; the Countess of Strathmore and Kinghorne; Mr Peter Maxwell Stuart, Laird of Traquair; the Surveyor of the Queen's Works of Art, Mr Geoffrey de Belleraigue, and his colleagues; Mr Denys Sutton, both at Westwood and

The Connoisseur; Margaret Swain, a continuous mentor; Susan Swan, from whom so much can be learnt; Patricia Tice at Dearborn; Mrs P. A. Tritton, for so many invitations to return to Parham; Flora Turnbull at Mellerstain; Mr and Mrs Richard Van Wagenen; Sheila Watson; and, finally, Ann Wilson.

Sources of Illustrations

Illustrations in this book are reproduced by kind permission of the following (numerals in italics indicate colour photographs; numerals in brackets denote accession numbers):

By gracious permission of Her Majesty the Queen 97 (left)
By gracious permission of Her Majesty the Queen Mother 70
Chottie Alderson 240 (bottom)
The American Museum in Britain 19 (58.59) 21 (74.112), 22 (top) (58.91), 22 (bottom) (60.791), 23 (64.5), 24 (76.57), 25 (76.58)
The Duke of Atholl *14, 15, 26–7, 28, 29, 30, 31, 32,* (top and bottom), 33 (left and right)
The Lord Binning 118, 119, *122* (top and bottom), *123,* 124 (left and right), *126, 127*
The Bodleian Library, Oxford 66 (bottom)
The British Library 120 (462.b.18(1))
The College of Arms 33 (right)
Colonial Williamsburg Photographs 37 (1952–421), 38 (1930–412), 39 (1936–187), 40 (left) (1961–43), 40 (right) (1959–383)
Daughters of the American Revolution Museum 42 (ME.72.86 Gift of Miss Elwina Durgin), 43 (73.86), 46–7, 49 (64.129 Gift of Mrs John H. Burns), 50, 51 (4312 Bequest of Mrs Frances Spencer Marsh), 52, 53 (72.72 Gift of Mrs James Thornton), *54* (63.11 Gift of Mrs W. W. Brother, *55, 56* (66.219 Friends of the Museum Purchase), *58* (63.44.2 Friends of the Museum Purchase), *59* (63.44.1 Friends of the Museum Purchase)
Elsa Williams School of Needleart 238
The Fitzwilliam Museum, Cambridge 95 (bottom) (T5-1954)
The Earl of Haddington KT 240 (left and right)
The Helen L. Allen Collection, the University of Wisconsin–Madison 82, 83, 84, 86, 87, 88, 89, 90 (top and bottom), 91
The Henry Ford Museum 94, 98
The Henry Francis du Pont Winterthur Museum 100, 104 (top) (64.186), 104 (bottom) (61.102.1), 105 (58.1525), 106

(top) (62.588), 106 (bottom) (62.29), 109 (56.62)
Historic Deerfield Inc. 113 (54.178) 114 (left) (845), 114 (right), 115 (left) (F.163), 115 (right)
Kenmore Association, Historic Fredericksburg Foundation Inc. 210
Mrs R. Gilman Lunt (photograph Maude Banta) 116 (right)
The Metropolitan Museum of Art, New York 97 (right) (39.13.7)
Mrs E. J. Mockler *130–31,* 132, 134 (top and bottom), *135,* 137 (left), 140 (top and bottom)
The National Cathedral *back jacket,* 142, *143,* 146, 147, 148 (left and right), 149, 150, 152
The National Gallery of Scotland 12 (top) (2171)
The National Library of Scotland 137 (right)
The National Portrait Gallery 99 (215)
The National Trust (GB) 66 (top), 73, 77, 78 (top and bottom), 79
Ohio Historical Society *138, 139,* 158, 159
Old Sturbridge Village 163 (left and right), 164 (top), 165 (left) (26.67.19), 165 (right) (26.67.26), 166 (top left) (26.45.23a), 166 (top right), 166 (bottom) (26.35.33), 167 (left) (26.29.34), 167 (right) (26.29.69), 168 (26.55.106)
Anna Pearson 242 (top right)
Pocumtuck Valley Memorial Association 116 (left)
Royal Ontario Museum, Toronto 190 (right) (928.14.2/5)
Diana Springall (photograph John Hunnex) 242 (top left)
Statens Museum for Kunst, Copenhagen 178
Gigs Stevens 224
The Earl of Strathmore and Kinghorne *62, 63, 68, 69*
Mr Peter Maxwell Stuart *188, 189,* 190 (left), *192,* 193 (top and bottom), 194, 195
Mr Denys Sutton and the National Trust endpapers, 220, 221, 233, 235, 236 (top left, top right and bottom)
Mrs P. A. Tritton *front jacket,* frontispiece, *8, 10, 11, 172, 174, 175,* 176 (top and bottom), *177,* 179 (left and right), *180, 181, 182, 183, 184–5*
The Valentine Museum 196, 200 (bottom) (L.75.1.226), 201 (52.181.2), 202 (56.89), 203 (V.77.46)
Victoria and Albert Museum, Crown Copyright 65 (T.31-1955), 96 (T.204–1953)
Wells Cathedral *212, 213,* 216, 217, 218, 223, 226, 227 (top and bottom), 228, 229 (top and bottom), 230, 231
Woodlawn Plantation and the National Trust for Historic Preservation 207, 208, 209 (top and bottom)

Index